THE GRAPHIC WORK OF
ALPHONSE MUCHA

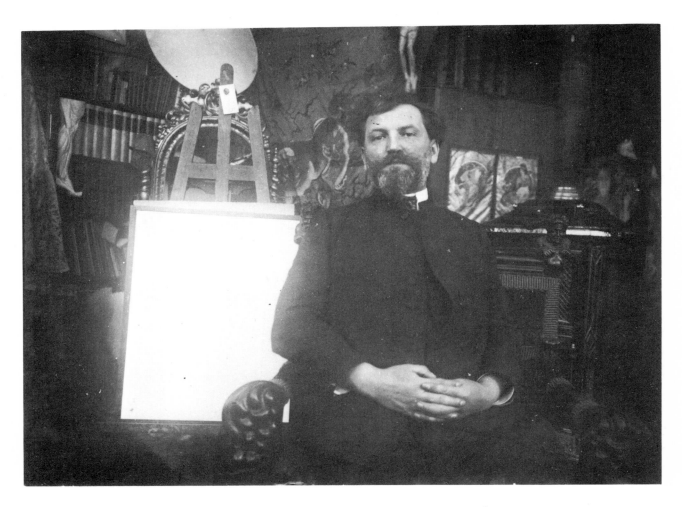

Alphonse Mucha at his studio in the Rue du Val de Grâce 1898

THE GRAPHIC WORK OF ALPHONSE MUCHA

EDITED BY

JIRI MUCHA

WITH AN INTRODUCTION BY

MARINA HENDERSON

ACADEMY EDITIONS · LONDON
ST. MARTIN'S PRESS · NEW YORK

The illustrations on pages 42, 92, 134, and 136 reproduce photographs of models taken by Mucha.

First published in Great Britain in 1973 by
Academy Editions 7 Holland Street London W8

SBN 85670 146 7

First published in the U.S.A. in 1973 by St. Martin's Press Inc.
175 Fifth Avenue New York N.Y. 10010

Library of Congress Catalog Card Number 73 - 89209

Printed and bound in Great Britain at
Burgess & Son (Abingdon) Ltd and at
the University Printing House Cambridge

CONTENTS

ACKNOWLEDGEMENTS

We should like to thank the many galleries and private collections for their co-operation and permission to reproduce illustrations. In particular we should like to thank MARTA KADLECIKOVA who undertook the initial research for the catalogue and compiled the bibliography. We are also grateful to ALEXANDER KASPAR for compiling the section on French postcards and allowing us to reproduce from his extensive collection.

WOMEN AND FLOWERS

THE LIFE AND WORK OF ALPHONSE MUCHA

The image of Paris as the city of elegance, frivolity, extravagance and sophistication, spiced with more than a hint of naughtiness, is the legacy of the *Belle Epoque* when Parisian society seemed to act out a Freydau farce to the accompaniment of the can-can. As the essential of farce is the contradiction between reality and appearance, it is in keeping that the period's most fashionable decorative artist should be a man whose life seems totally at variance with the work that made him famous. Alphonse Mucha, whose delicately sensuous style epitomizes the urbane grace of French Art Nouveau, was a Czech, born in 1860, next to the local jail in the remote Moravian town of Ivancice, who died, after being questioned by the Gestapo, in Prague, in 1939.

To examine the unlikely path by which Mucha travelled from provincial obscurity to international fame is to sympathize with his conviction that his life had been shaped by the direct intervention of Fate. Certainly, at three crucial stages in his life, his future was determined by chance encounters, in a country church, a small market town and a Paris printing works.

The youngest son of a court usher who was ambitious for his children and had destined Alphonse for the priesthood, Mucha's childhood was dominated by the two forces that he recognised as the inspiration of his art – religion and nationalism. He was born in a region where Slav language and traditions had only been retained with difficulty against the Hapsburg policy of the Germanization of their Slav provinces and where the emergent pan-Slavic and Czech nationalist movements were to find some of their most fervent adherents. Throughout his life his favoured associates were fellow-Slavs and he was eventually to reject the adulation of Paris and New York to dedicate his art and twenty-five years of his life to *The Slav Epic* for the Czech people.

Always deeply religious and convinced of the occult workings of the supernatural in daily life, his first aesthetic experiences had sprung from church ritual and music of which, as a choirmaster at the great Baroque cathedral of St. Peter in Brno, he had an intimate knowledge and lifelong love. Perhaps the most significant encounter in his life also took place in a church. Returning home from Brno after his voice had broken, he

chanced to visit the church at Usti nad Orlici which was being frescoed by the painter Umlauf. In the restricted society in which he had moved, his undoubted precocious talent for drawing was accepted as a pleasant pastime. Never before had he realised that there were such people as living artists, and an artist he now determined to become.

Few fathers have greeted such a decision by their sons with enthusiasm and Mucha's was no exception. For two years the boy acted as court scribe at Ivancice, learning more from the endless amateur theatricals he organized than the cases he reluctantly recorded. His release came from the theatre. An application to join the Prague Academy having been refused, on the grounds that an artist's life was too risky, Mucha left home to become an apprentice scene-painter in Vienna, where he was also able to attend some drawing classes. The near-bankruptcy of his employers in 1881 left him workless and penniless and in the summer of that year he arrived, completely without plans or purpose, at the small town of Mikulov. Here his sketches, displayed by a friendly bookseller, were brought to the attention of the local landowner Count Carl Kheun. From the Count, Mucha received his first important commission and for nearly two years worked at his castle, the Emmahof, restoring family portraits and decorating the dining room with classically inspired murals. A similar commission came from the Count's brother at whose castle in the Tyrol Mucha's work attracted the attention of the German painter Wilhelm Kray, Professor at the Munich Academy. It was through Kray's encouragement and the Count's support that Mucha, in 1885 arrived in Munich for his first formal art training. On leaving Munich after two years of study, and having won two prizes, the Count suggested that Mucha continue his studies in Paris where, first at the Academie Julian and then the Academie Colarossi, Mucha first came into contact with the latest art movements and theories.

The abrupt termination of his allowance in 1889 resulted in two years of the artist's traditional lot – starvation in a garret, from which he was saved by his growing reputation as a skilled, versatile and dependable illustrator. Initially, his work was for cheaper journals, like *Le Petit Paris Illustré* and other enterprises of the friendly publisher Armand Colin, but he then

secured a commission to illustrate Zavier Marmier's fairy tales *Les Contes des Grand-Mères*. These illustrations brought Mucha's first public recognition, gaining an Honourable Mention at the Salon and slowly, during the next four years, Mucha consolidated his growing reputation with increasingly prestigious commissions such as his contributions to Seignobos' monumental *Scènes et Episodes de l'Histoire d'Allemagne*.

Until the end of 1894 there was little remarkable in Mucha's life and nothing particularly outstanding, certainly in a Parisian context, about his work. Distinguished by a remarkable graphic fluency and a certain elusive charm, his style, from the first surviving Mikulov sketches to the Seignbos illustrations, was strictly within the high academic tradition. Only in the isolated, and now very rare, calendar that he designed for Lorilleux in 1893, is there a faint hint of *le style Mucha*. Self-taught to a considerable extent, his innate technical skill had been well trained under Herterich at Munich, but neither in form nor in subject matter did his work display any great originality, reflecting rather the influence of established artists he admired, Meissonier, Delacroix, Doré and that immensely successful painter of Viennese matrons in decent allegorical nudity, Hans Makart.

It was the third crucial intervention of chance that produced the style so essentially his own. In the afternoon of Christmas Eve, 1894, Mucha was correcting proofs, for a friend, at the printing works of Lemercier when Sarah Bernhardt, dissatisfied with the poster for her new production, *Gismonda*, by Sardou, telephoned demanding another poster to be ready for billing on New Year's Day. For want of another immediately available artist, Mucha was offered the job and produced a poster so radically new in design that from the moment it appeared on the hoardings it became a collector's piece (not unaided by Bernhardt's shrewd business dealings) and Mucha was catapulted to immediate fame.

Not until recently have posters attracted the same critical attention as in the Paris of the eighties and nineties when a new example by Cheret, Toulouse-Lautrec or Steinlen merited reviews in serious art journals. Now, when Art Nouveau posters, for the most part abominably reproduced in Mucha's case, are a staple of fashionable interior decoration, it is difficult to appreciate the impact of Mucha's *Gismonda*, in many ways

the most impressive poster he ever produced, in 1895, the distinctive shape, muted colouring and exquistely simplified draughtsmanship allied to a Byzantine richness of decoration were completely novel. The poster's obvious merit, allied to the publicity value of anything or anybody connected with Bernhardt, ensured that within a week Mucha was the most talked about artist in Paris.

As a result of *Gismonda*, Mucha signed a six-year contract with Bernhardt for whom he not only designed nine outstanding posters (of which only one, *Les Amants*, 1895, was not in the elongated format he had established at the first) but costumes, sets, jewellery and with whom he produced two extremely successful plays, Rostand's *La Princesse Lointaine* and *La Dame aux Camélias*. Bernhardt's patronage and the sheer prettiness of the work that Mucha was now producing, brought a flood of commissions and one of the first to realize the commercial possibilities of Mucha's decorative designs was the printer Champenois. In return for a fixed, and generous, salary, Champenois secured the exclusive right to print as much of Mucha's lithographic work as he required. A shrewd businessman, it was he who suggested the idea for the famous *panneaux décoratifs*. These were basically posters, without textual matter, printed on quality paper or even satin and sold, in considerable quantities, for framing or display in private houses and shops. Of the surviving panneaux those, now rare, printed on satin give the most accurate impression of Mucha's original colour schemes. Overwhelmed with work, he often did not have the time to correct the colour proofs of the many cheaper editions printed on paper and which, even in the cases of corrected editions, have tended to discolour. Although Mucha found his contract with Champenois increasingly onerous and complained that he was being commercially exploited, he produced some of his most attractive and popular lithographic work for him, like the delightful *Four Seasons* of 1896, perhaps his most spontaneous and relaxed series, and the *Four Flowers*, the most frequently reproduced of all his designs. Champenois, who was not one to let a saleable commodity fade, used Mucha's designs repeatedly, as posters, calendars, *panneaux* and, ultimately postcards. These postcards, of which reproduction in France reached a peak around 1900, are interesting both because designs originally produced in monochrome are here first pro-

duced in colour and because they proved useful in dating otherwise undated work. The variations in colour can be attributed to the frequent occasions when Mucha was not able to supervise the final printing and as time went on and Mucha increasingly lost interest in this sort of work, the colouring often tended to become coarser and more harsh.

Within eighteen months of *Gismonda*, Mucha held his first one-man show at the *Salon des Cents* in the galleries of the influential *La Plume* magazine. Over four hundred items, two-thirds completed within the last two years, ranging from religio-historical illustrations to his latest panneau, were displayed. The complete break in his style pre- and post-*Gismonda* must have been patent but few critics paid much attention to his 'serious' work, preferring to rhapsodize, with some exceptions, over Mucha's women and flowers. Thus, at the very start of his success, attention was focussed on that aspect of his work that Mucha came to despise and for which, paradoxically, he is now best remembered. For Mucha's view of art is totally unexpected if, as is general, only the decorative work in the idiom of his Paris period is known and considered. To Mucha, art was essentially concerned with the propagation of ideas that would contribute to the spiritual evolution of the human spirit, hence his slightly unexpected admiration for Puvis de Chavannes and some other Symbolists. Mucha repudiated any such description and classification of his work as Art Nouveau, protesting that, as art was eternal, it could never be new. Equally, he refused to enter into any discussions on his affinities and links with any individual school or movement. A friendly, gregarious, attractive man, generous to a fault, he had met many artists during his Paris apprenticeship. For six years his studio which for some months he shared with Gaugin had been over the famous *crémerie* owned by Madame Charlotte, a patron of modern art despite herself, and here he had become familiar with the latest experiments and theories of artists who were seeking to break the conventions of academic art and to take art out from the Salon and back to the people. By the arguments for and against academic art, Mucha was unmoved, his admiration for the artists who had influenced him in his youth persisted all his life, but with the gospel of William Morris, spread by the enthusiastic Delius, he was in complete agreement. Mucha welcomed the comparative cheapness of his lithographic work

for this very reason. Not for him the creed of art for art's sake, art was for the people.

On examination, his style, of which the obsession with curves and the wandering strands of women's hair, became the most easily plagiarised features, can be seen to have affinities with many trends current in the art world of the time. The interest in Japanese graphics, the cloissonism of Gaugin and Grasset, the spangled skies of Schwabe, the development of simplified line as the essential element in composition of Beardsley. But to Mucha, his style was the natural evolution of purely Czech artistic traditions organically growing from roots in the country he loved so well. The criticism that most saddened him was that of jealous Czech artists who derided his work because "it is French". Perhaps the most convincing explanation of the sudden efflorescence of Mucha's style is that given by his son Jiri Mucha in *Alphonse Mucha: Posters and Photographs*: "I can only suggest that it was the power of Bernhardt's personality and the emotional force of the scene in which he chose to depict her – on her way to church – in a Byzantine setting, which acted as a catalyst on the diverse strands which must have contributed to his artistic development". For more than a decade, until his first visit to America in 1904, Mucha's studio in the rue Val de Grâce, where the atmosphere reminded one observer of the mysteriously lit interiors of Czech Baroque churches, became one of the sights of fashionable Paris. An impression of the confusion of bizarre objects with which it was crammed can be gained from several of Mucha'a own photographs where the studio appears as a background for his models. He had moved to this, larger, studio towards the end of '96 in order to have room to complete one of his most interesting and successful commissions, *Ilsée*. Published, in 1897, by Piazza, *Ilsée* was a bibliographical rarity from the day of publication and has always retained its value. It is Mucha's most successful illustrated book, displaying his authoritative mastery of design on every page and, at a time of distinguished book illustration and production, it is unquestionably a masterpiece. With what now appears a wanton inability to appreciate the true strength of his work, however, Mucha preferred his designs for *Le Pater* (1899) in which his supreme decorative gifts while, as always, apparent, were subordinated to an emotional romanticism in the style he was later to perfect in *The Slav Epic*. Indeed, in the

chaotic months leading up to the Paris Exhibition in 1900, *Le Pater* and similarly inspired murals for the Bosnian-Herzogovinan Pavilion, together with his extremely polished essays in sculpture, were Mucha's consolation for the increasing amount of commercial work, in the style demanded by his popularity, which he was undertaking.

From 1896 to 1902 were the years of Mucha's maximum graphic activity and those when, on balance, his best graphic work was produced – the early *panneaux*, the superb *Job* posters of '96 and '98, *The Zodiac* and the poster for *Moet & Chandon's 'Dry Imperial'* of 1896, that forerunner of all evocatively glamorous travel posters *Monaco-Monte Carlo* (1897), *Ilsée, Documents Décoratifs* (1902) and all but one (uncompleted) Bernhardt poster. Already in the gorgeous *La Plume* and *Primevère* of 1899 a certain hardening of his style can be discerned and in the glowing *Four Precious Stones* (1900) maturity and worldly wisdom has replaced the untested charm of his earlier models. His style is more tightly organized and more dependent on the reiteration of the stock motifs that people had come to expect in his work. Amongst his later posters few, like *Princess Hyacinth* (1911) totally capture the carefree, innocent sexuality that contributed so greatly to the charm of the work of his early Paris years. What was lost in sponteneity and originality was largely replaced by astoundingly confident graphic virtuosity and inventiveness. Qualities apparent in every attractive page of *Documents Décoratifs*. Issued as a folio with seventy-two monochrome, two or three colour plates, many hand-coloured under Mucha's supervision, *Documents Décoratifs* is an encyclopaedic source for Mucha's style in every branch of decorative and applied art and one of the few books on design where even individual plates are sought after by collectors. Both in conception and execution it is superior to the later *Figures Décoratives* (1905) in which only a few plates are more than pedestrianally competent.

Mucha's reason for visiting America, where between 1904 and 1912 he was more frequently than in France, was uncomplicated – money. In 1903 he had met the young Czech girl that he was to marry and spendthrift and generous, he had accumulated no capital in Paris in spite of his high earnings. Sarah Bernhardt's vivid account of the profitability of her first American tour and his friendship with the Baroness de Rothschild who was only

too happy to supply introductions to suitably wealthy potential clients, seemed to auger well. Moreover, he was now determined to establish a new reputation as a serious painter and a portraitist, a reputation which his very popularity would make virtually impossible to acquire in Paris.

Leaving Paris at the height of his fame, when the most popular item at the Folies Bergère had been the dancer Lugie in *poses plastiques* based on his *panneaux* and fashionable dress and interior decoration, theatre and commercial design and his many imitators testified to the triumph of *le style Mucha*, he found that his hopes of America were, from the financial point of view, soon dashed. New York welcomed him as enthusiastically as Paris with two full pages of panegyric heralding his arrival in the *New York Times* and countless social invitations. But the Mucha that America demanded was the Mucha of the posters and *panneaux*, the type of work that he had determined to abandon.

During his years in America, Mucha's main source of income was from teaching (he gave classes both in New York and in Chicago). He secured several commissions for portraits but painting in oil was a medium he found tediously time-consuming although he greatly enjoyed it. A task that also engaged much of his time was the complete decoration of the German Theatre in New York (converted to a cinema in 1909 and demolished in 1929). His graphic output in the States was limited and much of it for magazines like *Hearst's*. Perhaps his most 'commercial' undertaking was a set of delightful soap wrappers for Armour of Chicago but no *panneaux* and only four of his posters are known to have been designed and executed in the States. Of these two were for the theatre, one for the ill-fated super-production *Kassa* (1908) starring the sadly over-ambitious Leslie Carter, for which Mucha also designed the costumes and sets, and a poster (which does not appear to have been published) for Maude Adam's one night production of Schiller's *The Maid of Orleans* (1909) at the Harvard Stadium.

The most momentous result of Mucha's American sojourn was the support of the millionaire Charles R. Crane who agreed to finance what had become Mucha's one ambition, *The Slav Epic*. In 1909, he, in the teeth of violently jealous objection from local

artists, had been commissioned to decorate the Mayor's Parlour in Prague municipal buildings. In this task, for almost the first time, he felt that he was employing his art for its proper end – the celebration of the spirit of the Czech people. He produced a triumphantly theatrical fresco which even today when national-heroic art is little esteemed cannot fail to impress. *The Slav Epic*, twenty vast panels in tempera and oil depicting incidents from Slav history, was completed between 1912 and 1928. Executed with all the technical skill and mastery of composition inseparable from any of Mucha's work, one cannot question the effectiveness of these monumental pictures. What can be questioned is whether Mucha's unique abilities were used to their best advantage in this genre. For, with the exception of his work for Bernhardt, for whom he had unstinted admiration and with whom he shared a deep rapport, it can be argued that the less Mucha's ideals and emotions were aroused by his subject, the more direct and individual is the impact of his art. The posters he designed in Czechoslovakia, the majority for charitable organisations or national events, are unmistakably Mucha but are rarely as successful as the purely 'commercial' work he had done in France at the height of his fame. In place of effortless elegance there is a striving to communicate emotion which too often only succeeds in creating an uneasy imbalance between form and content. An uncomplicated, successful and, as far as can be judged, fundamentally happy man, Mucha's strength lay in his celebration of natural, and feminine, beauty. His best work seems to flow from an inner equilibrium between an uncomplicated response to physical beauty, whatever its manifestation, and a rarely surpassed graphic dexterity and ornamental fluency. In attempting to communicate emotional or intellectual concepts, this equilibrium tended to be thrown out of balance and the result, however competent, lacks the qualities of Mucha's best design – uncomplicated, immediate and totally satisfying grace.

After the glittering scene of the Paris of the *fin-de-siècle*, Mucha's later years, spent largely in Czechoslovakia, must inevitably seem an anti-climax. But in the content of his family life, the assurance that he was directly serving his nation, as with his designs for stamps, bank-notes and even policemen's uniforms for all of which he would not accept any payment, he appears to have been fulfilled. His European and international

reputation was kept alive by the extremely successful exhibition of his work at the Brooklyn Museum in 1921 (which featured *The Slav Epic*) and a comprehensive retrospective exhibition at the Jeu-de-Paume in Paris in 1936. But already by then his art did not seem so much outmoded as representative of a Europe and a civilization that had disappeared in which the *douceur de vie* whose passing Talleyrand had lamented in the Revolution had, briefly, been revived.

Mucha was an old man when the Germans marched into Czechoslovakia in 1939. His life had seen the birth and the effectual death of the nation that had for so long been the focus of his aspirations. He was one of the first in Prague to be questioned by the Gestapo and his health, already suffering, did not long withstand the interview. Three months later he died leaving behind him an unparalleled collection of every aspect of his work done in his long and ultimately successful life.

Among the cognoscenti, Mucha's name was never forgotten but, suitably, it was an exhibition at the Musée des Arts Décoratifs in Paris in 1966 that again drew general attention to this superb decorative artist. Since then his work has been amongst the most sought-after of any Art Nouveau artist (one of his busts fetching a world record price for any piece of Art Nouveau sculpture at Sotheby's, London, in 1972) and, at a time of proliferating poster reproduction, his posters and *panneaux* are, internationally, perhaps the most consistently popular. Published in considerable quantities in his lifetime, a substantial amount of his lithographs executed under his direct supervision, sometimes drawn directly on the stone but more often transferred from carefully detailed sketches, is still available at prices that make it a field in which the amateur can still compete with the professional. This catalogue of Mucha's printed work, as comprehensive as exhaustive research can make it, listing those items whose publication and authenticity can be established, has been produced in response to the immense popular interest in these items, an interest which Mucha, with his belief in the relevance of his art not to the few but to the many, would be the first to welcome.

MARINA HENDERSON

PANNEAUX

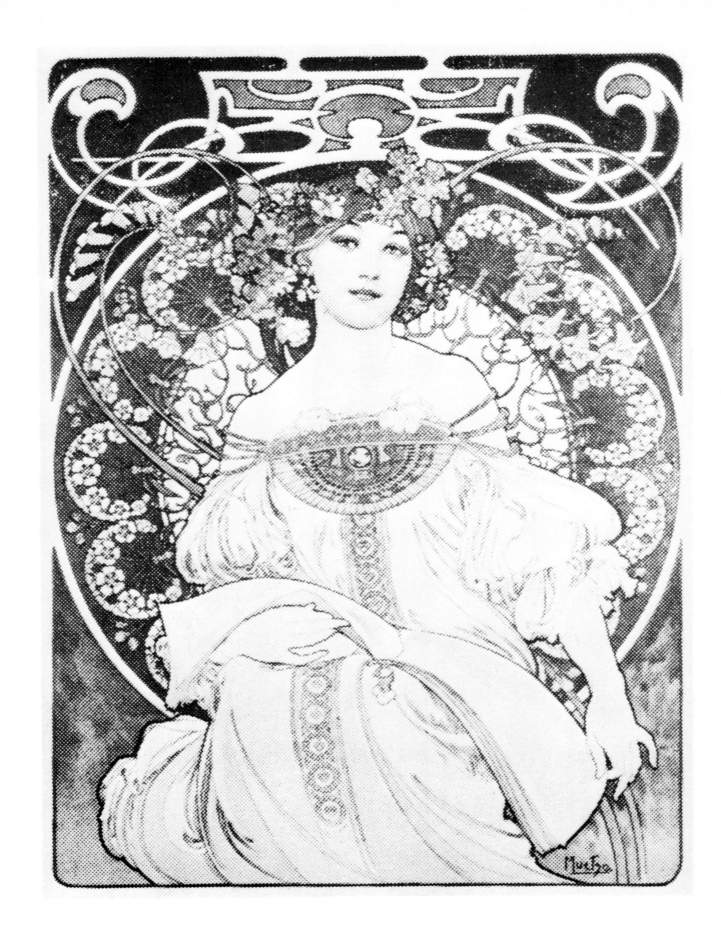

1. REVERIE 1896

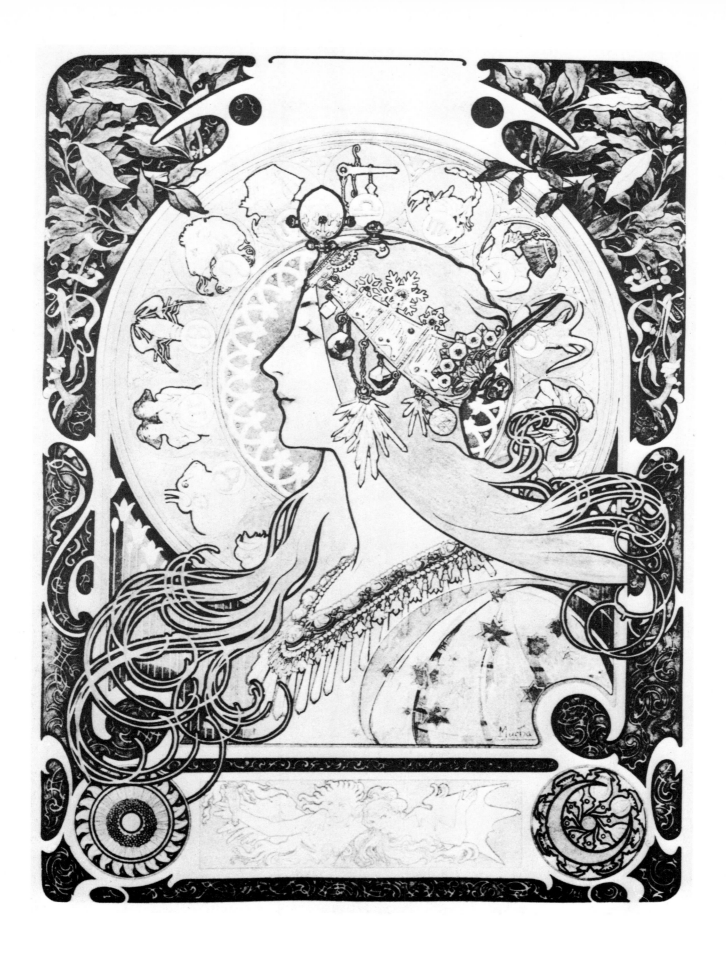

2. ZODIAC 1896

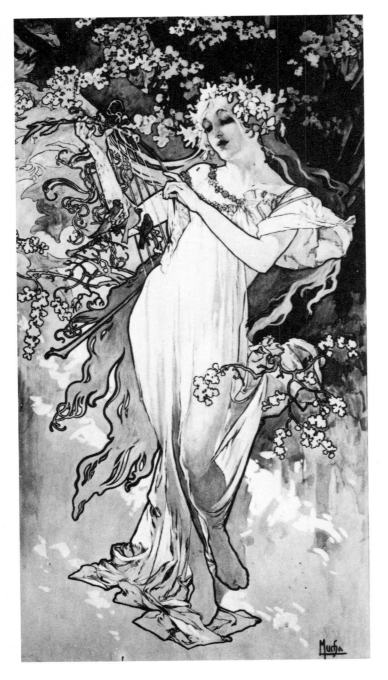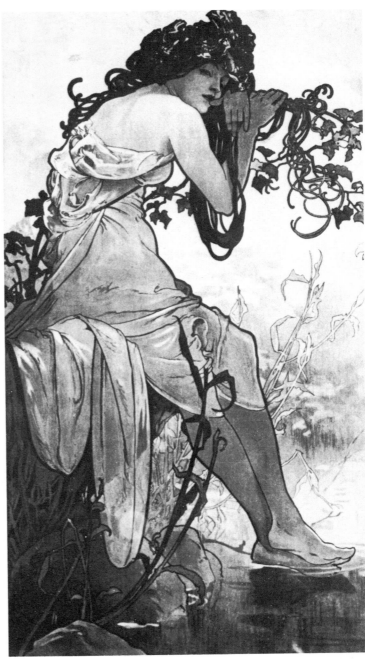

3. PRINTEMPS 1896 4. ETE 1896

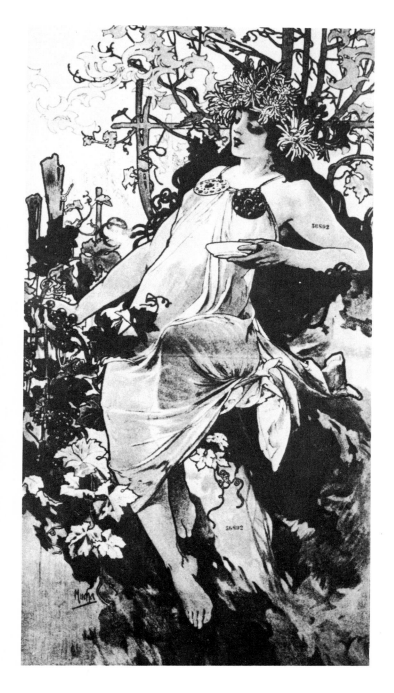

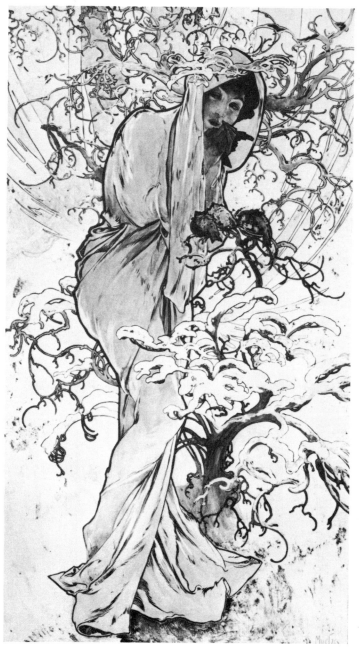

5. AUTOMNE 1896

6. HIVER 1896

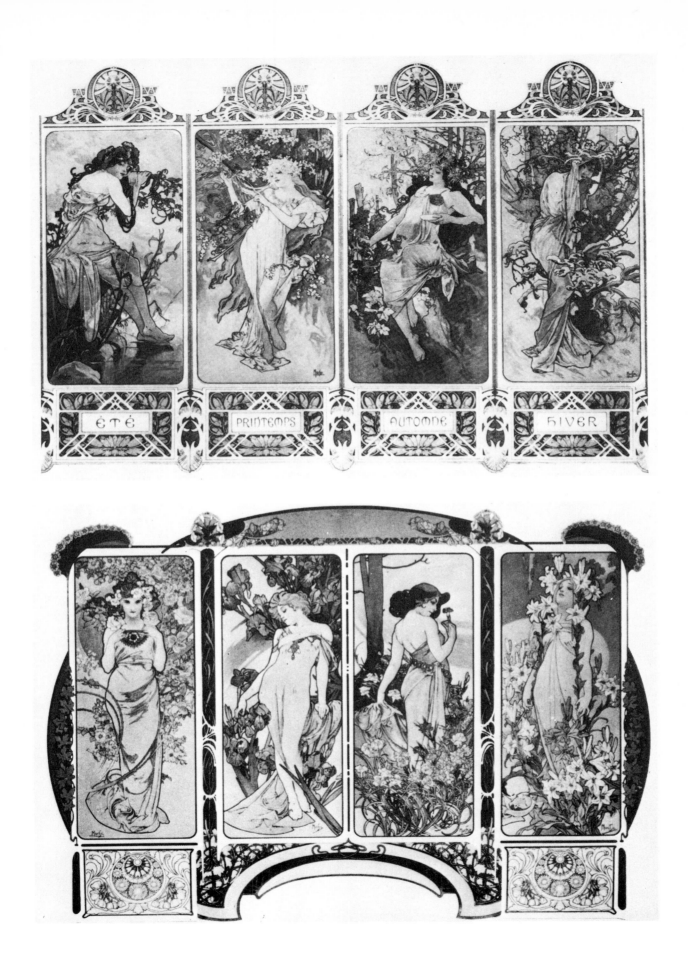

7. LES SAISONS 1896

8. LES FLEURS 1897

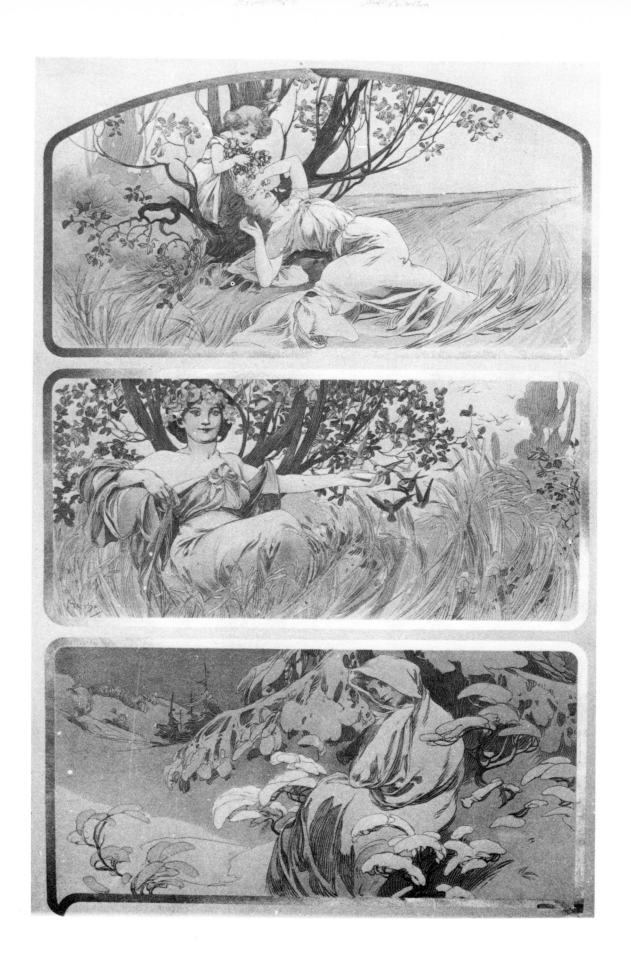

9. THREE SEASONS OF THE YEAR c. 1896

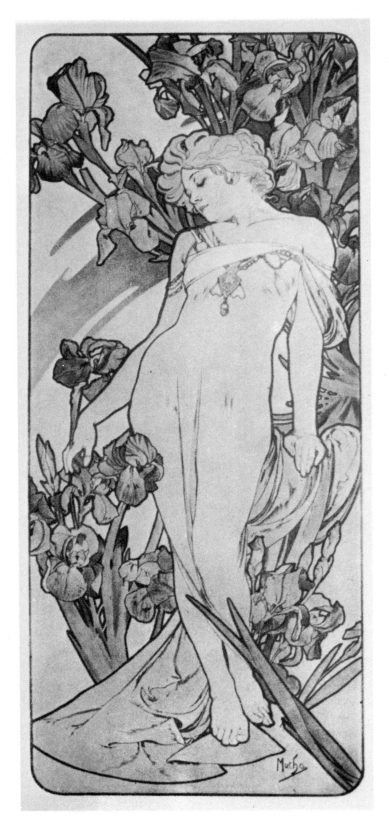

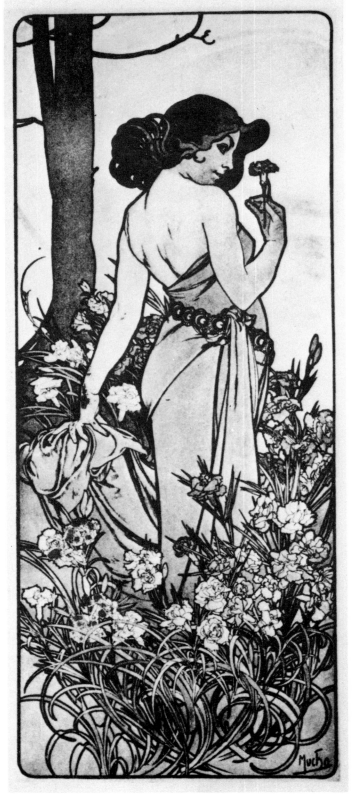

10. IRIS 1897

11. OEILLET 1897

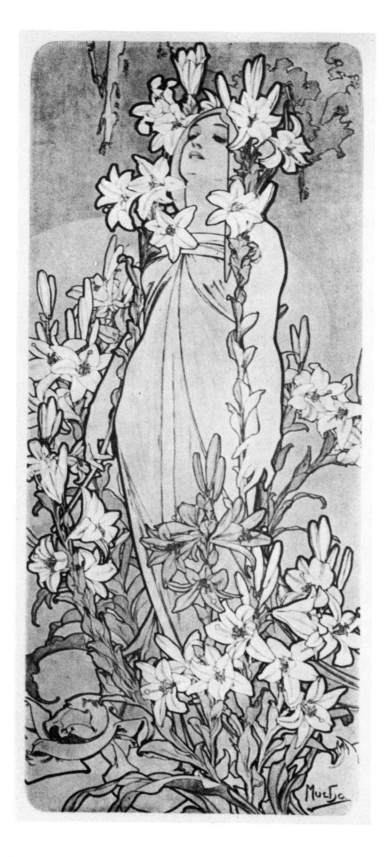

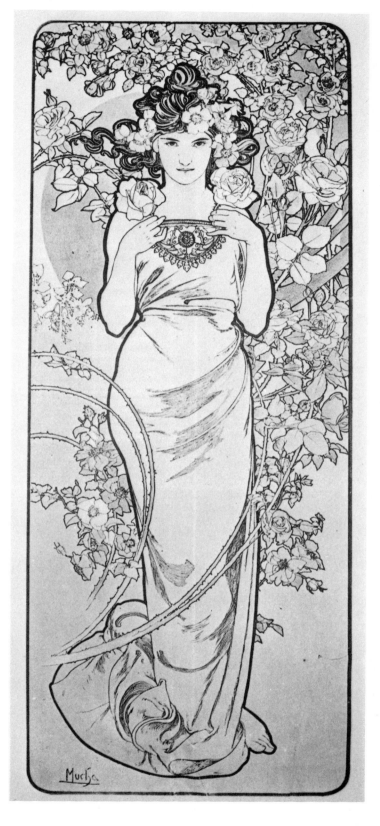

12. LYS 1897

13. ROSE 1897

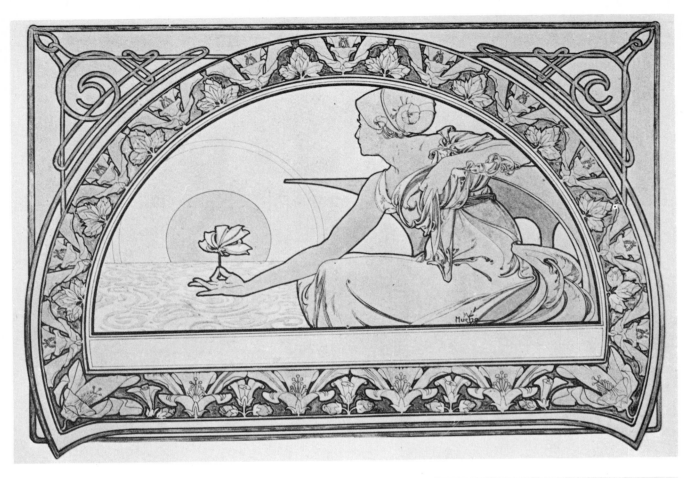

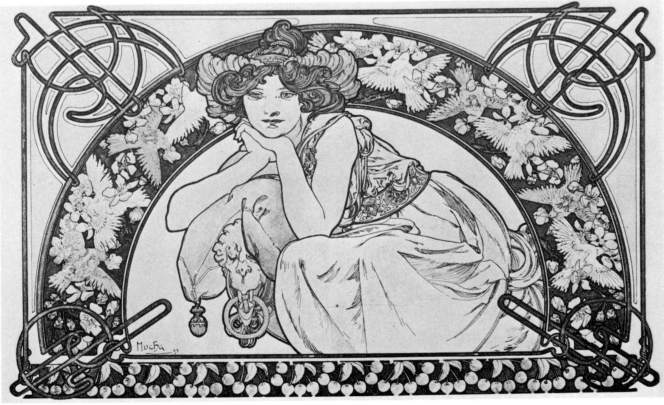

14. NENUPHAR 1898

15. FLEUR DU CERISIER 1898

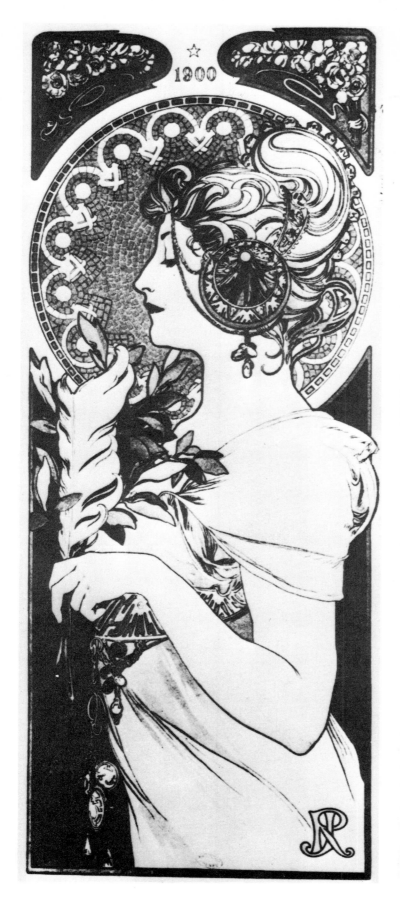

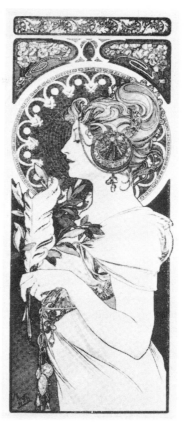

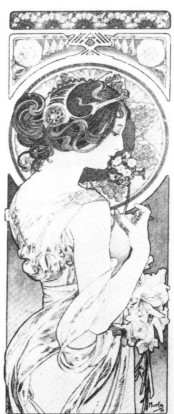

16. LA PLUME 1900

17. LA PLUME 1899

18. PRIMEVERE 1899

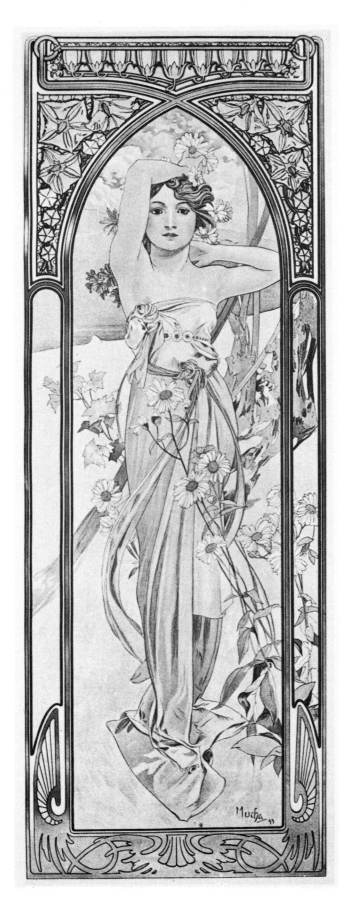

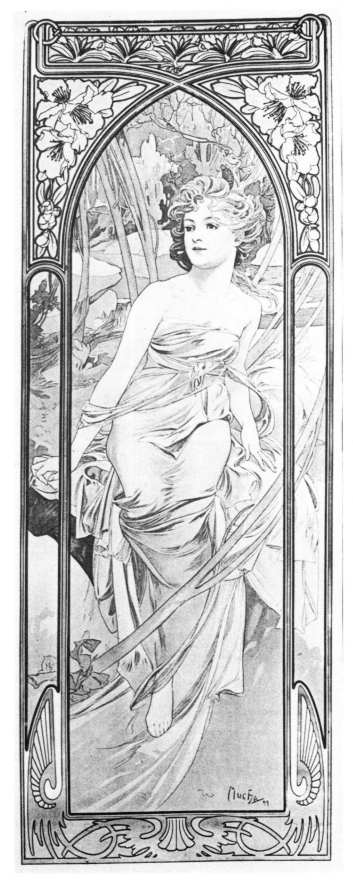

19. EVEIL DU MATIN 1899

20. ECLAT DU JOUR 1899

28

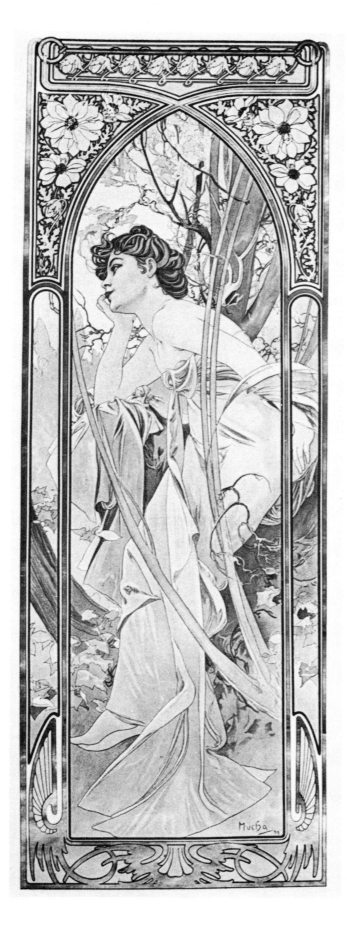

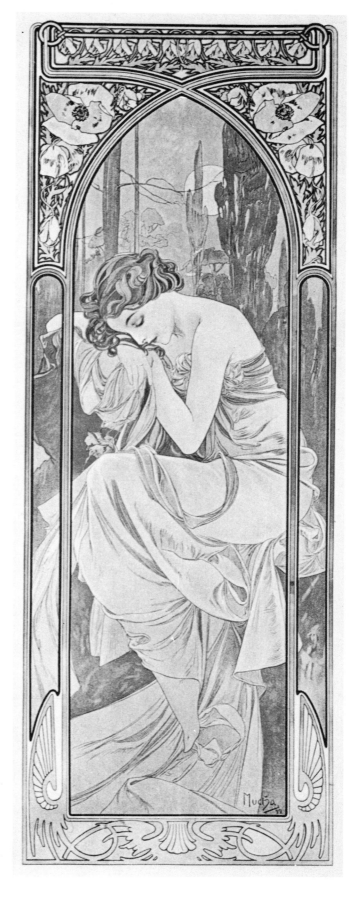

21. REVERIE DU SOIR 1899

22. REPOS DE LA NUIT 1899

29

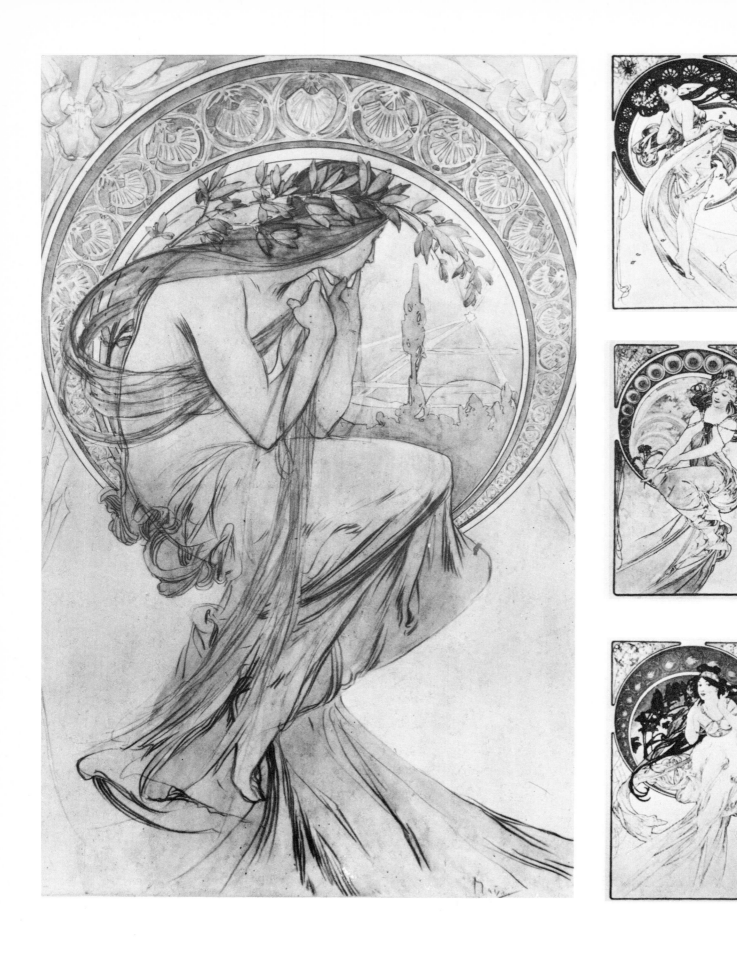

23. LA POESIE 1898

24. LA DANSE 1898

25. LA PEINTURE 1898

26. LA MUSIQUE 1898

30

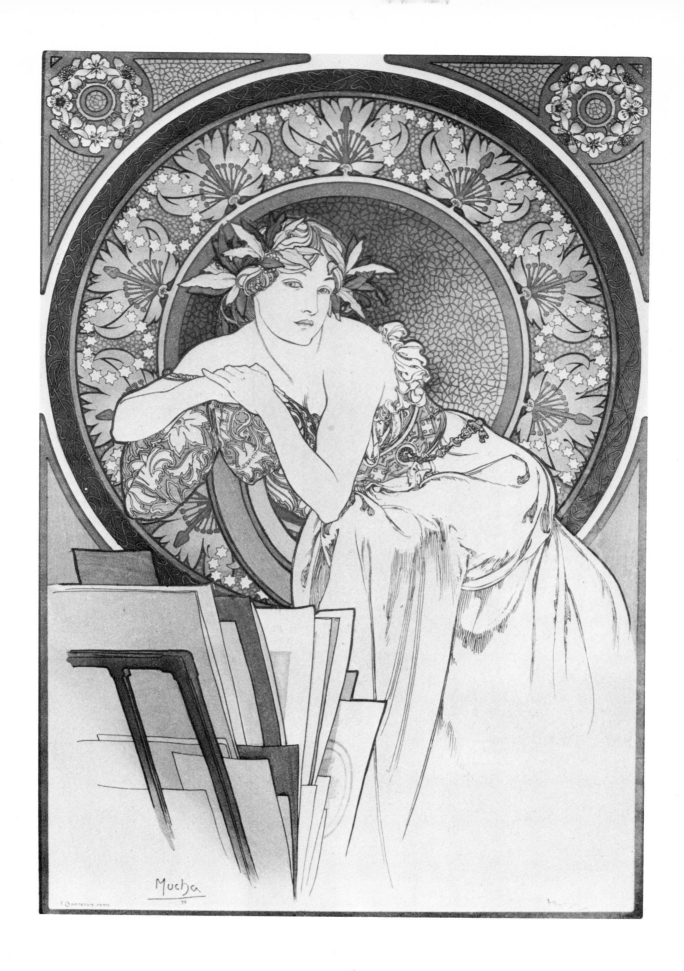

27. GIRL WITH EASEL 1898

31

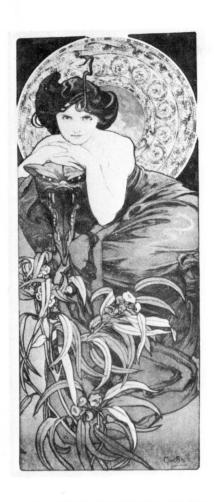
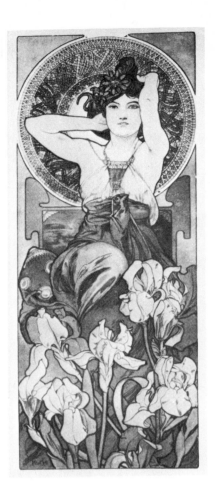
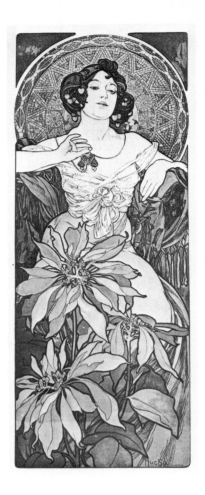

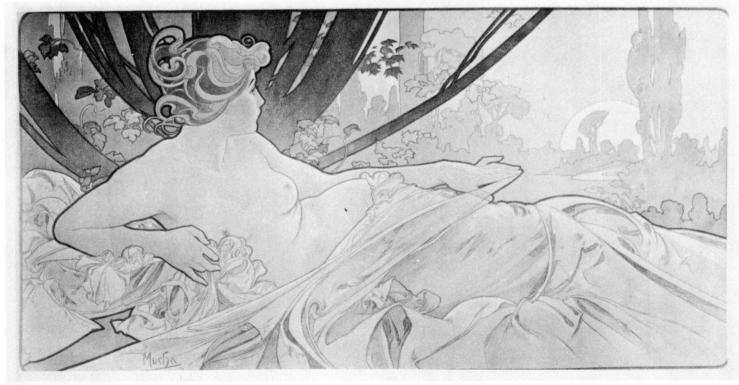

28. EMERAUDE 1900

29. AMETHYSTE 1900

30. RUBIS 1900

31. AURORE 1899

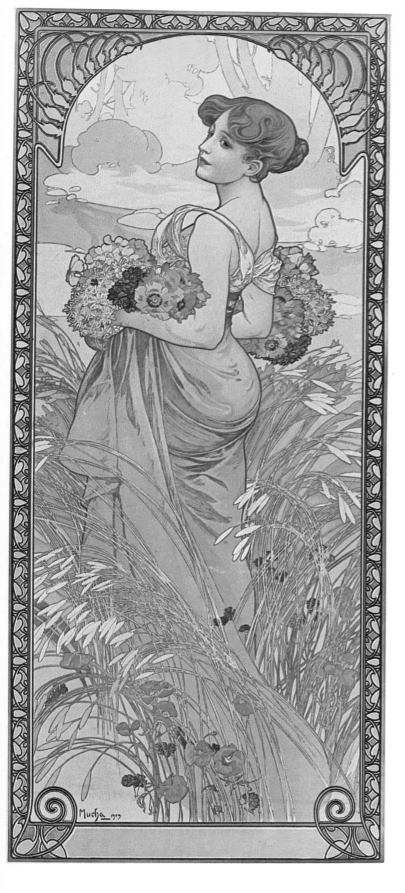

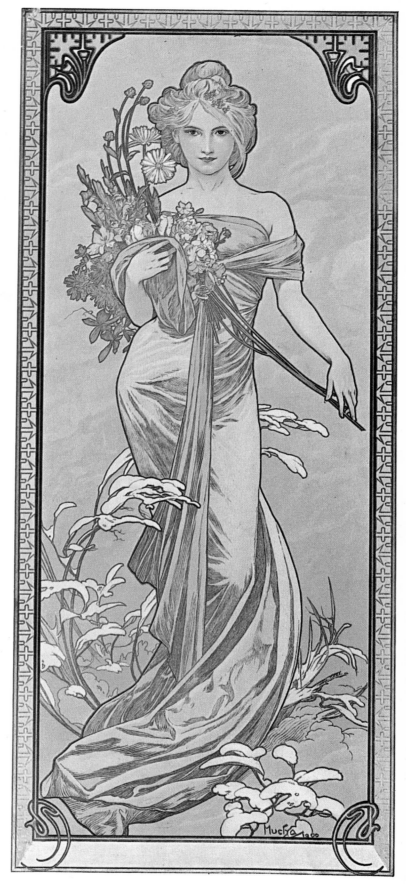

ETE 1896

PRINTEMPS 1896

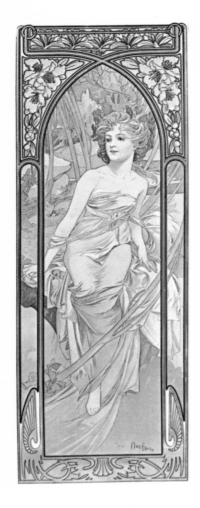

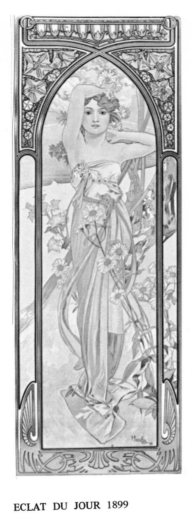

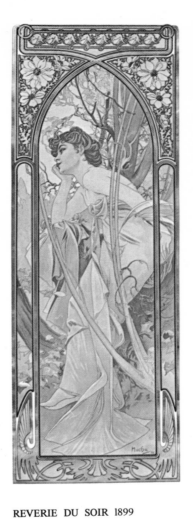

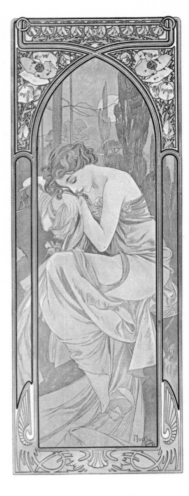

EVEIL DU MATIN 1899

ECLAT DU JOUR 1899

REVERIE DU SOIR 1899

REPOS DE LA NUIT 1899

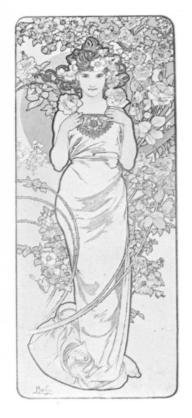

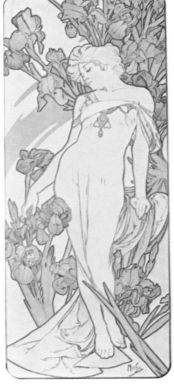

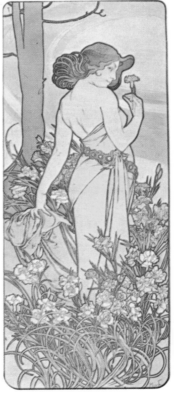

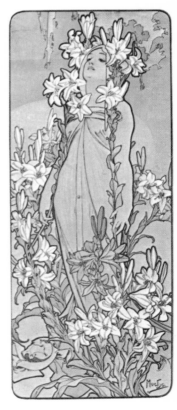

ROSE 1897

IRIS 1897

OEILLET 1897

LYS 1897

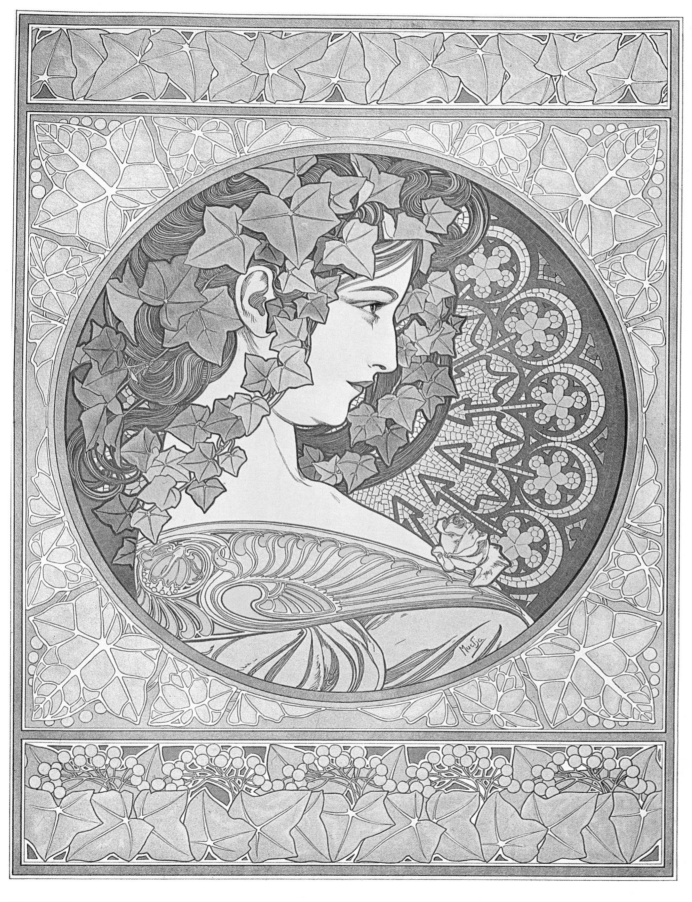

LIERRE 1901

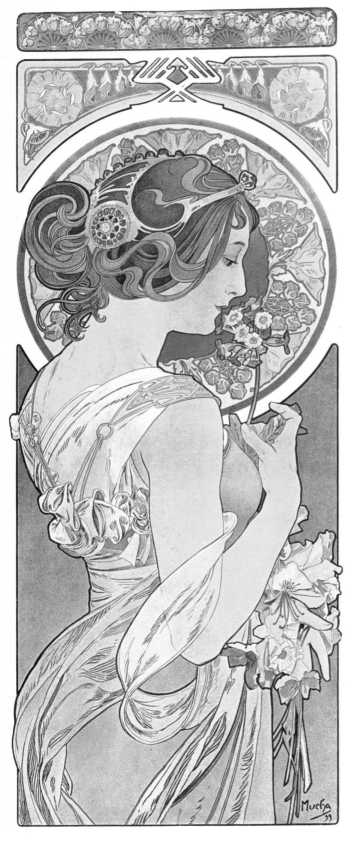

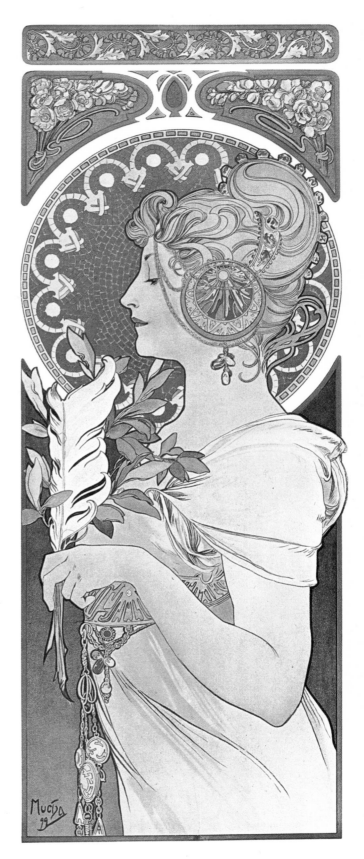

PRIMEVERE 1899

VI

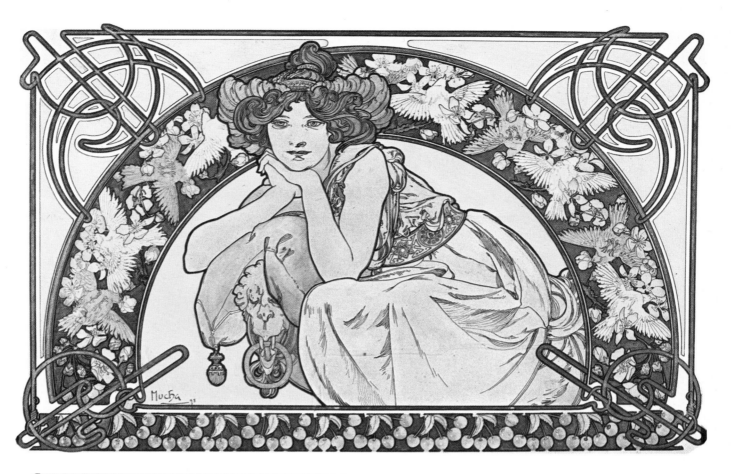

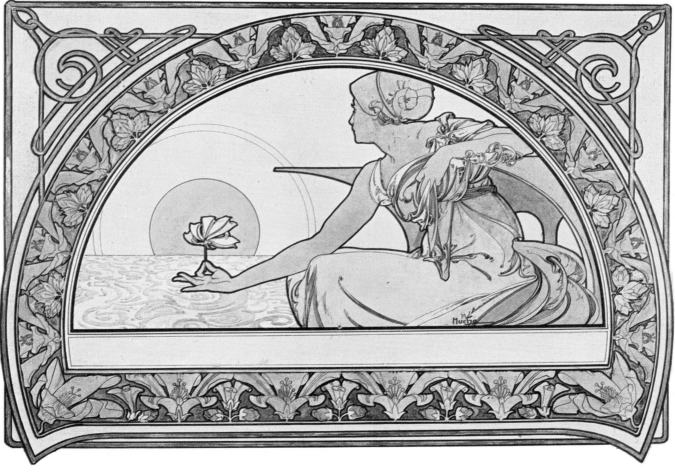

FLEUR DU CERISIER 1898

NENUPHAR 1898

VII

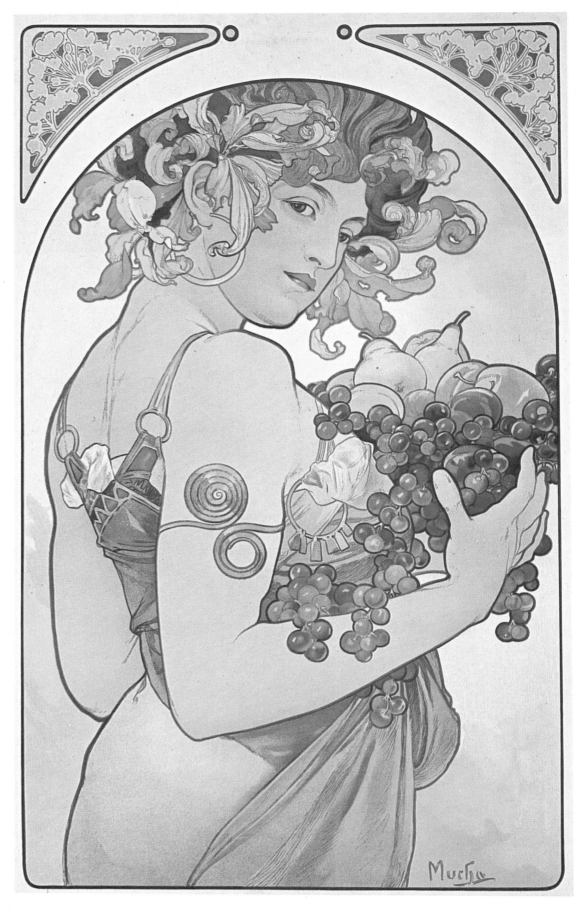

LE FRUIT c. 1897

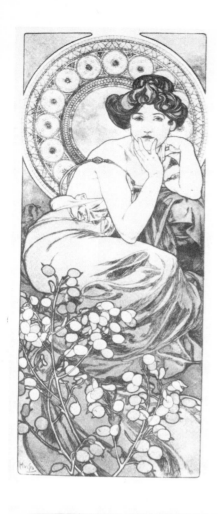

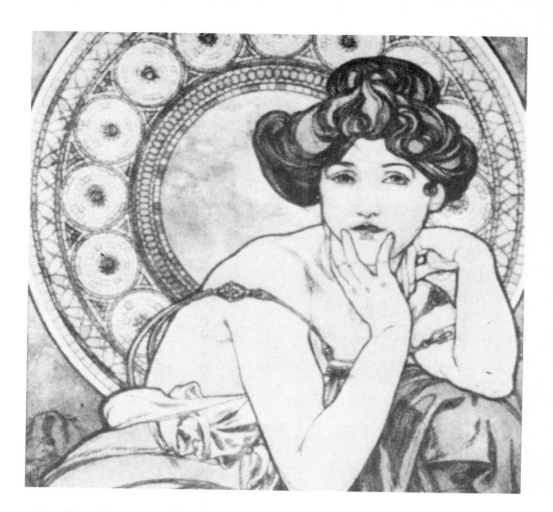

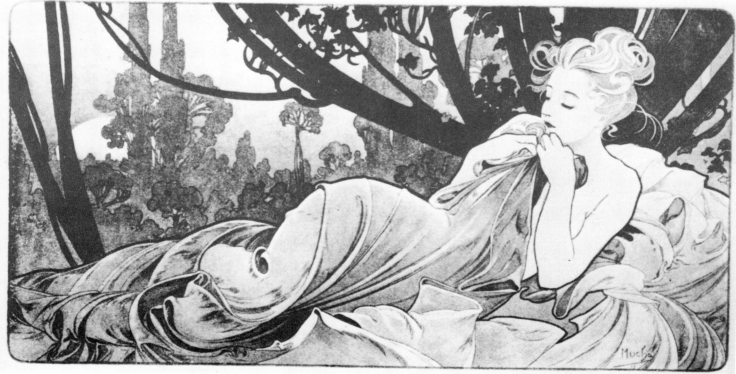

32. TOPAZE 1900

33. TOPAZE 1900 (DETAIL)

34. CREPUSCULE 1899

33

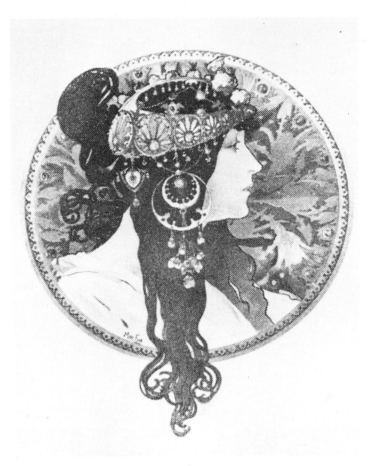

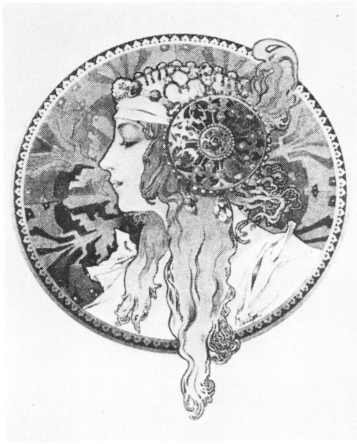

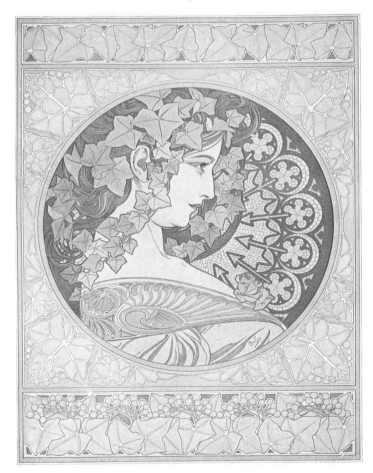

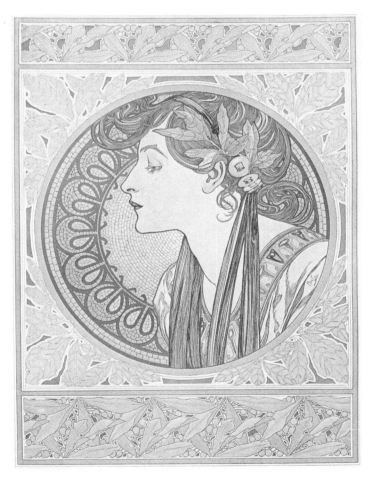

35. TETE BYZANTINE - BRUNETTE c. 1897

37. LIERRE 1901

36. TETE BYZANTINE - BLONDE c. 1897

38. LAURIER 1901

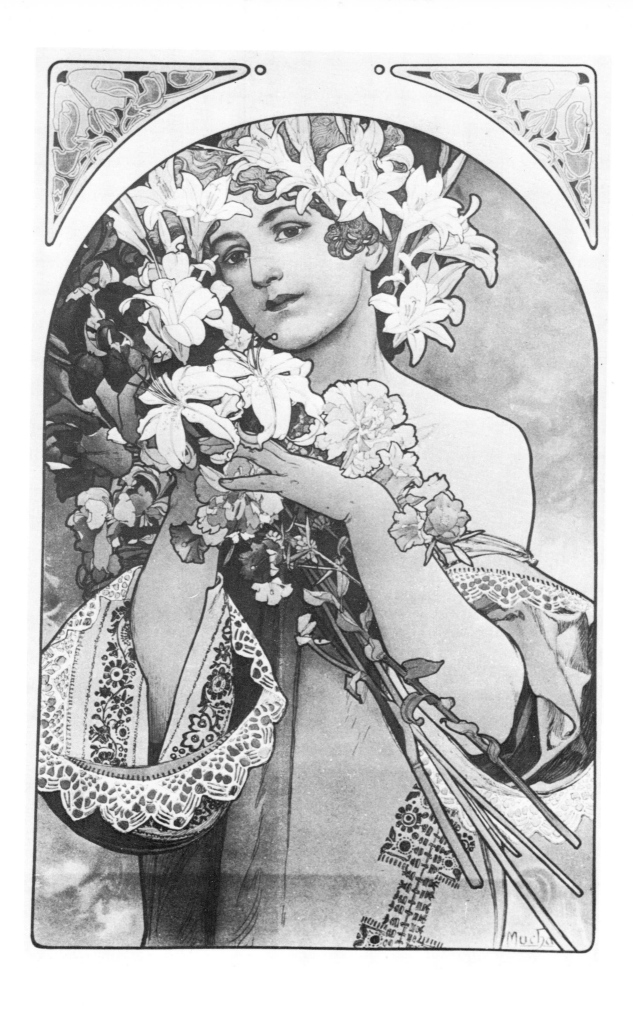

39. LA FLEUR c. 1897

35

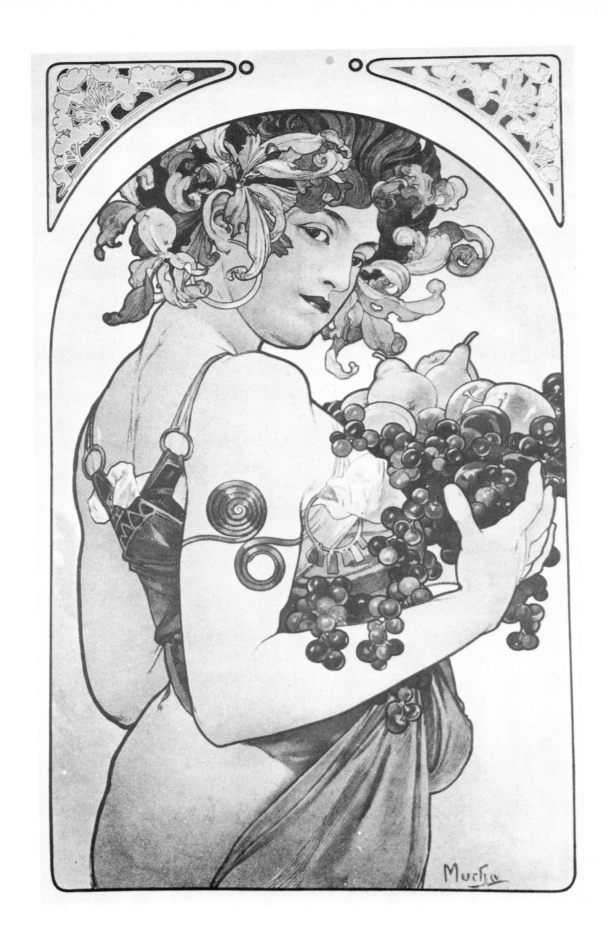

40. LE FRUIT c. 1897

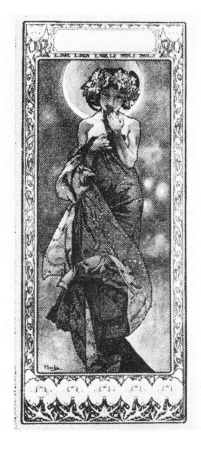
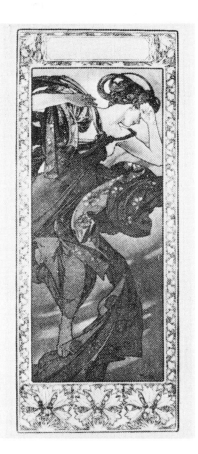
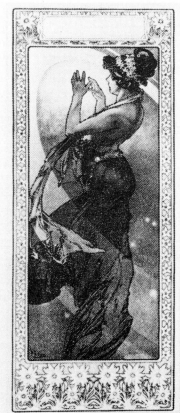
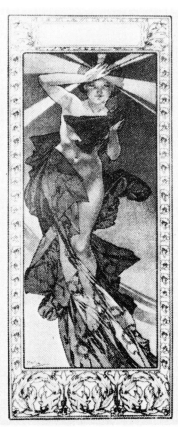

41. LA LUNE 1902 42. ETOILE DU SOIR 1902

43. ETOILE POLAIRE 1902 44. ETOILE DU MATIN 1902

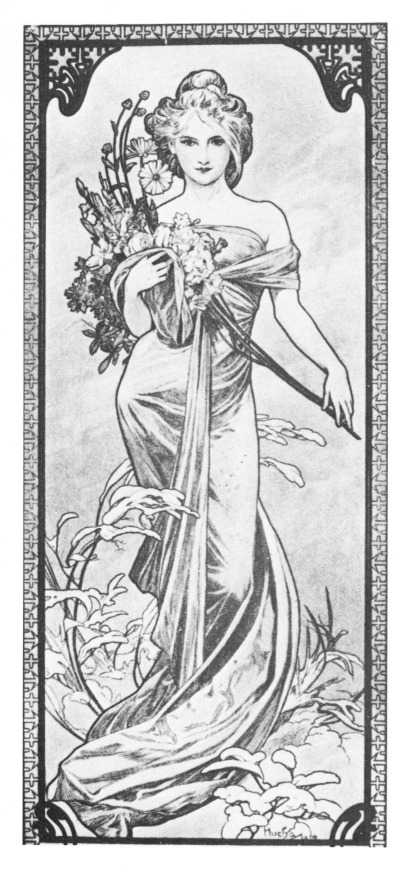

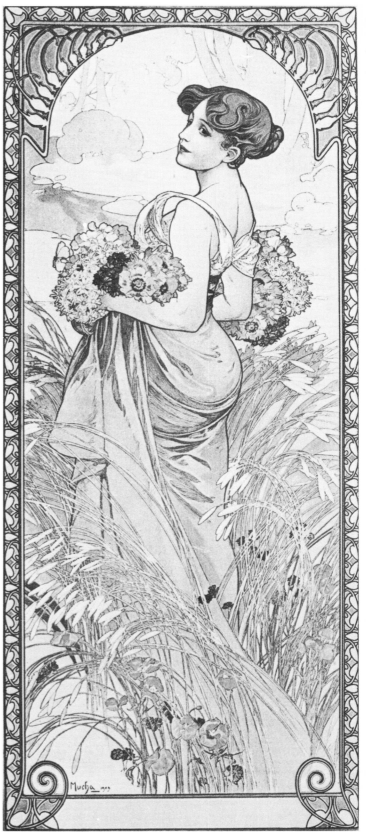

45. PRINTEMPS 1900

46. ETE 1903

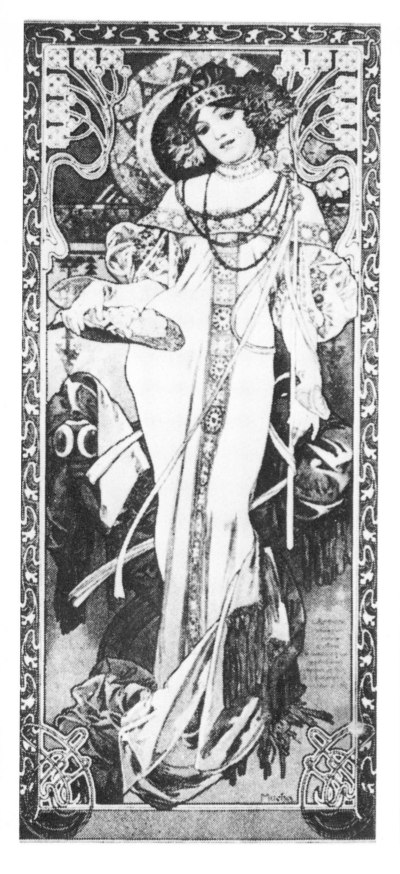

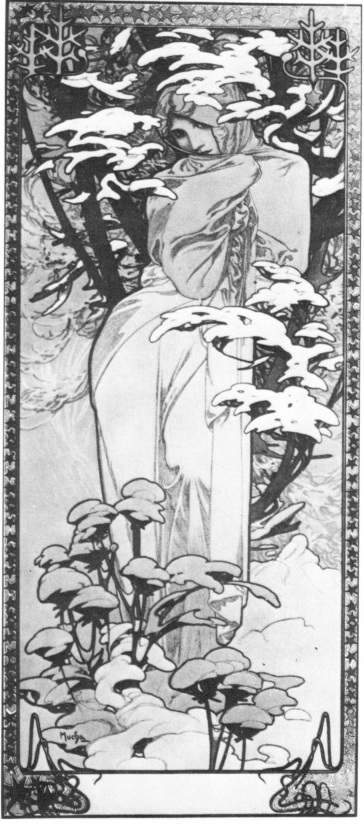

47. AUTOMNE c. 1903

48. HIVER c. 1903

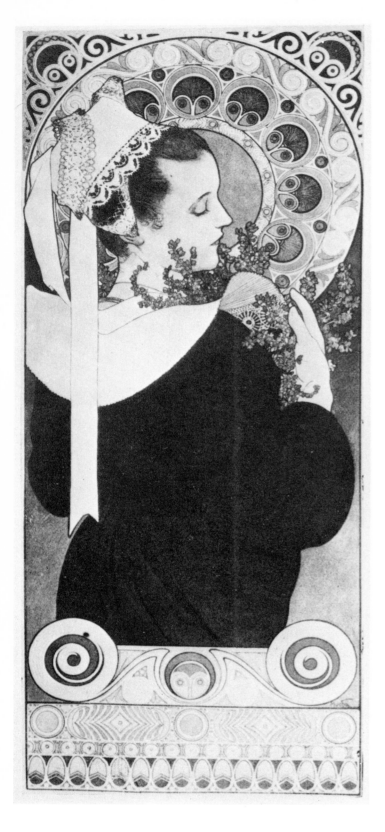

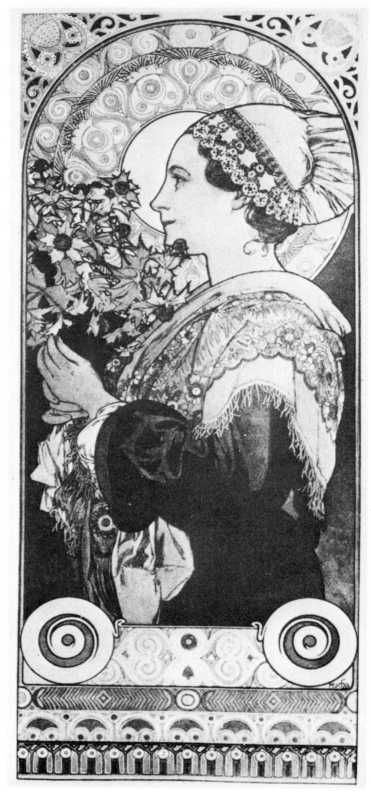

49. BRUYERE DE FALAISE c. 1901

50. CHARDON DE GREVES c. 1901

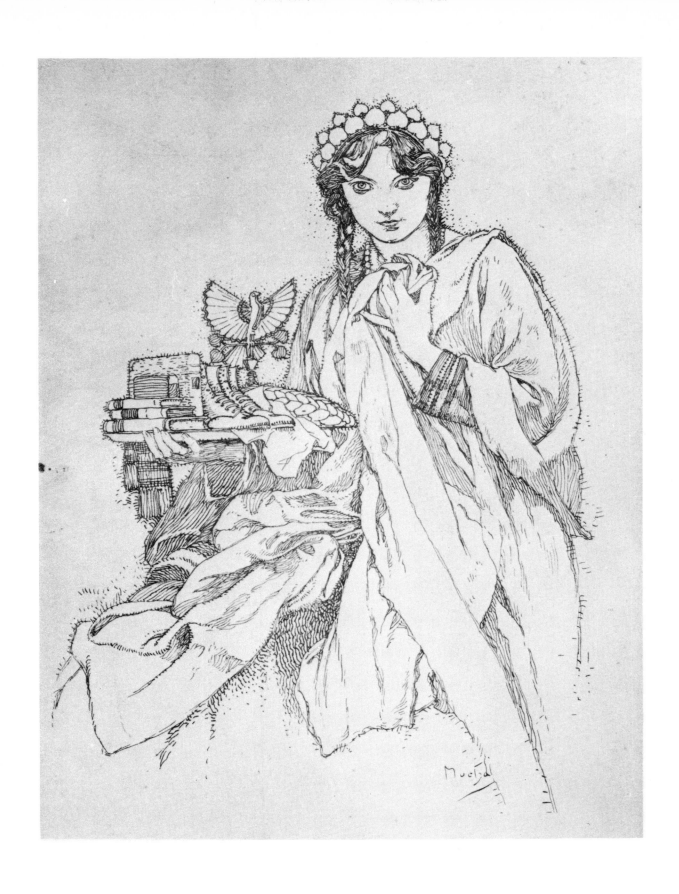

51. KOMENSKY SOCIETY c. 1920

41

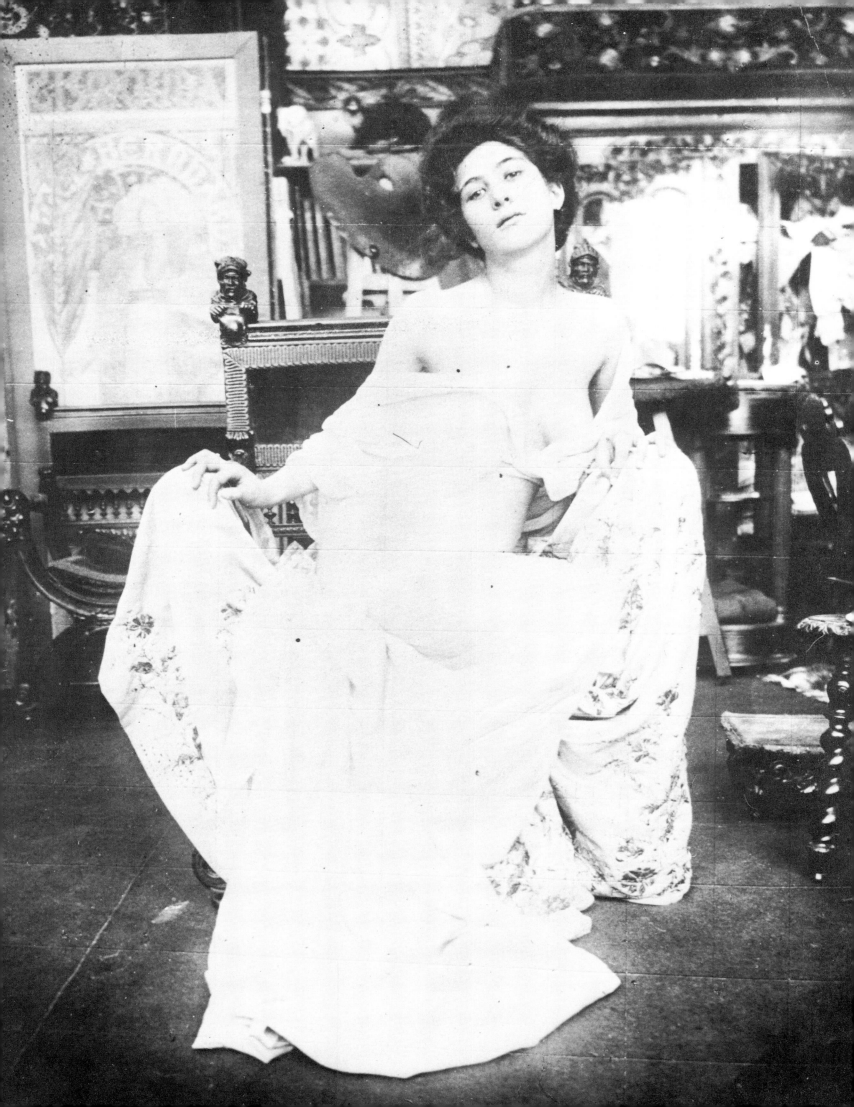

POSTERS

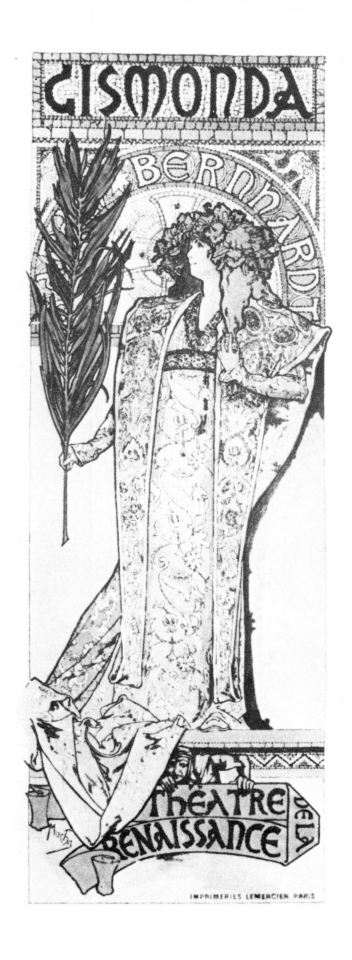

52. GISMONDA 1894

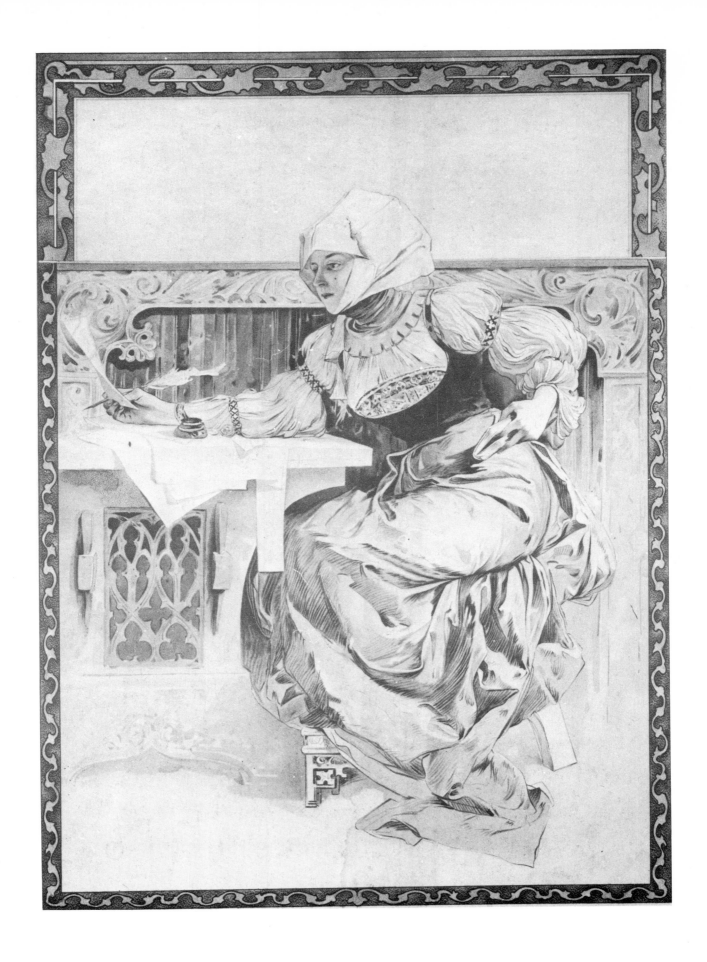

53. PAPETERIE c. 1894

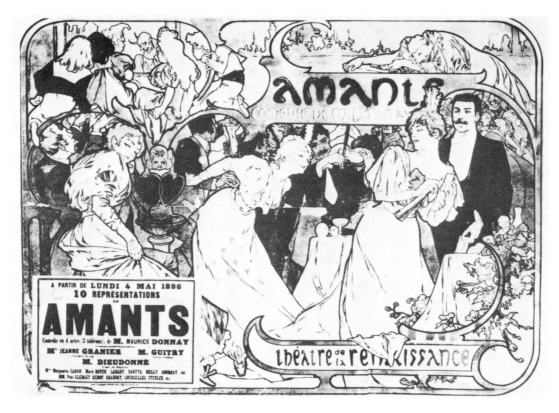

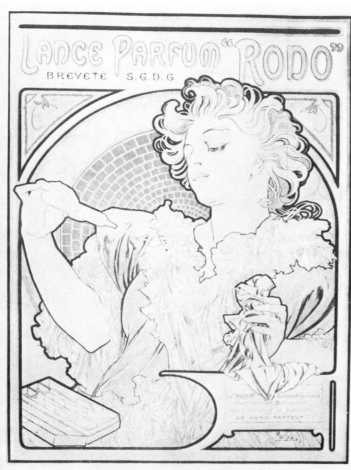

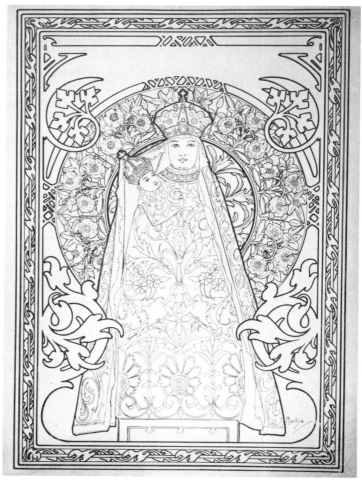

54. AMANTS 1895

55. LANCE PARFUM "RODO" 1896

56. SAVON DE NOTRE DAME c. 1896

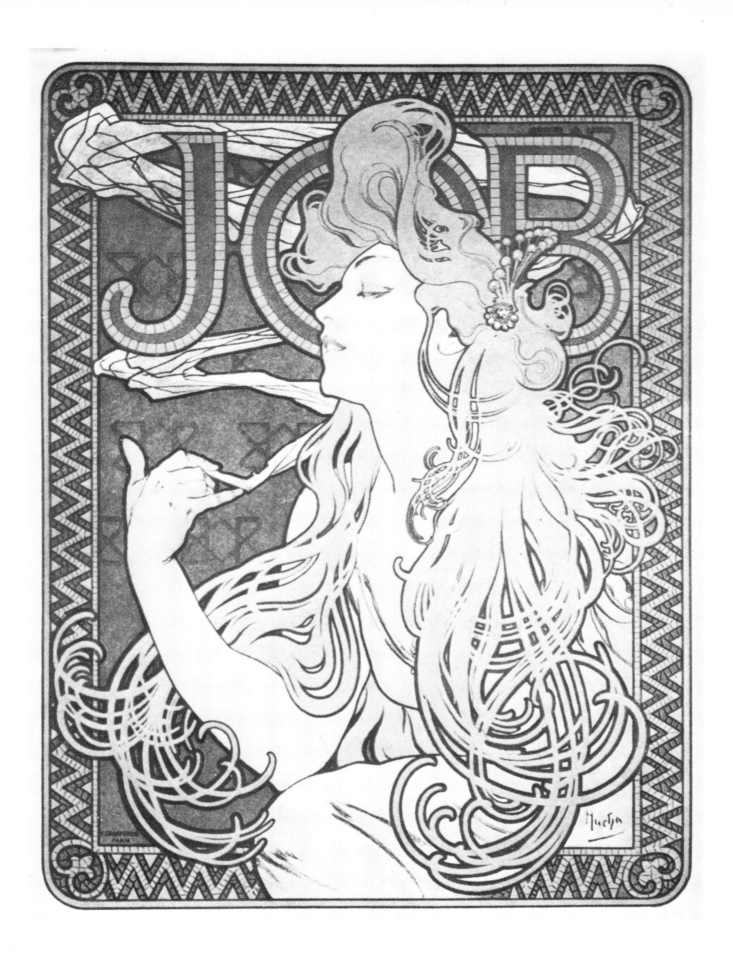

57. JOB CIGARETTE PAPERS 1896

47

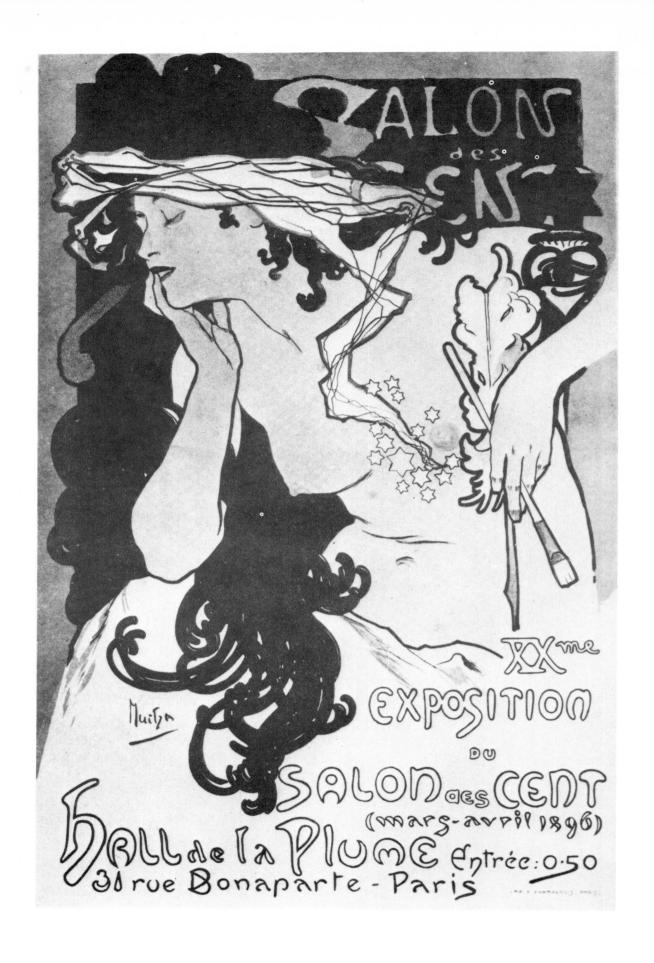

58. SALON DES CENT 1896

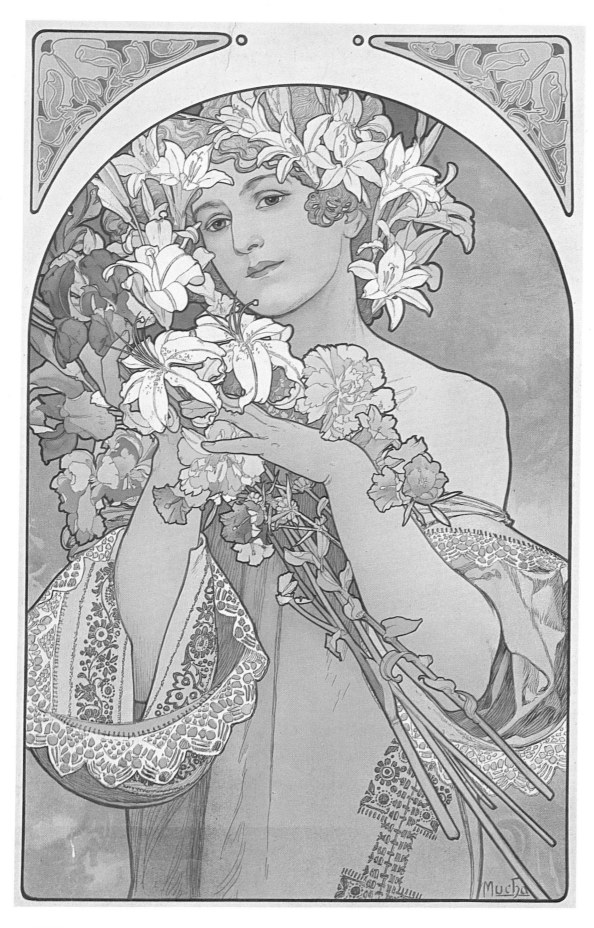

LA FLEUR c. 1897

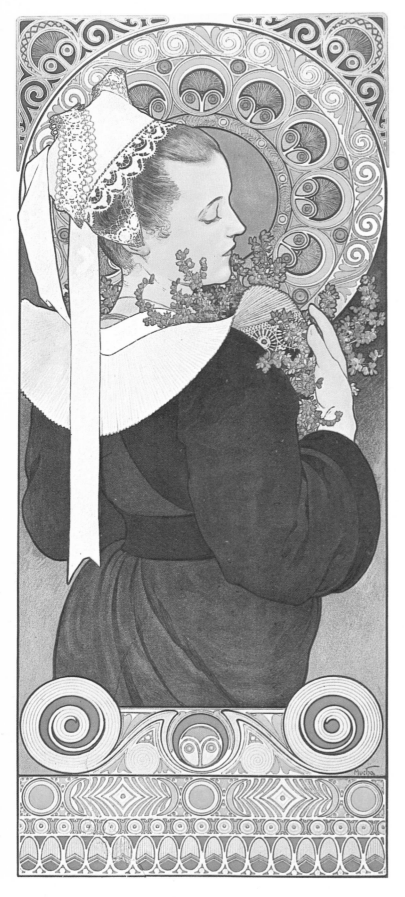

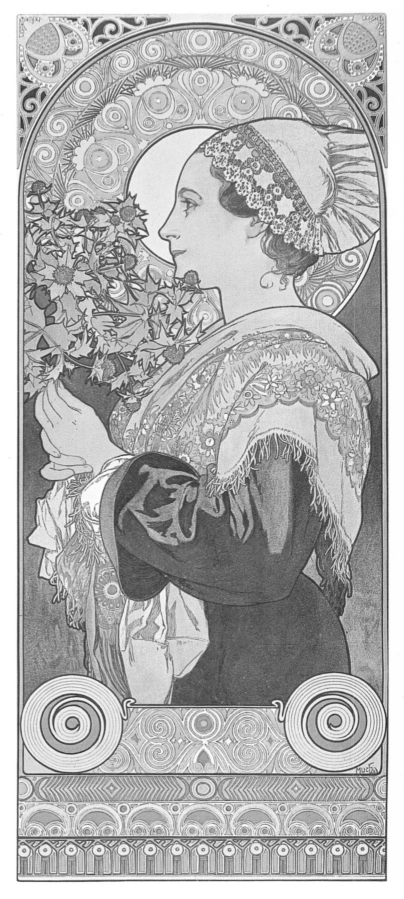

BRUYERE DE FALAISE c. 1901

CHARDON DE GREVES c. 1901

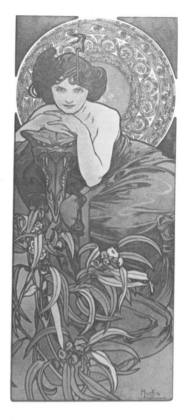

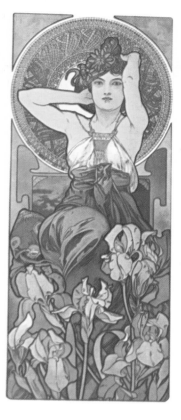

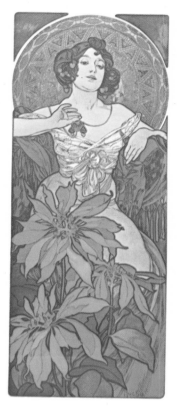

EMERAUDE 1900

AMETHYSTE 1900

RUBIS

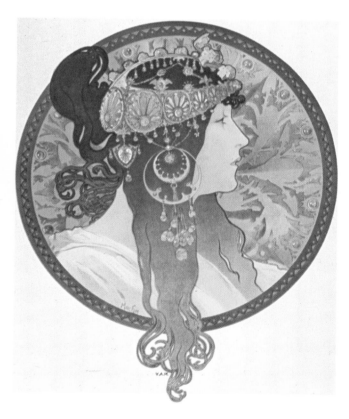

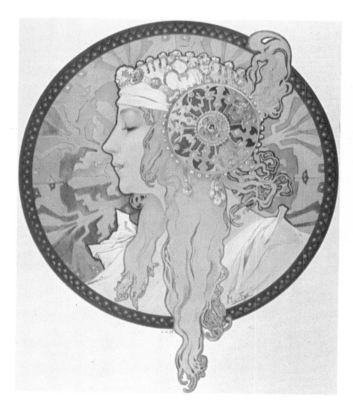

TETE BYZANTINE-BRUNETTE c. 1897

TETE BYZANTINE-BLONDE c. 1897

XI

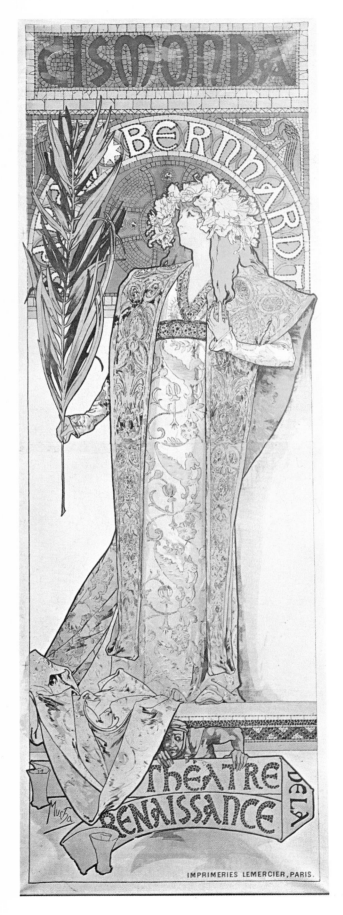

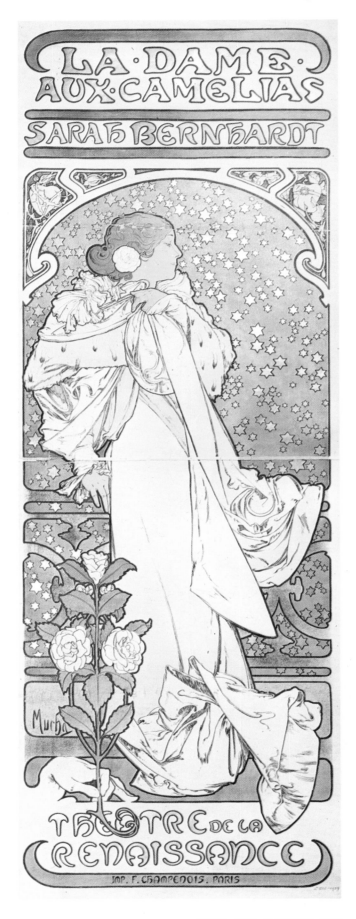

GISMONDA 1894

DAME AUX CAMELIAS 1896

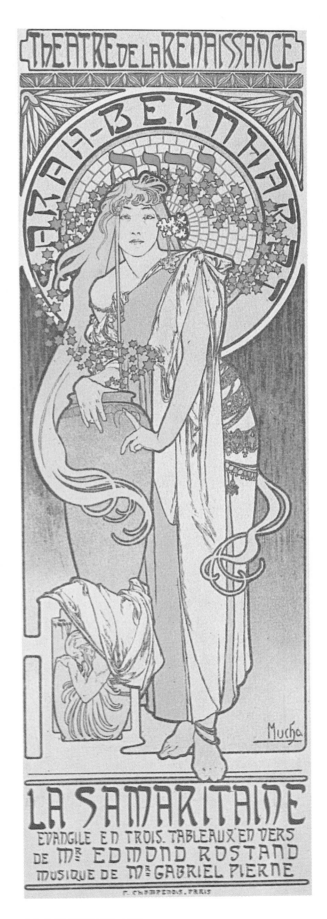

LA SAMARITAINE 1897

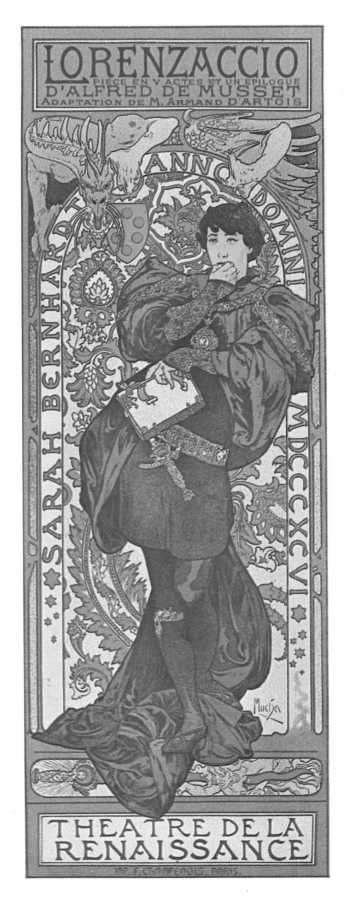

LORENZACCIO 1896

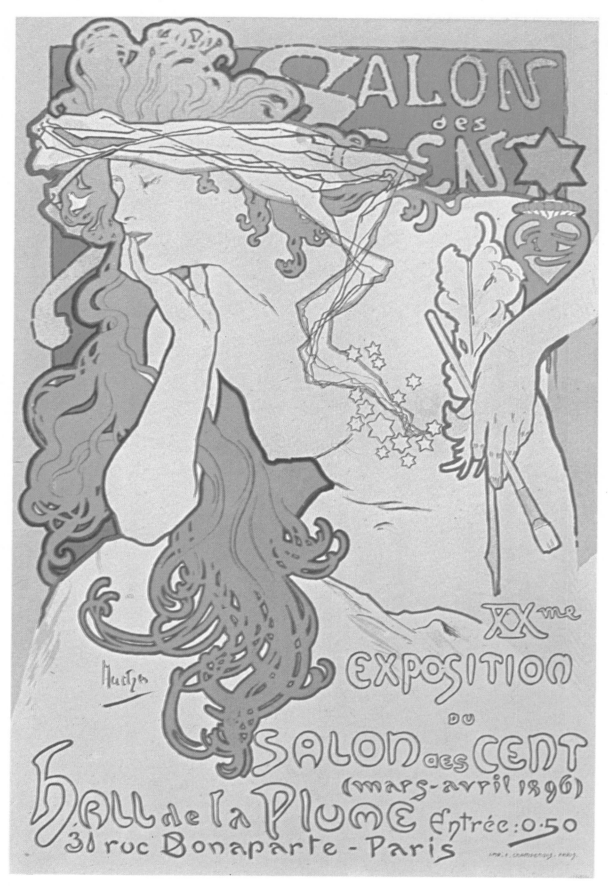

SALON DES CENT 1896

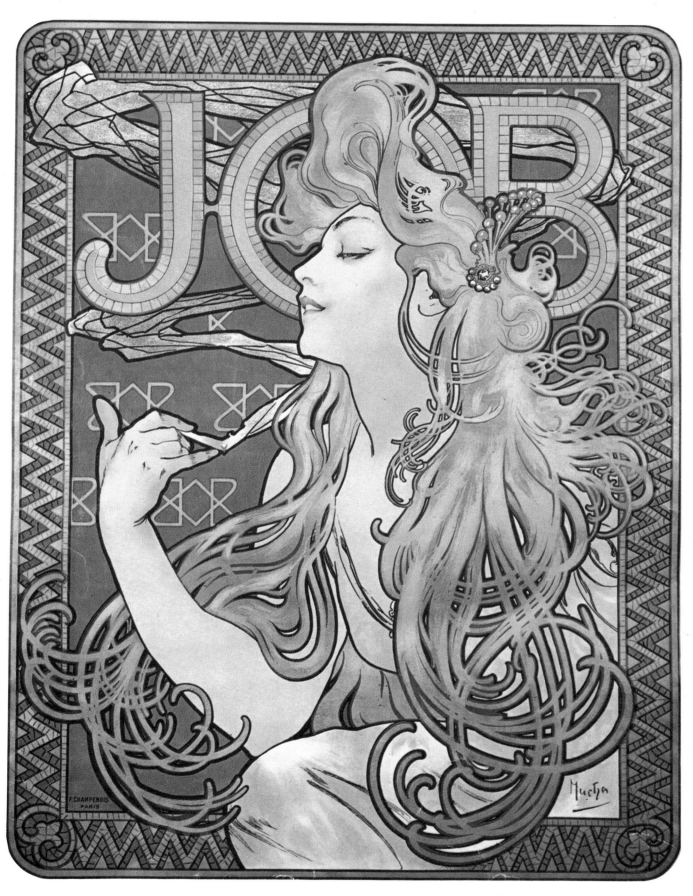

JOB CIGARETTE PAPERS 1896

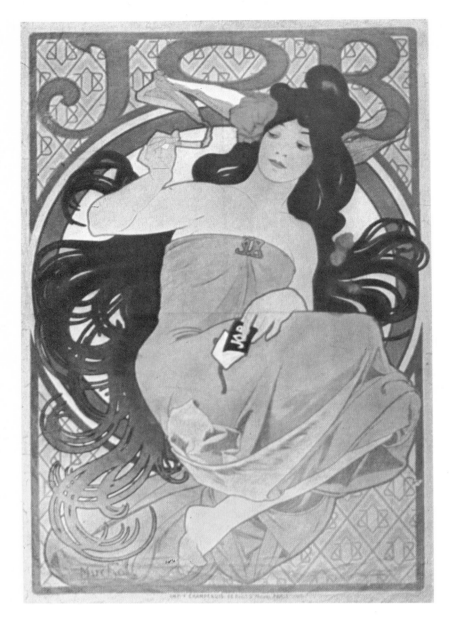

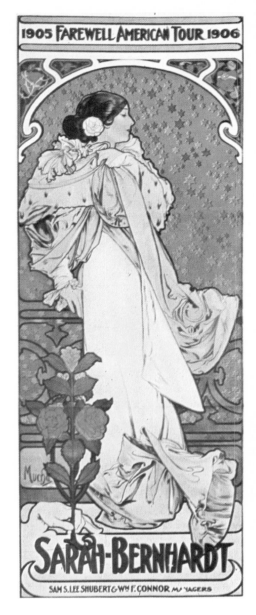

JOB CIGARETTE PAPERS 1897

FAREWELL AMERICAN TOUR 1906

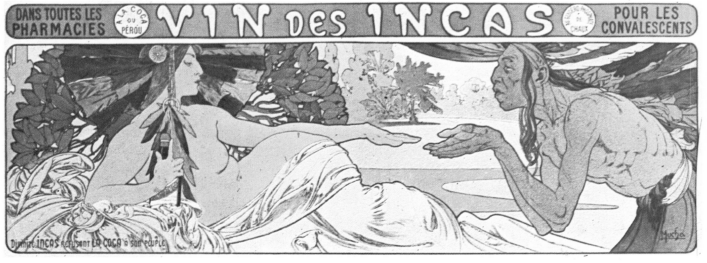

VIN DES INCAS c. 1899

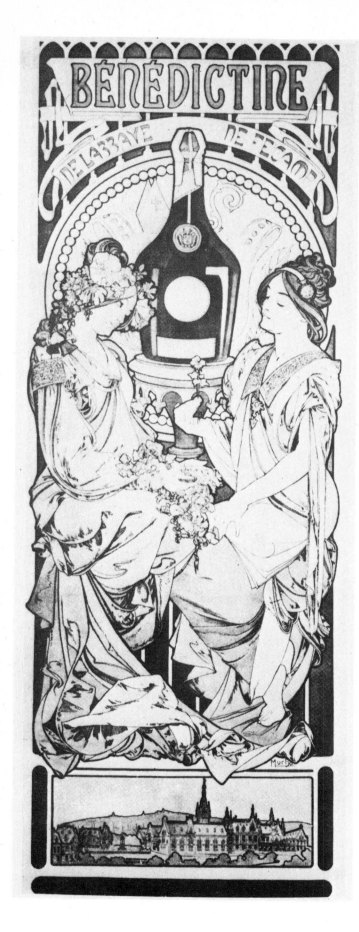

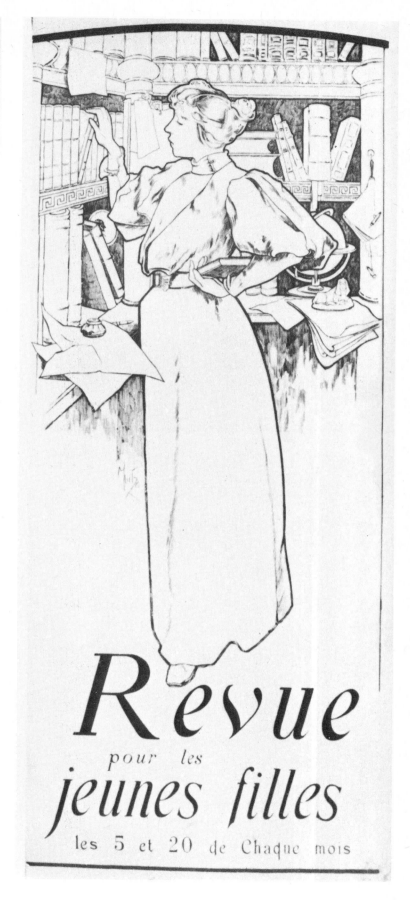

59. BENEDICTINE 1896

60. REVUE POUR LES JEUNES FILLES 1896

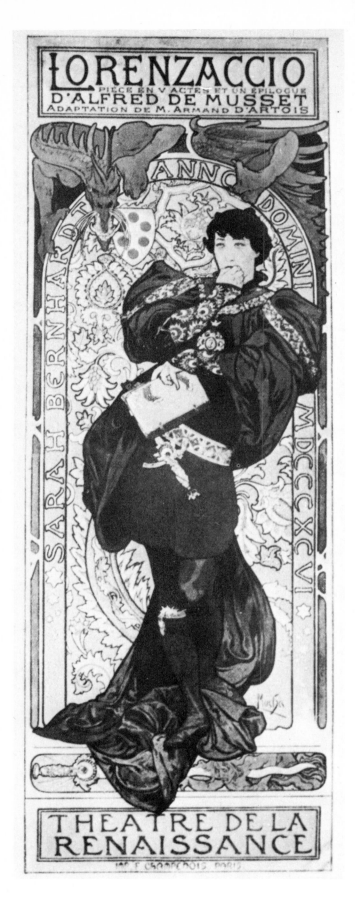

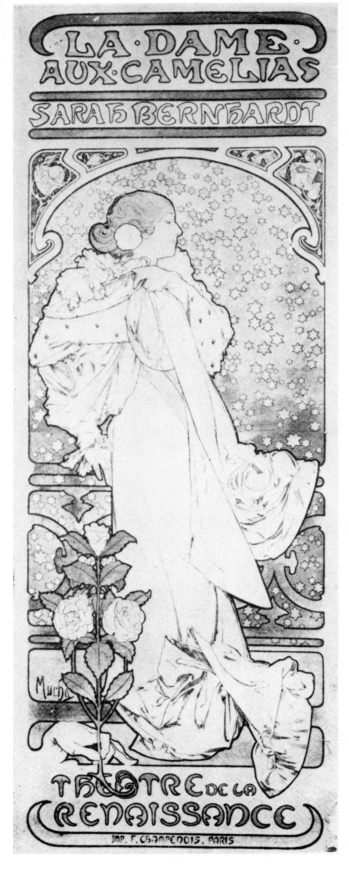

61. LORENZACCIO 1896 62. LA DAME AUX CAMELIAS 1896

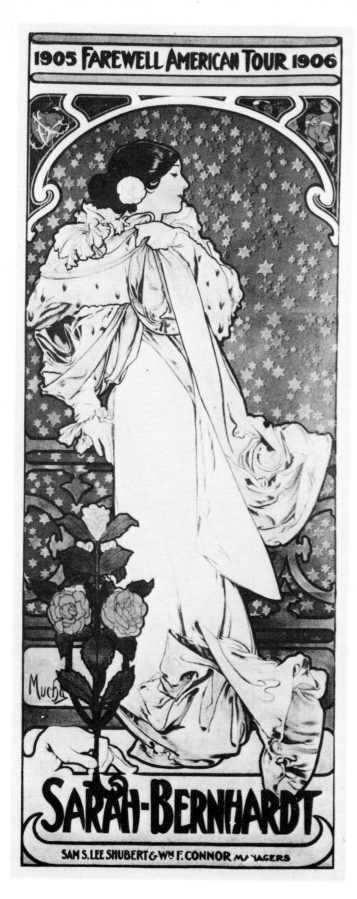

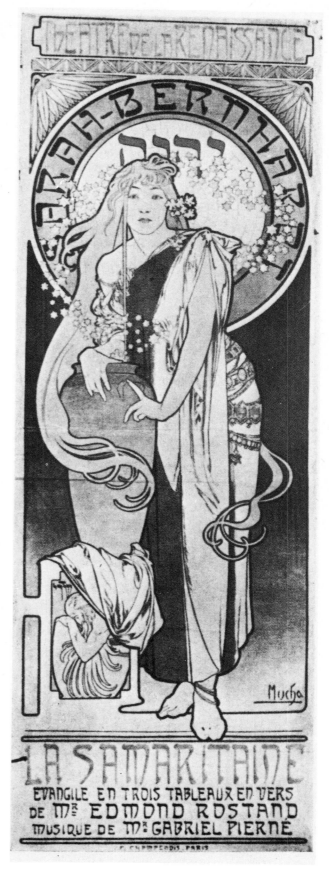

63. FAREWELL AMERICAN TOUR 1906

64. LA SAMARITAINE 1897

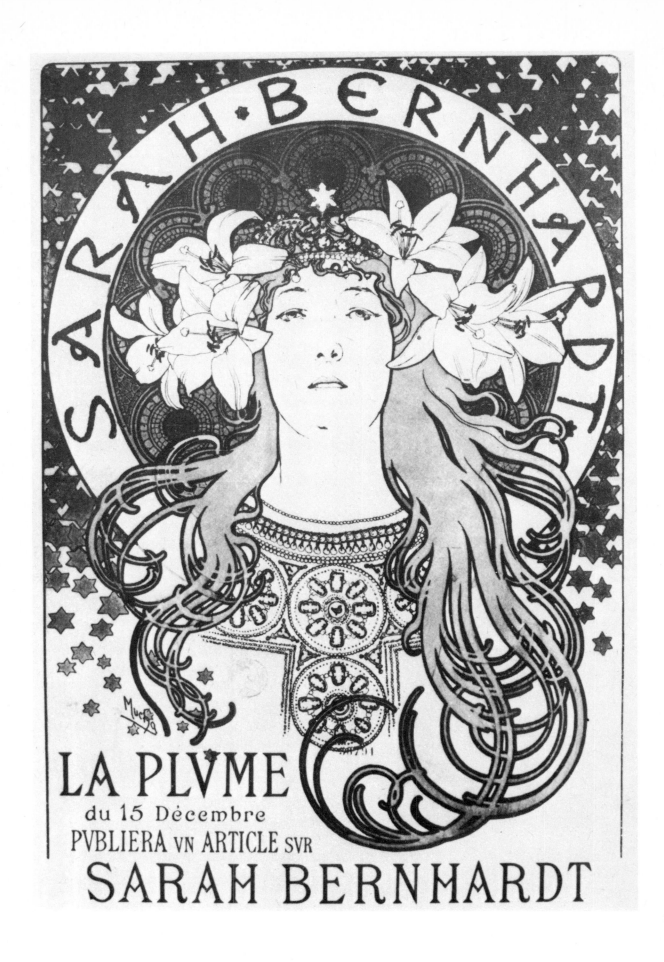

65. SARAH BERNHARDT *LA PLUME* 1897

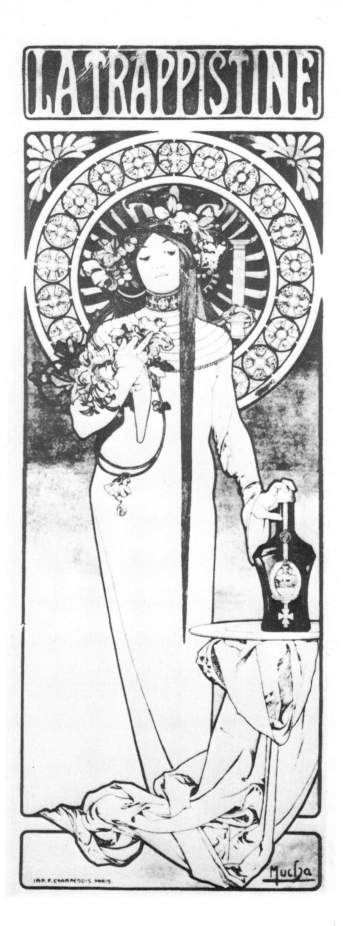

66. LA TRAPPISTINE 1897

67. COURS MUCHA 1897

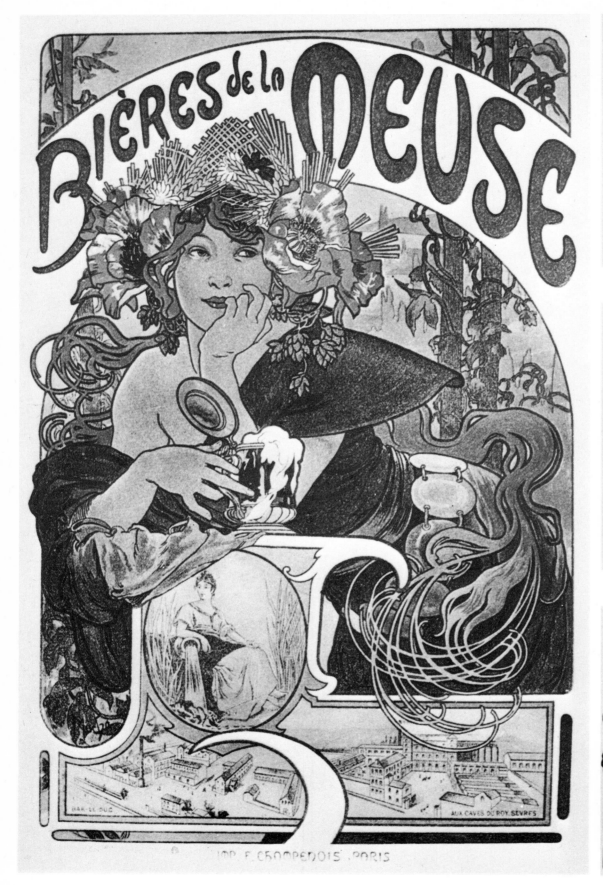

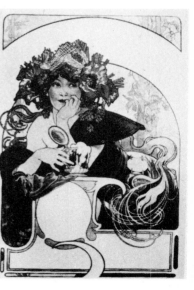

69. SOCIETE POPULAIRE DES BEAUX ARTS 1897

70. MONACO - MONTE CARLO 1897

68. BIERES DE LA MEUSE c. 1897

71. BIERES DE LA MEUSE (VARIANT) c. 1897

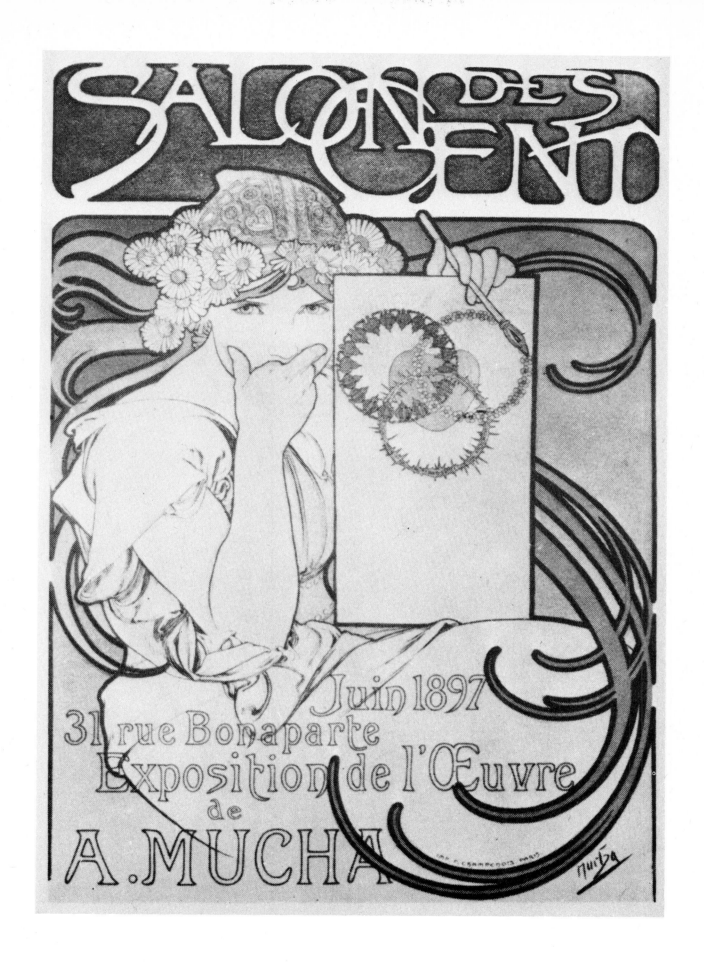

72. SALON DES CENT 1897

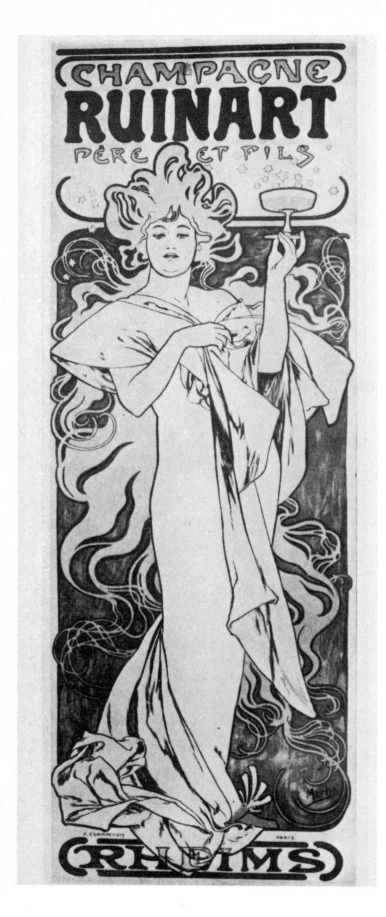

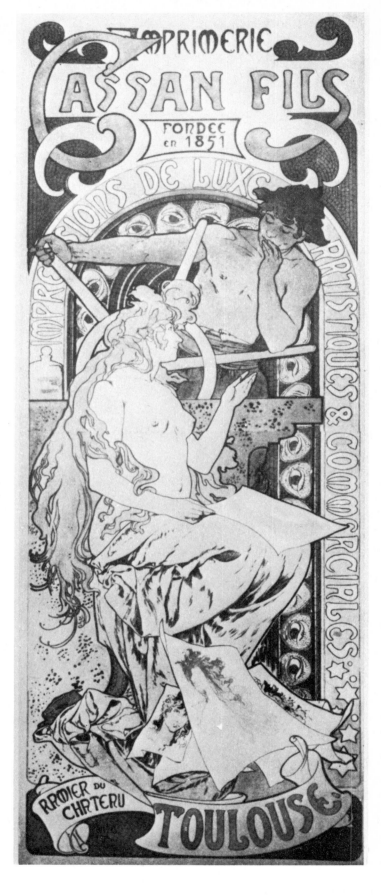

73. CHAMPAIGNE RUINART 1897

74. IMPRIMERIE CASSAN FILS 1897

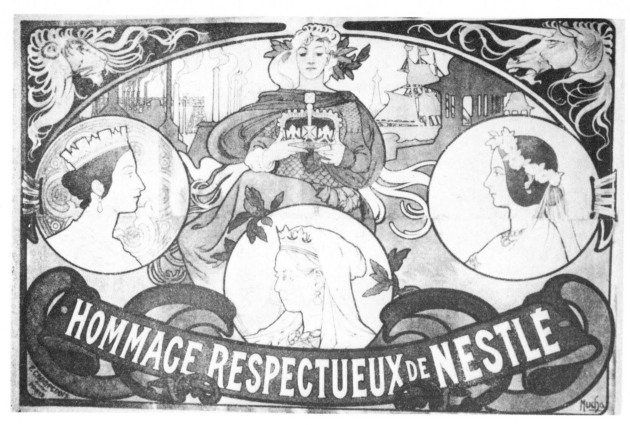

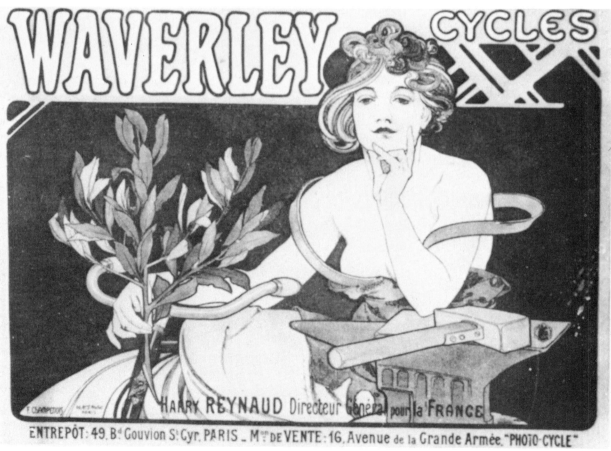

75. HOMMAGE RESPECTUEUX DE NESTLE 1897

76. WAVERLEY CYCLES 1897

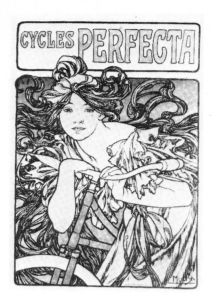

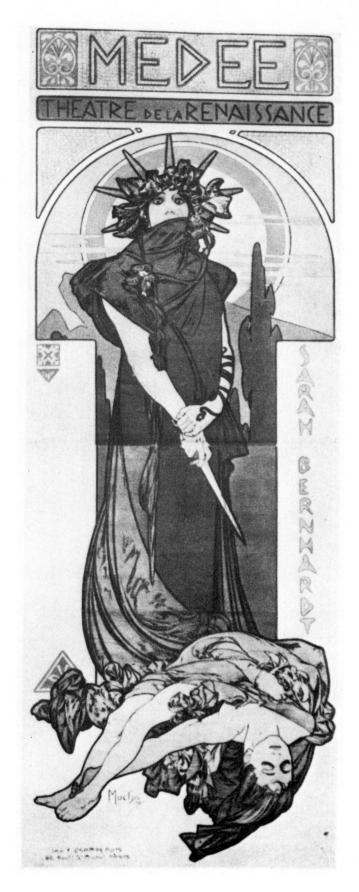

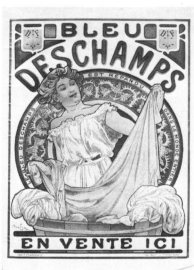

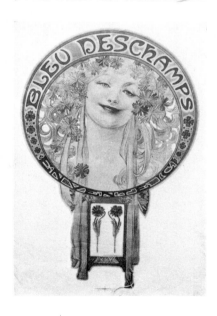

77. CYCLES PERFECTA c. 1897

78. BLEU DESCHAMPS EN VENTE ICI c.1897

79. BLEU DESCHAMPS c. 1897

80. MEDEE 1898

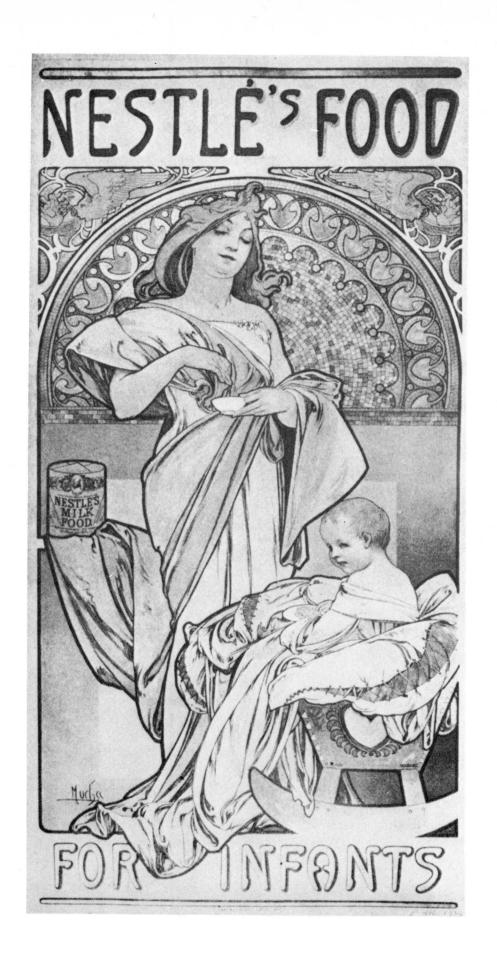

81. NESTLE'S FOOD FOR INFANTS 1898

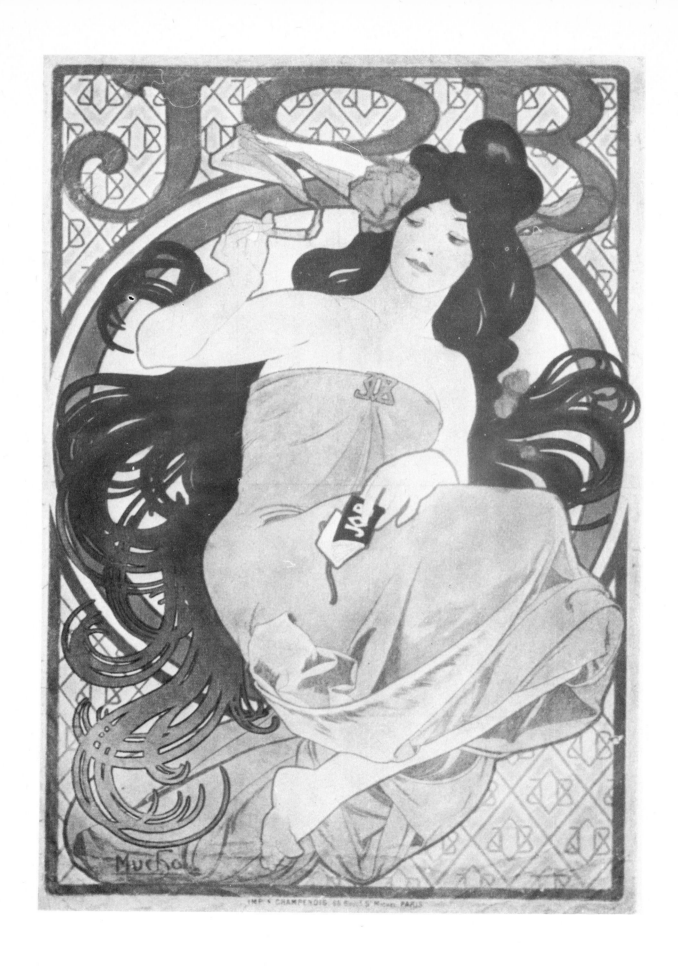

82. JOB CIGARETTE PAPER 1898

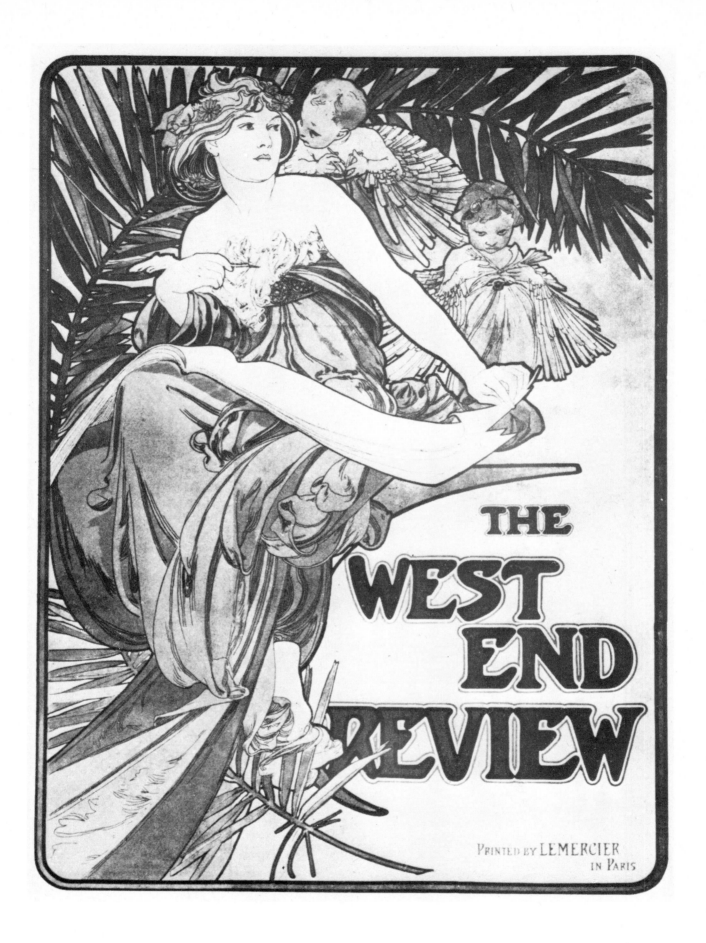

THE
WEST
END
REVIEW

PRINTED BY LEMERCIER
IN PARIS

83. THE WEST END REVIEW 1898

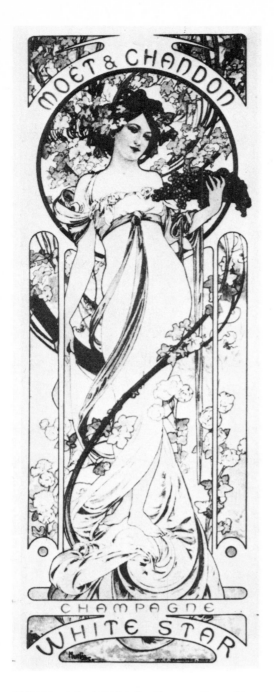

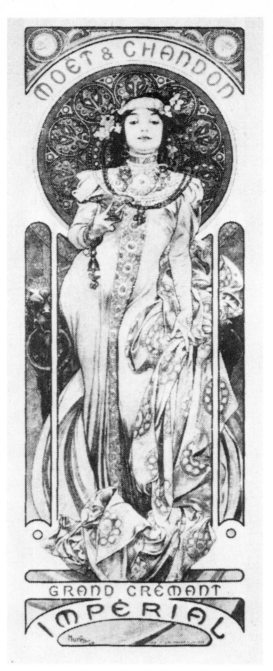

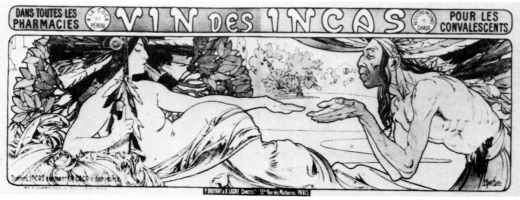

84. MOET & CHANDON, WHITE STAR 1899 85. MOET ET CHANDON, IMPERIAL 1899

86. VIN DES INCAS ᶜ· 1899

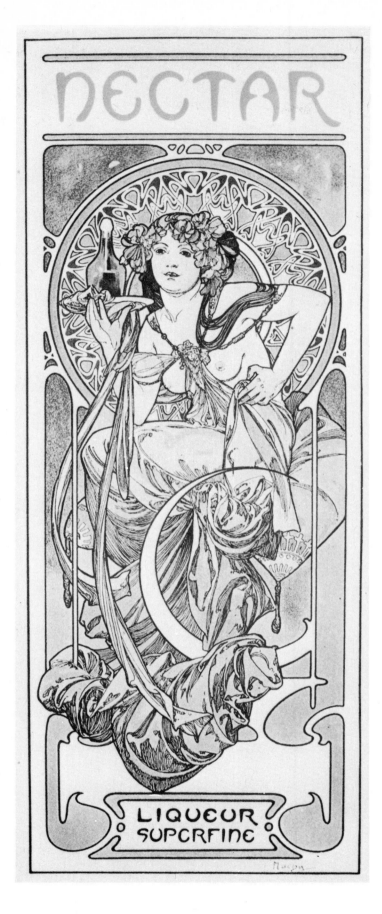

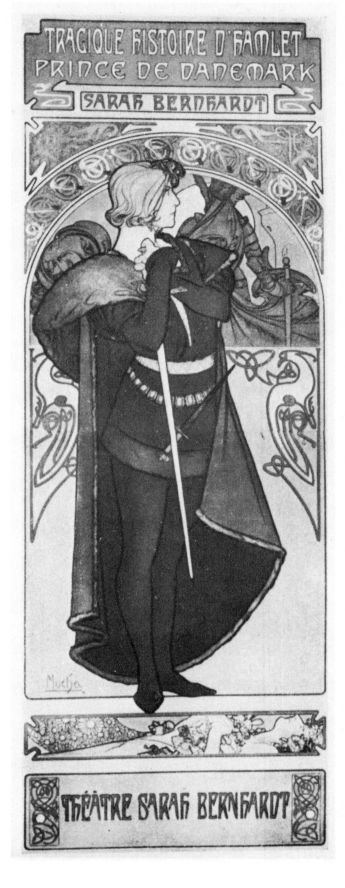

87. NECTAR 1899

88. HAMLET 1899

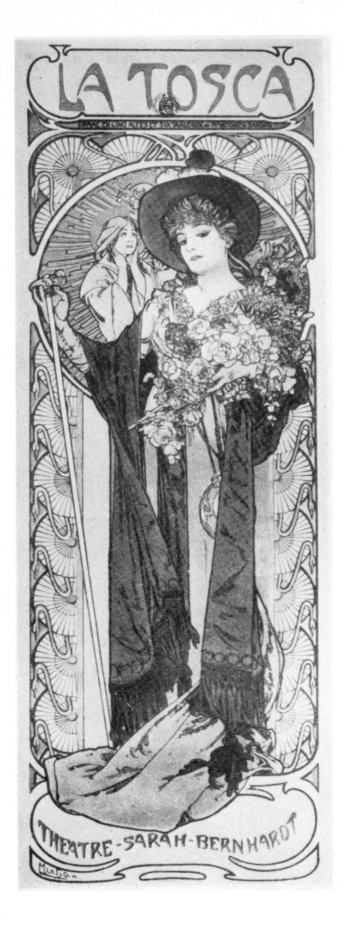

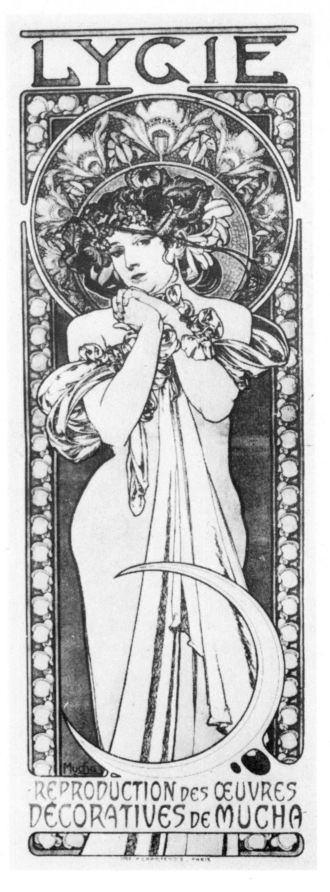

89. LA TOSCA 1899

90. LYGIE 1901

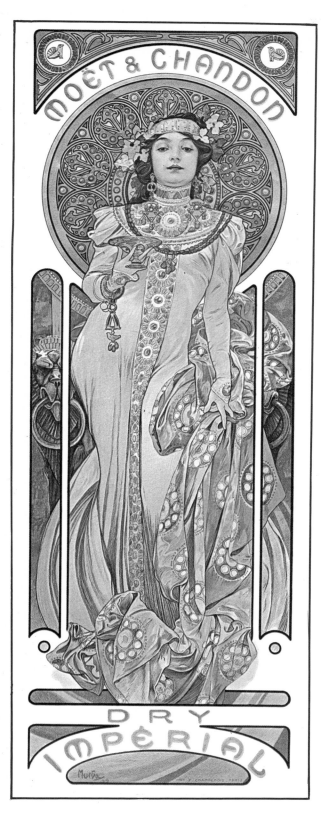

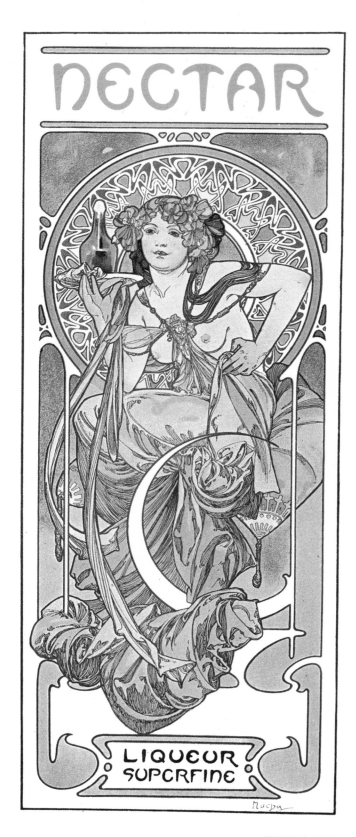

MOET ET CHANDON IMPERIAL c. 1899

NECTAR 1899

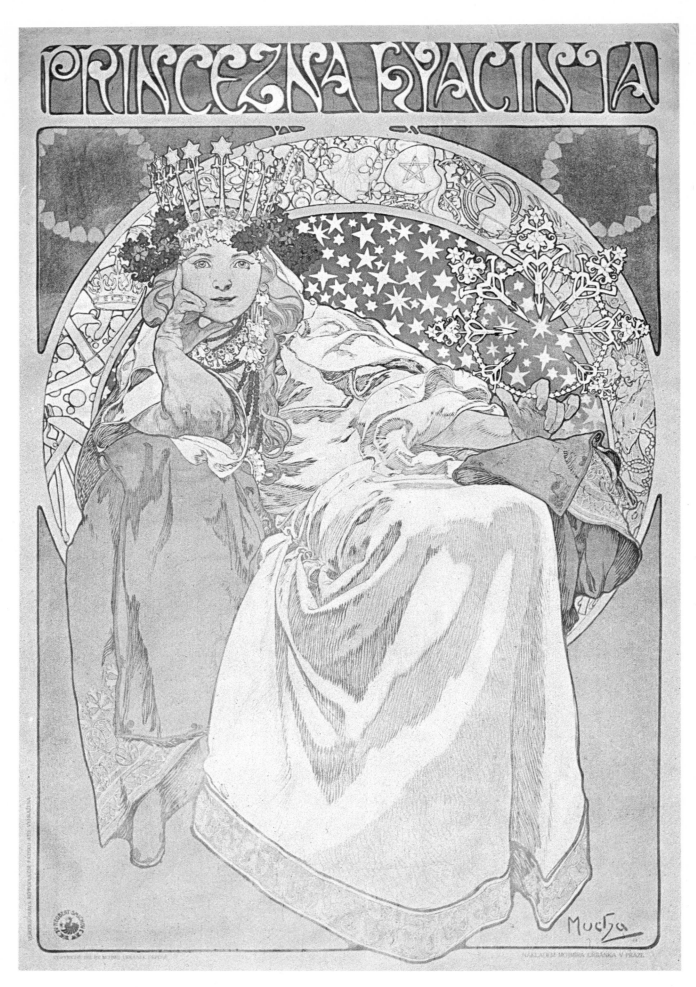

PRINCESS HYACINTH 1911

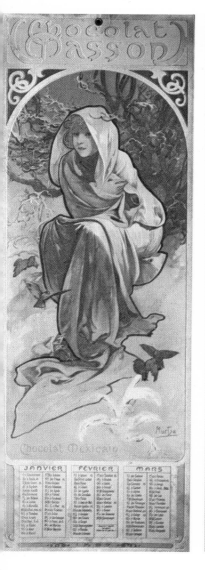
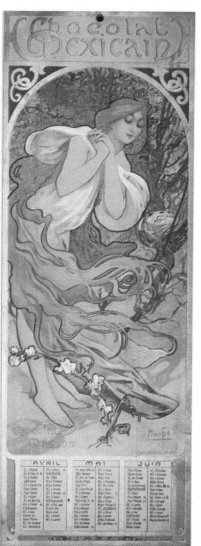
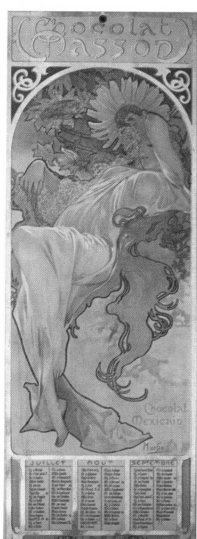
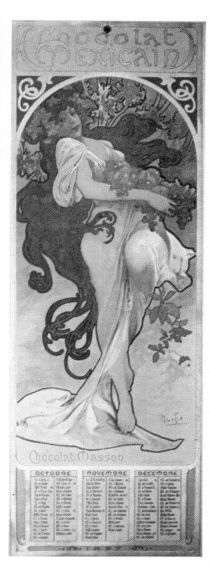

CHOCOLAT MASSON CALENDAR FOUR PANELS 1895-1900

CHILDHOOD 1900

ADOLESCENCE 1900

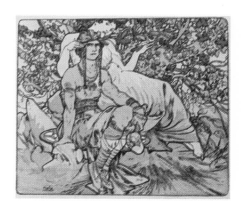

MANHOOD 1900

XIX

A PAGE FROM DOCUMENTS DECORATIFS 1902

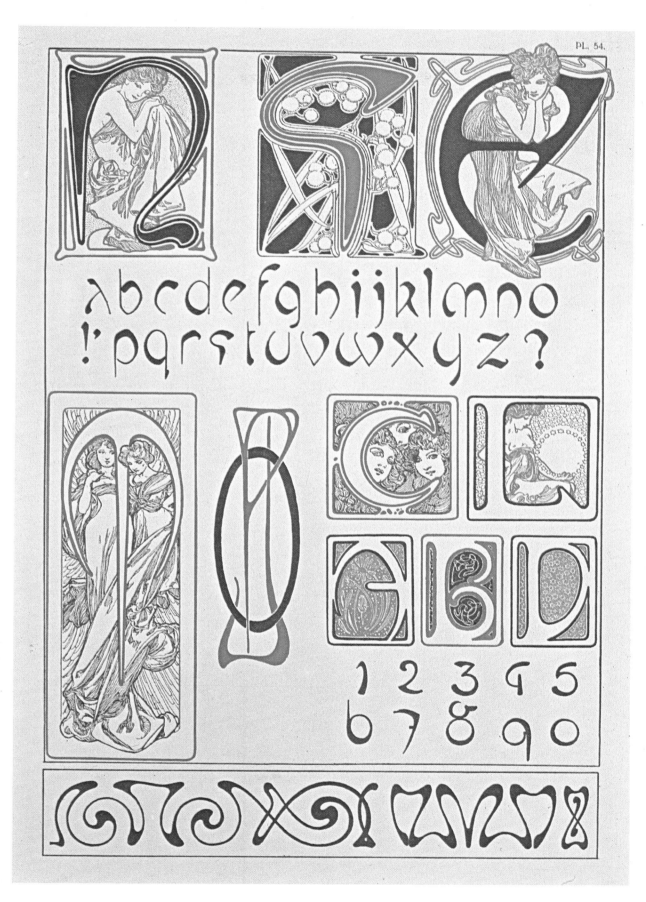

A PAGE FROM DOCUMENTS DECORATIFS 1902

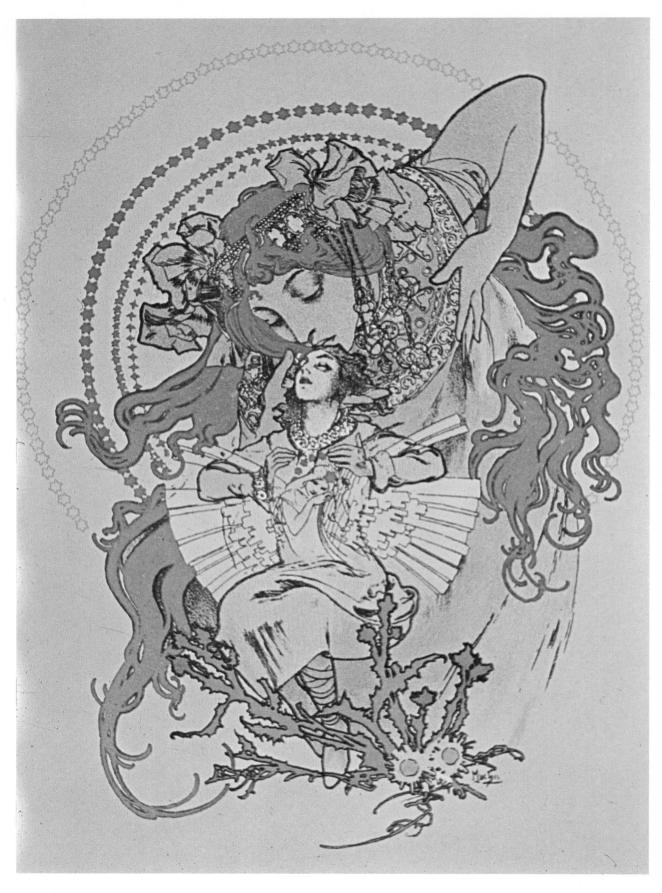

FRONTISPIECE FROM ILSEE

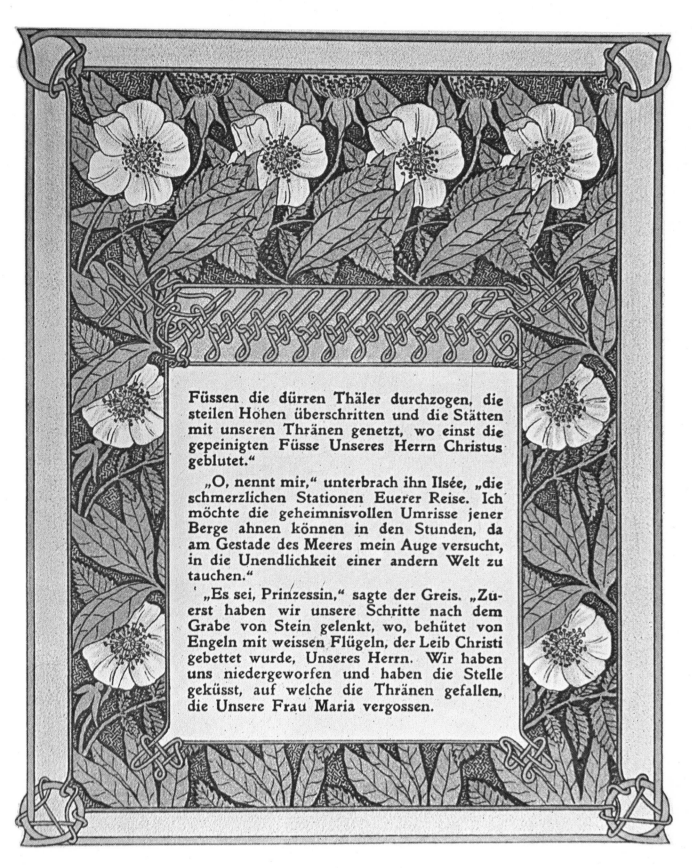

Füssen die dürren Thäler durchzogen, die
steilen Höhen überschritten und die Stätten
mit unseren Thränen genetzt, wo einst die
gepeinigten Füsse Unseres Herrn Christus
geblutet."

„O, nennt mir," unterbrach ihn Ilsée, „die
schmerzlichen Stationen Euerer Reise. Ich
möchte die geheimnisvollen Umrisse jener
Berge ahnen können in den Stunden, da
am Gestade des Meeres mein Auge versucht,
in die Unendlichkeit einer andern Welt zu
tauchen."

„Es sei, Prinzessin," sagte der Greis. „Zu-
erst haben wir unsere Schritte nach dem
Grabe von Stein gelenkt, wo, behütet von
Engeln mit weissen Flügeln, der Leib Christi
gebettet wurde, Unseres Herrn. Wir haben
uns niedergeworfen und haben die Stelle
geküsst, auf welche die Thränen gefallen,
die Unsere Frau Maria vergossen.

A PAGE FROM ILSEE 1896

XXIII

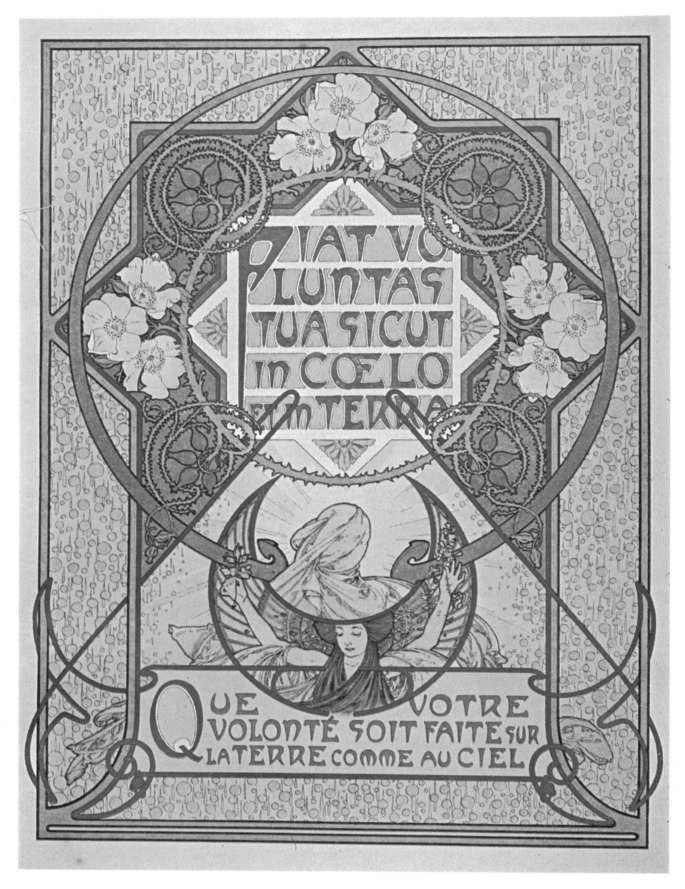

TITLE PAGE FROM LE PATER 1899

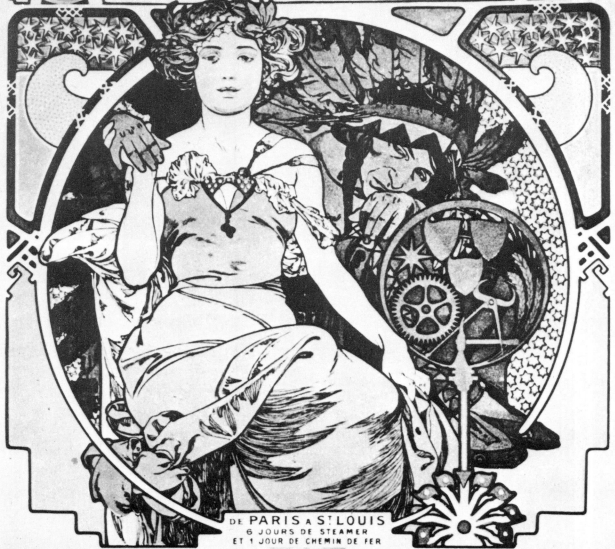

RÉPUBLIQUE FRANÇAISE
MINISTÈRE DU COMMERCE DE L'INDUSTRIE DES POSTES ET TÉLÉGRAPHES
EXPOSITION UNIVERSELLE & INTERNATIONALE
DE St LOUIS (ÉTATS-UNIS)
DU 30 AVRIL AU 30 NOVEMBRE 1904.

DE PARIS A St LOUIS
6 JOURS DE STEAMER
ET 1 JOUR DE CHEMIN DE FER

Pour renseignements et adhésions concernant la FRANCE s'adresser au Ministère du Commerce.
Commissariat Général du Gouvernement Français. *101, Rue de Grenelle. PARIS*, et au Comité
de la Section Française à la Bourse du Commerce de PARIS.

IMPORTANCE DE L'EXPOSITION

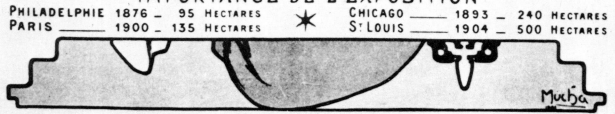

PHILADELPHIE	1876	95 HECTARES	CHICAGO	1893	240 HECTARES
PARIS	1900	135 HECTARES	St LOUIS	1904	500 HECTARES

IMP. P. CHARDENOIS. PARIS

94. EXPOSITION DE ST. LOUIS 1904

67

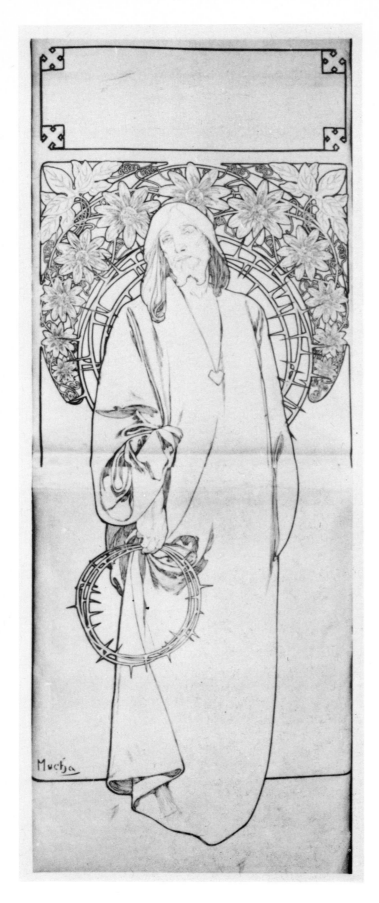

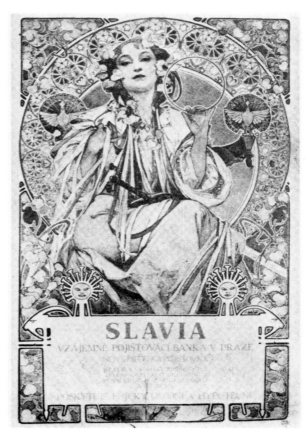

96. RUDOLF FRIML c. 1905

95. LA PASSION 1904

97. INSURANCE BANK SLAVIA 1907

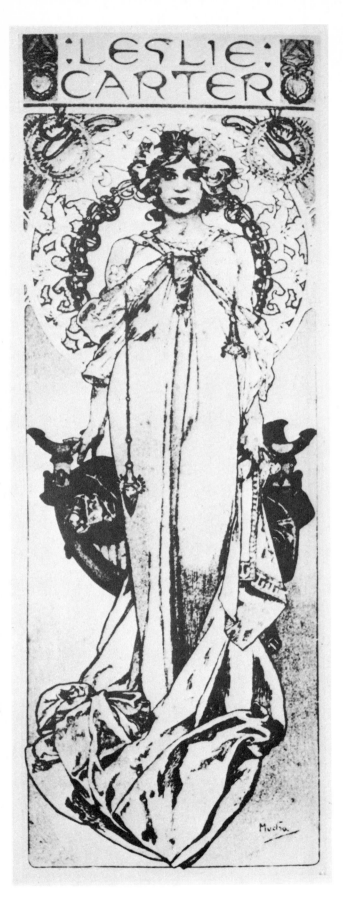

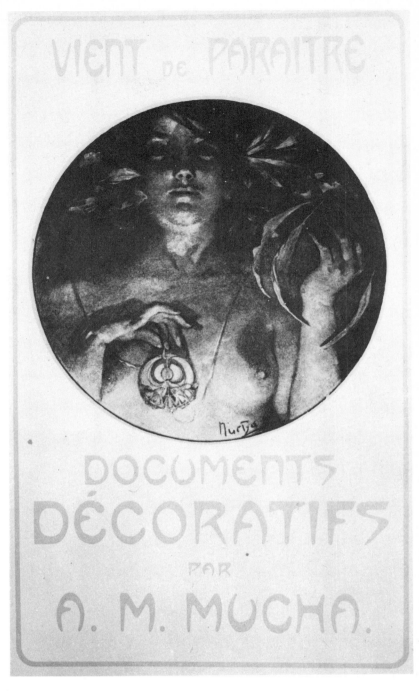

98. LESLIE CARTER 1908

99. DOCUMENTS DECORATIFS PARAITRE 1901

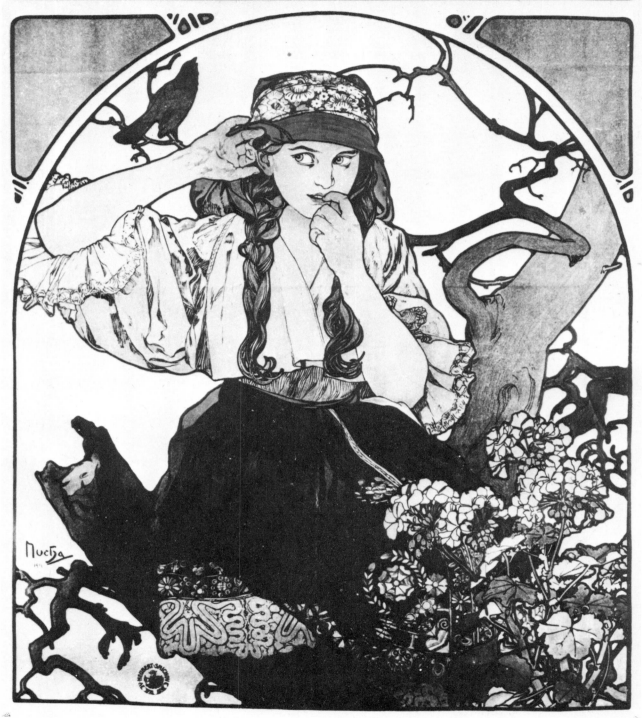

100 PEVECKE SDRUZENI UCITELU MORAVSKYCH 1911

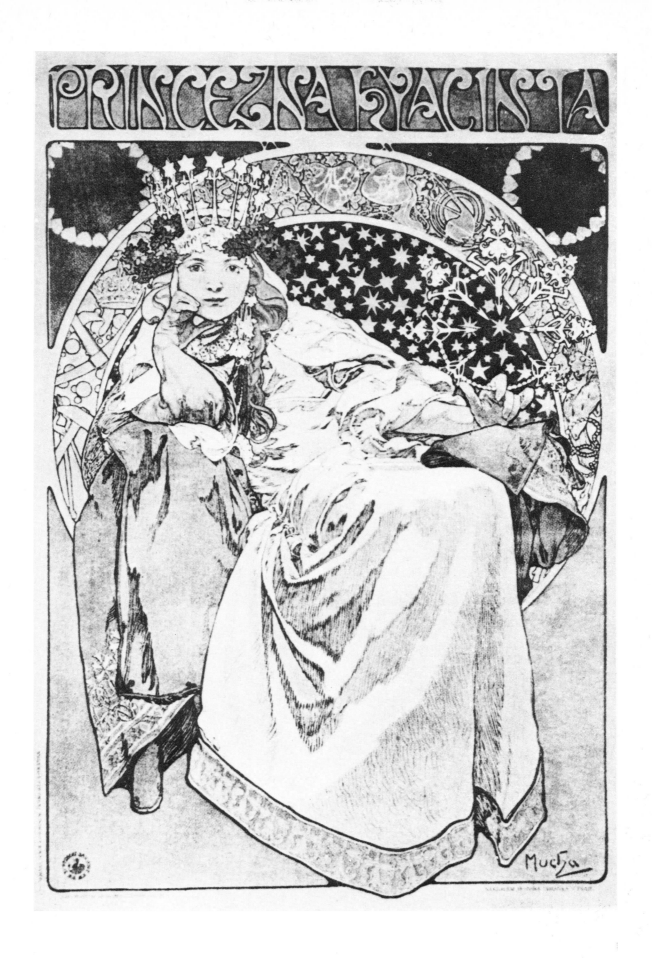

101. PRINCESS HYACINTH 1911

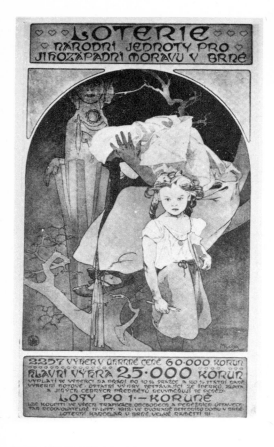

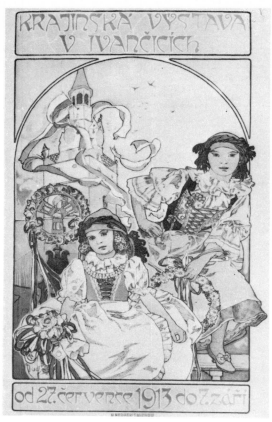

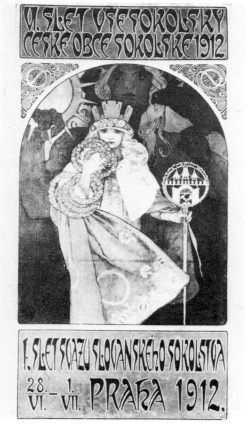

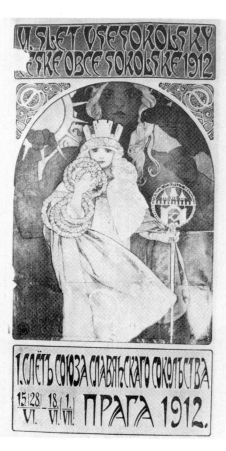

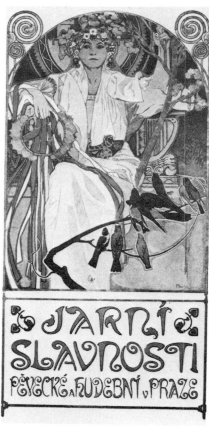

102. LOTERIE NARODNI JEDNOTY 1912

103. KRAJINSKA VYSTAVA V IVANICICICH 1913

104. SOKOL LOTTERY 1916

105. VI SLET VSESOKOLSKY 1912

106. VARIANT OF VI SLET VSESOKOLSKY 1912

107. JARNI SLAVNOSTI 1914

108. ZDENKA CERNY 1913

73

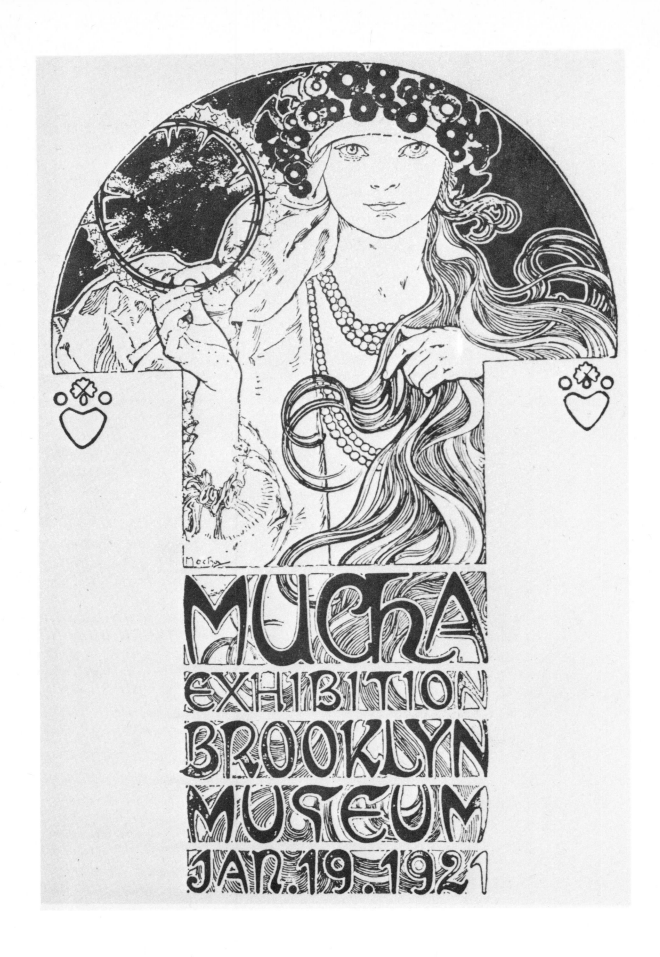

109. MUCHA EXHIBITION BROOKLYN MUSEUM 1921

74

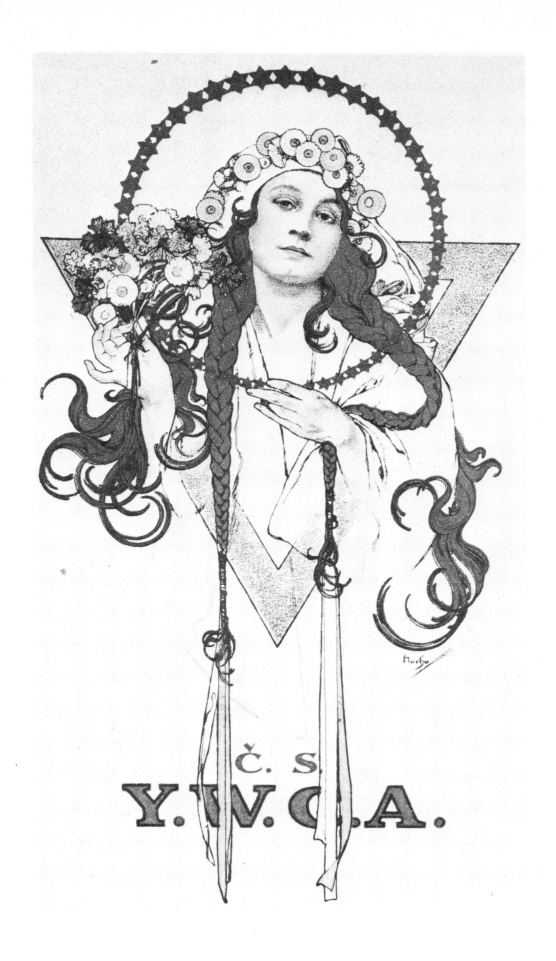

110. Y.W.C.A. c. 1922

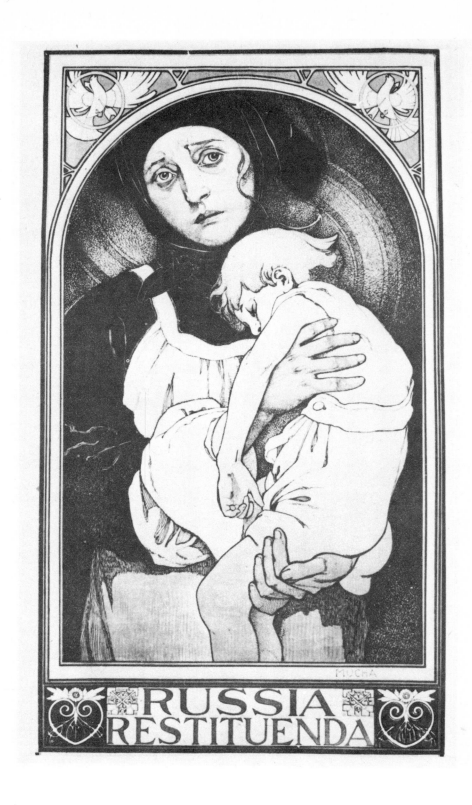

111. RUSSIA RESTITUENDA 1922

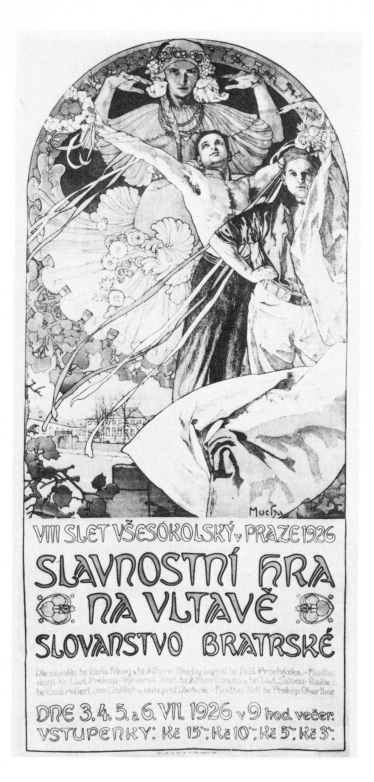

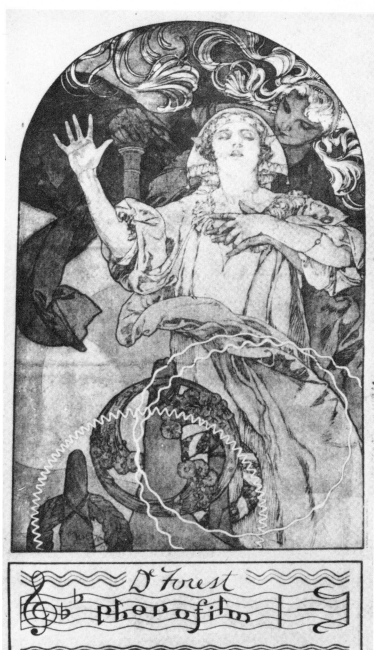

112. VIII SLET VSESKOLSKY 1926

113. DE FOREST PHONOFILM 1927

"SLOVANSKÁ EPOPEJ"
HISTORIE SLOVANSTVA V OBRAZÍCH
~ALFONS MUCHA~
VYSTAVENO OD 23. ZÁŘÍ DO 31. ŘÍJNA 1928
VE VELKÉ DVORANĚ I. VELETRŽNÍHO PALÁCE
V PRAZE
POD PROTEKTORÁTEM MINISTRA ŠKOLSTVÍ A NÁRODNÍ OSVĚTY
Dra MILANA HODŽI.
DENNĚ OTEVŘENO OD 8.— 17. HOD.

"SLOVANSKÁ EPOPEJ"
HISTORIE SLOVANSTVA V OBRAZÍCH
~ALFONSE MUCHY~
VYSTAVENO OD 1. ČERVNA DO 30. ZÁŘÍ 1930
VE VELKÉ DVORANĚ VÝSTAVNÍHO PALÁCE
V BRNĚ
POD PROTEKTORÁTEM
MĚSTSKÉ RADY BRNĚNSKÉ
DENNĚ OTEVŘENO OD 8.— 18. HOD.

114. SLAV EPIC 1928

115. SLAV EPIC 1928

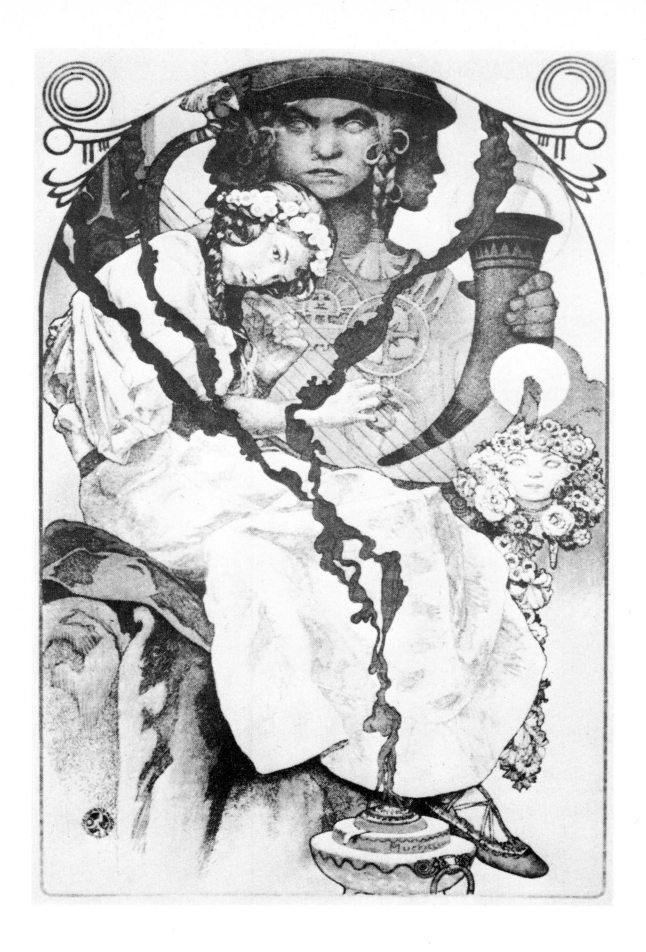

116. SLAV EPIC 1928

79

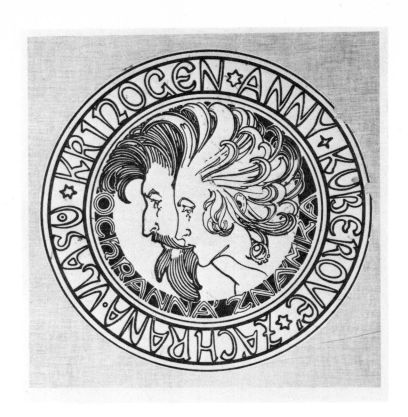

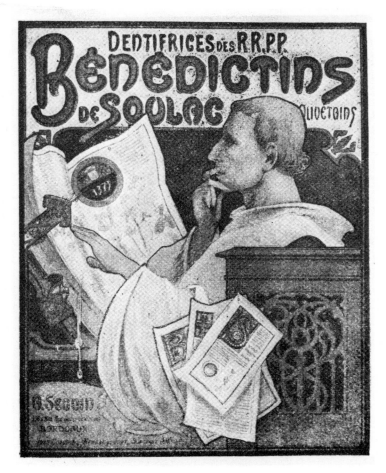

117. KRINOGEN C. 1928

118. DENTIFRICES DES BENEDICTINS DE SOULAC

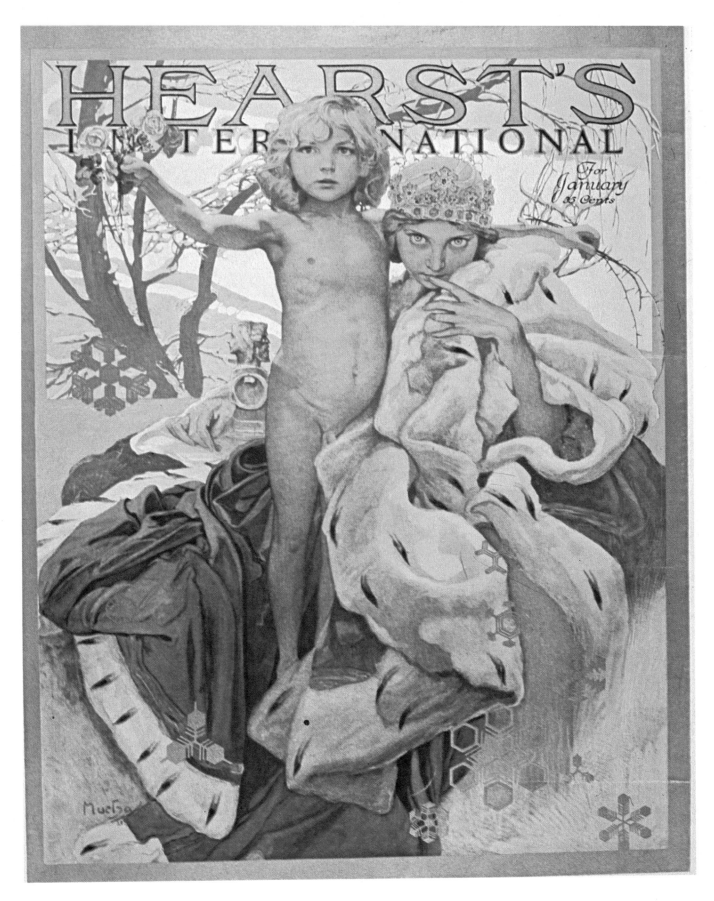

HEARSTS 1922

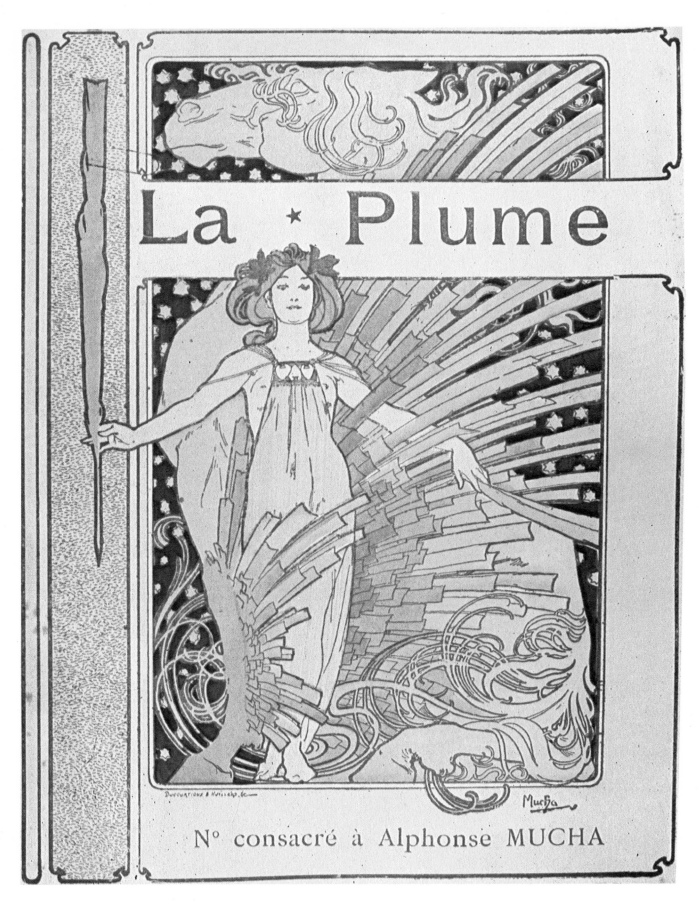

LA PLUME NUMERO CONSACRE A ALPHONSE MUCHA 1897

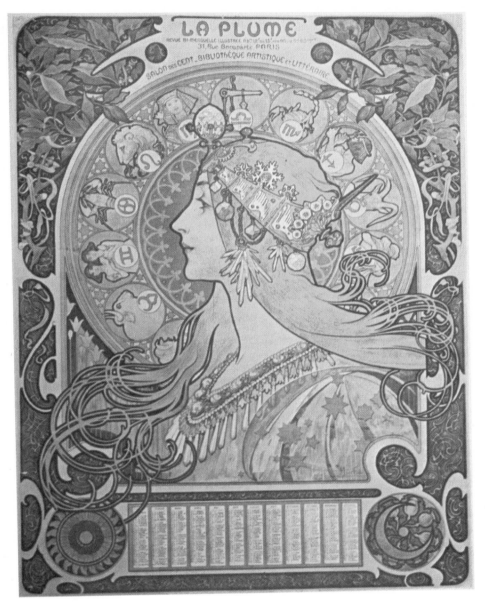

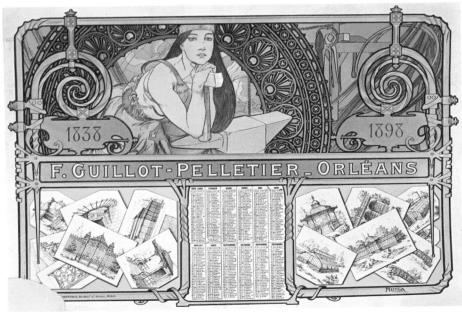

CHAMPENOIS CALENDAR (ZODIAC) 1896 F. GUILLOT-PELLETIER CALENDAR

XXVII

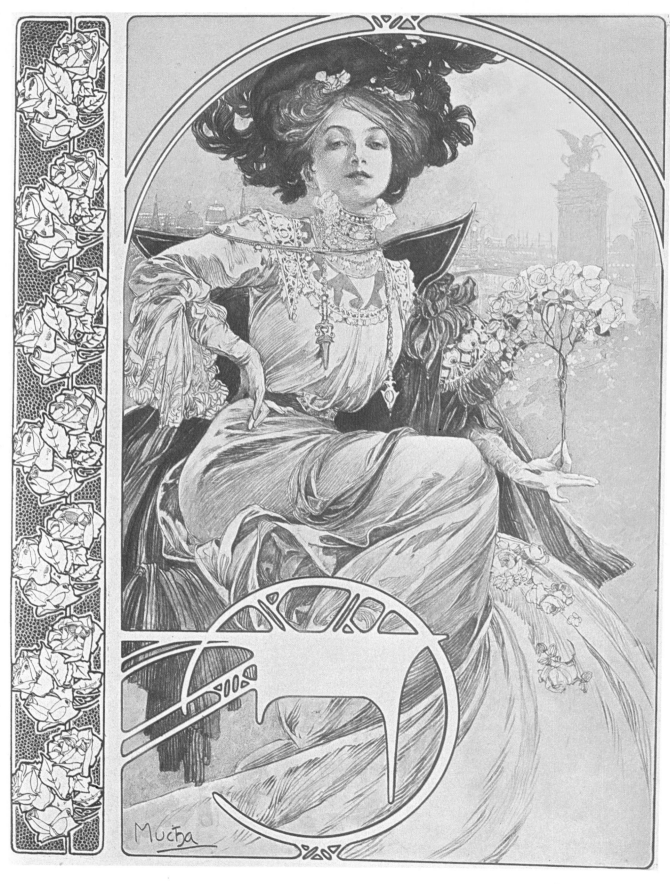

PARIS 1900

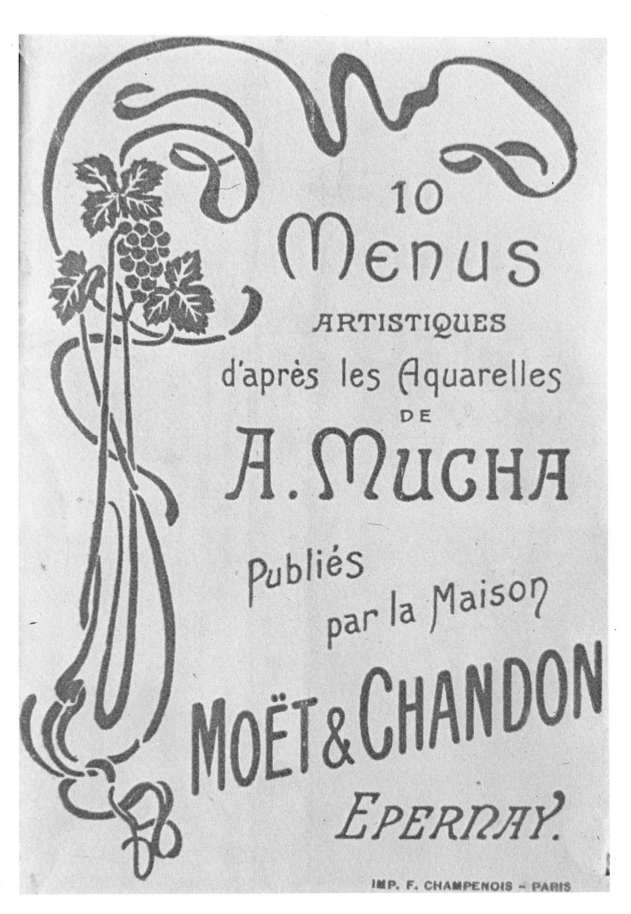

MOET ET CHANDON 1900 ENVELOPE AND (OVERLEAF) SET OF TEN MENU CARDS

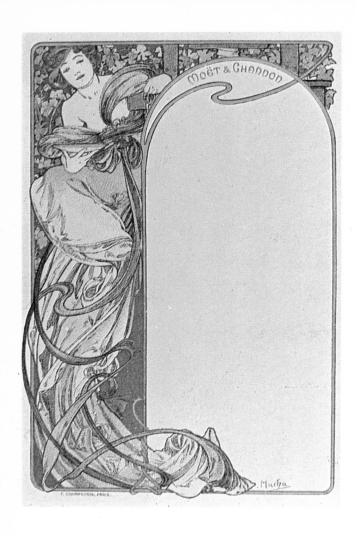

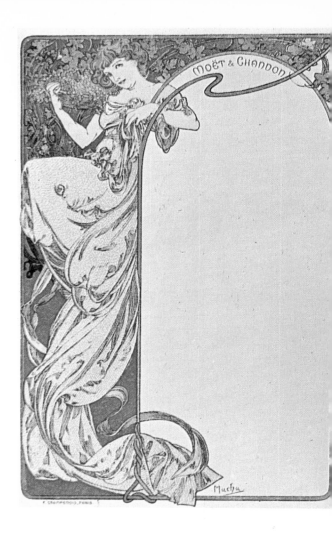

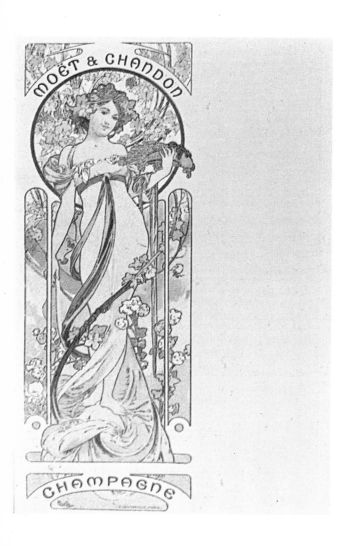

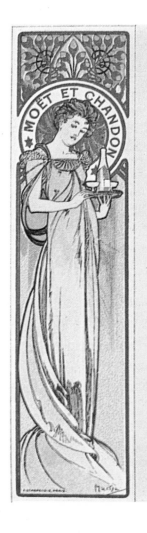

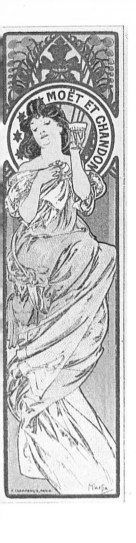
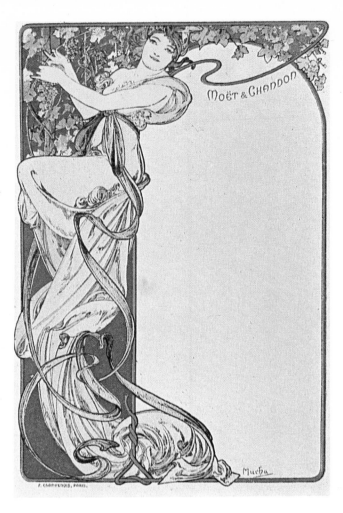
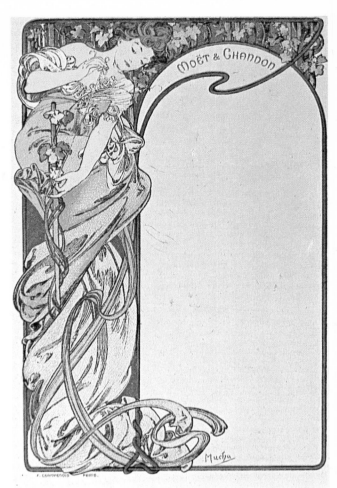
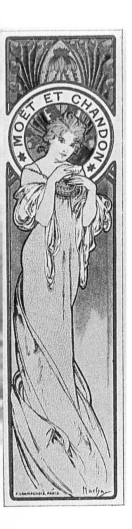
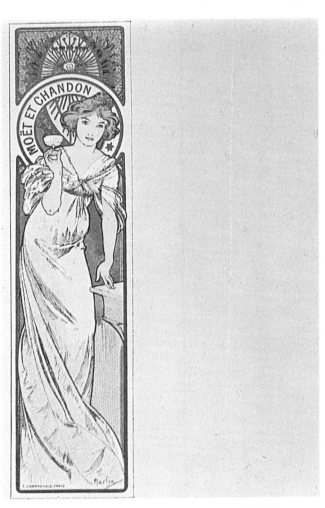
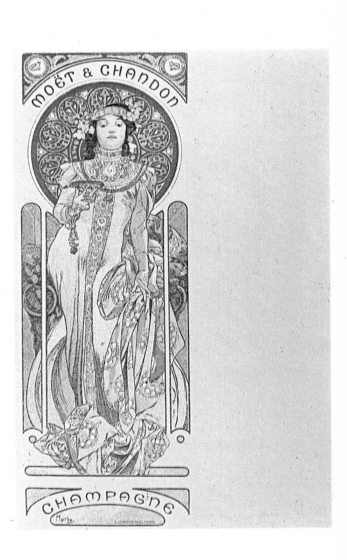

XXXI

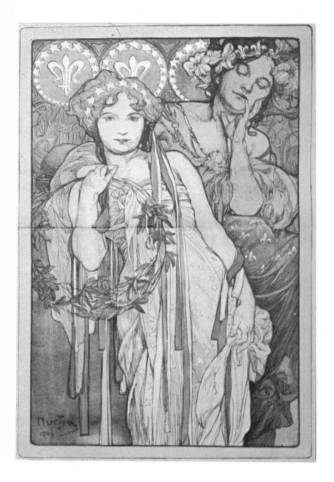

THE NEW YORK DAILY NEWS 1904

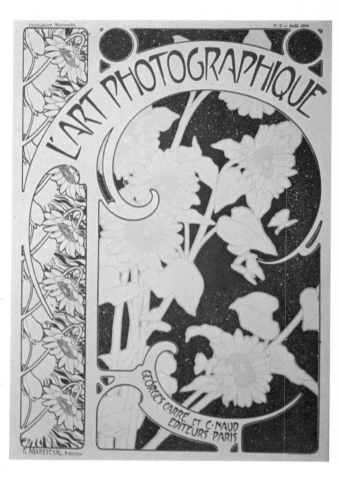

L'ART PHOTOGRAPHIQUE 1899

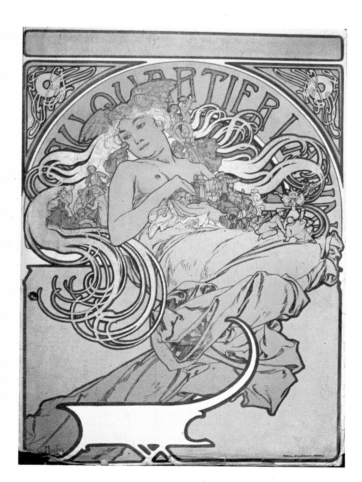

AU QUARTIER LATIN 1897

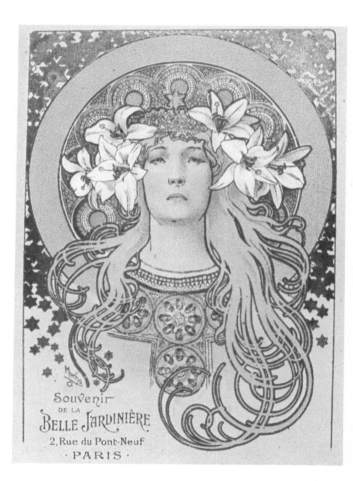

SARAH BERNHARDT FROM LA PLUME 1900

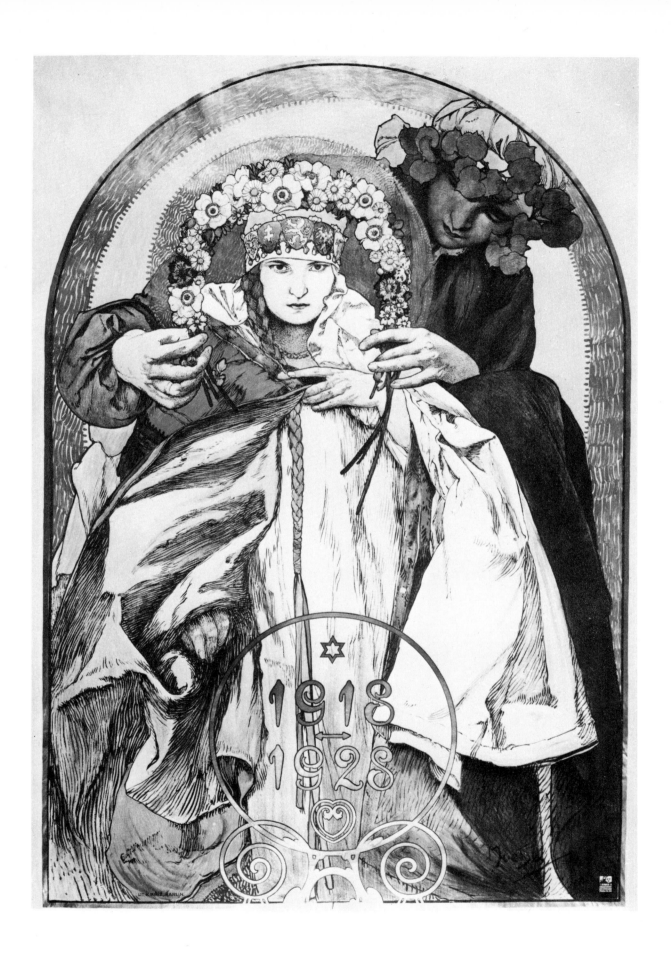

119. "1918 - 1928"

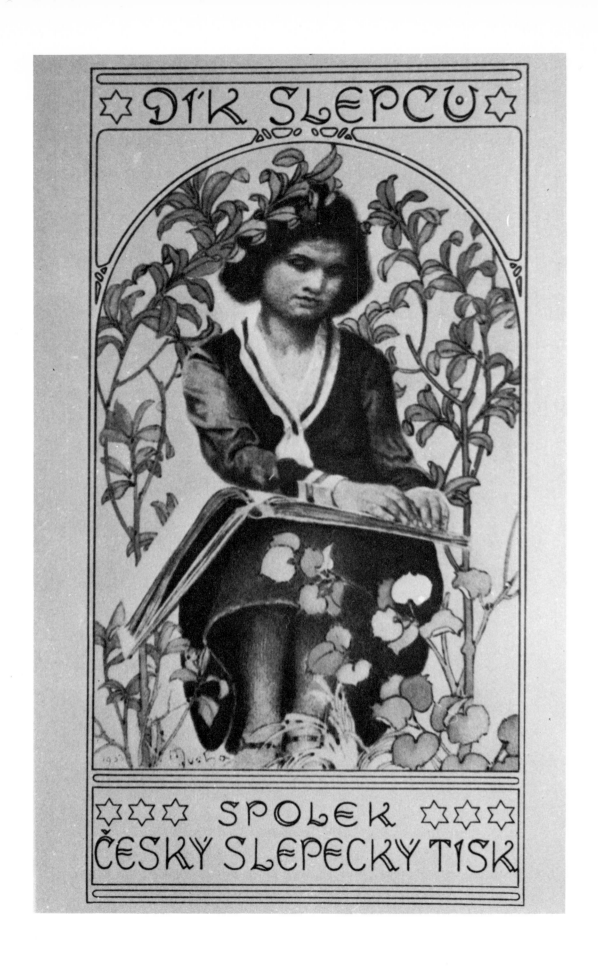

120. DIK SLEPCU c. 1935

CALENDARS

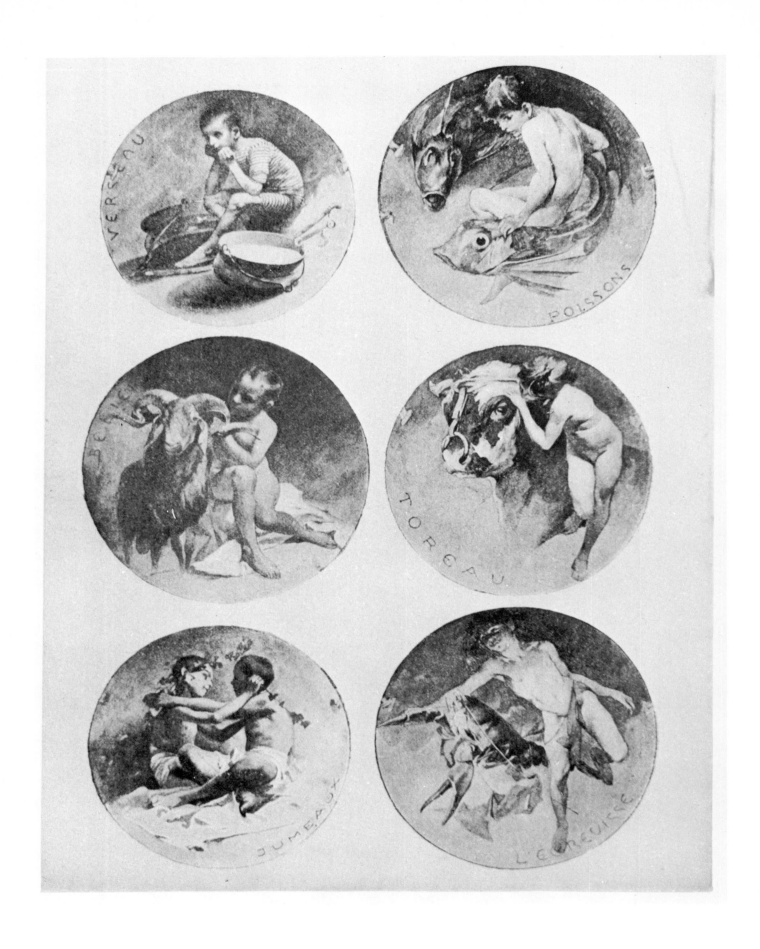

121 - 122 ZODIAC SIGNS: DETAILS FROM

CALENDAR FOR LORILLEUX

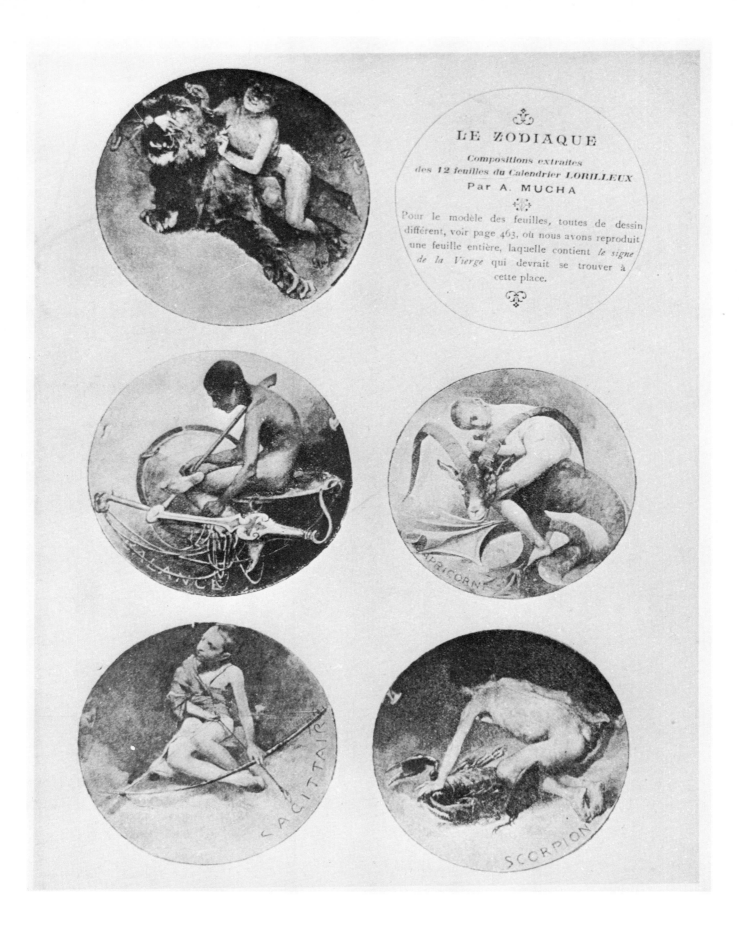

LE ZODIAQUE

*Compositions extraites
des 12 feuilles du Calendrier LORILLEUX
Par A. MUCHA*

Pour le modèle des feuilles, toutes de dessin différent, voir page 463, où nous avons reproduit une feuille entière, laquelle contient *le signe de la Vierge* qui devrait se trouver à cette place.

123 . CALENDAR FOR LORILLEUX ET CIE 1892

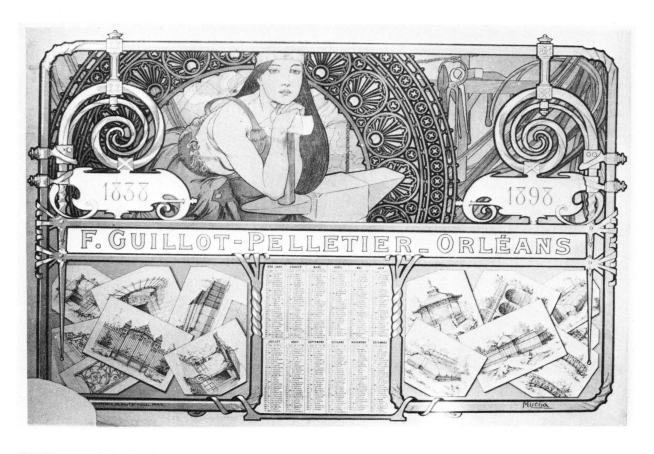

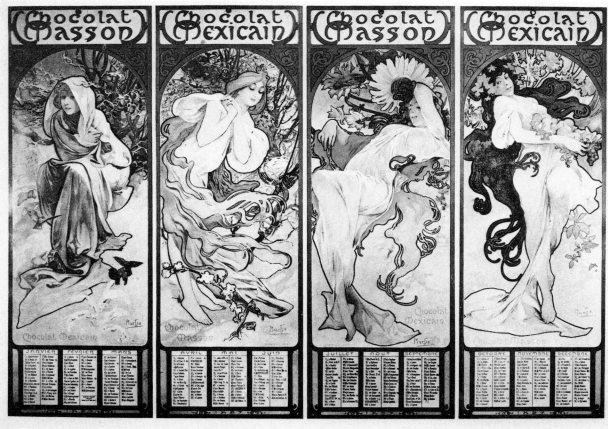

124. CALENDAR FOR F. GUILLOT-PELLETIER,

125. CALENDAR FOR CHOCOLAT MASSON

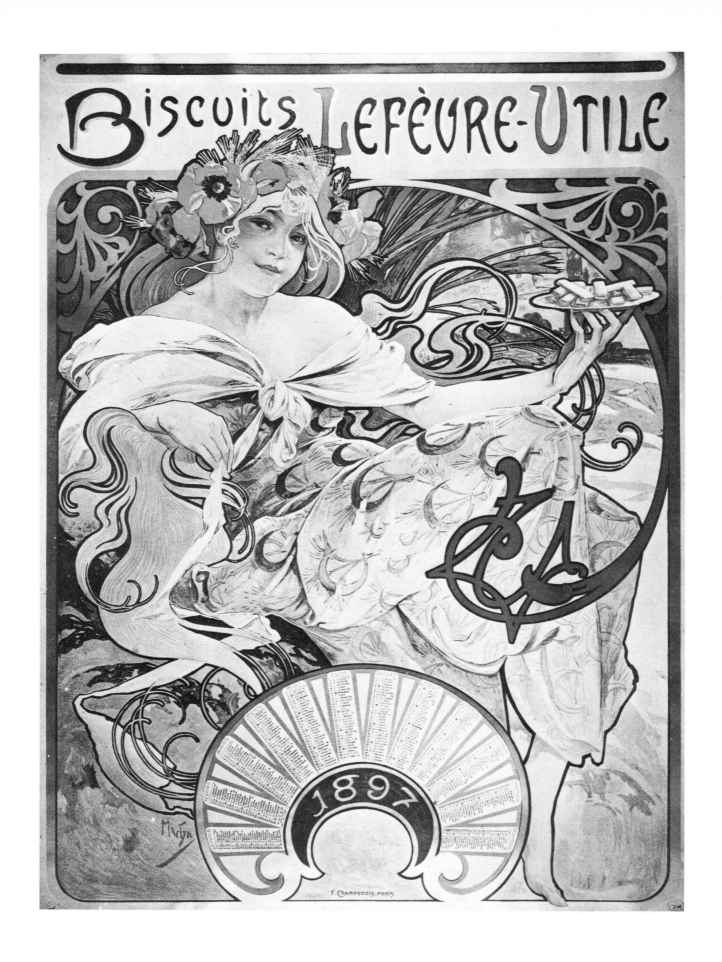

126. CALENDAR FOR BISCUITS LEFÈVRE-UTILE

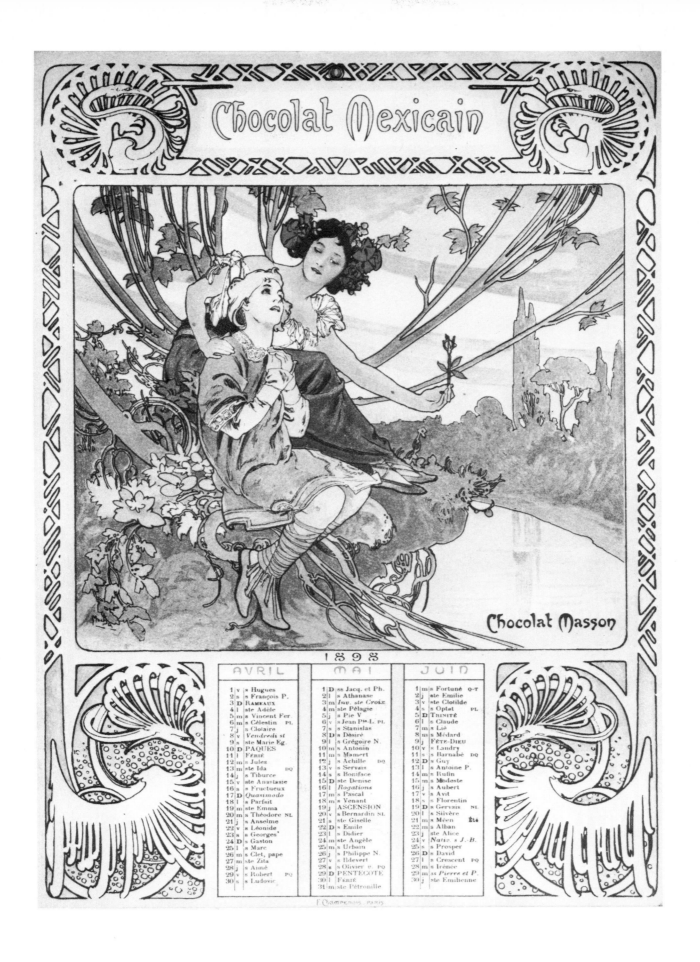

127. CALENDAR FOR CHOCOLAT MASSON 1898

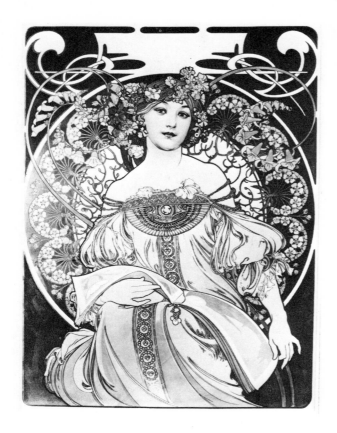

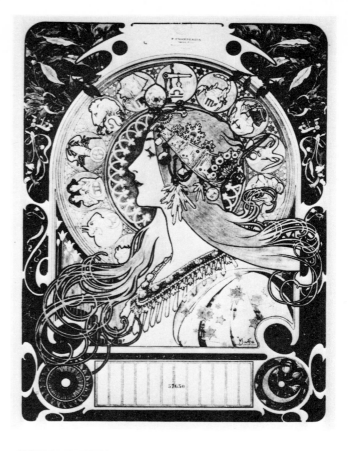

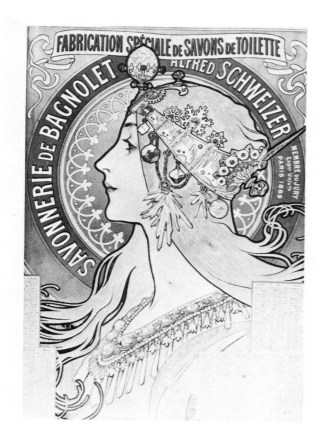

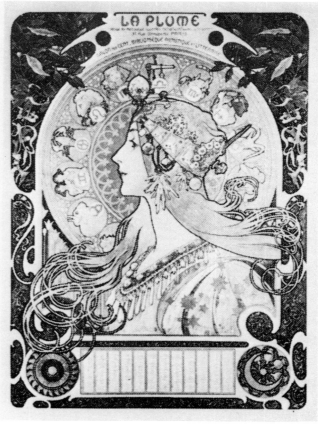

128. CALENDAR FOR CHAMPENOIS (REVERIE) 1898

129. CALENDAR FOR CHAMPENOIS (ZODIAC) 1896

130. CALENDAR FOR SAVONNERIE DE BAGNOLET

131. CALENDAR FOR LA PLUME

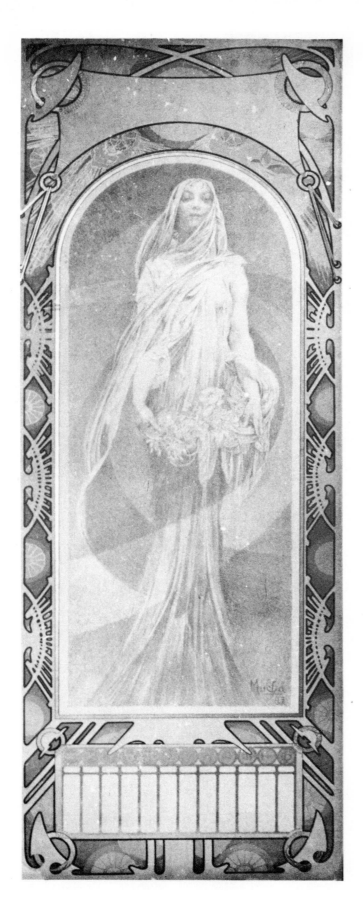

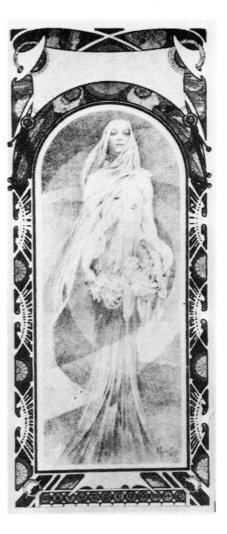

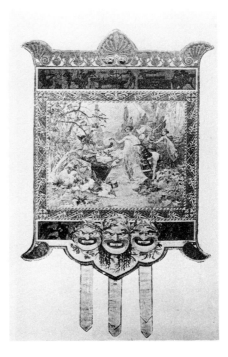

133. L'ANNEE QUI VIENT, PANNEAU 1897

132. L'ANNEE QUI VIENT, CALENDAR 1897 134. PERPETUAL CALENDAR

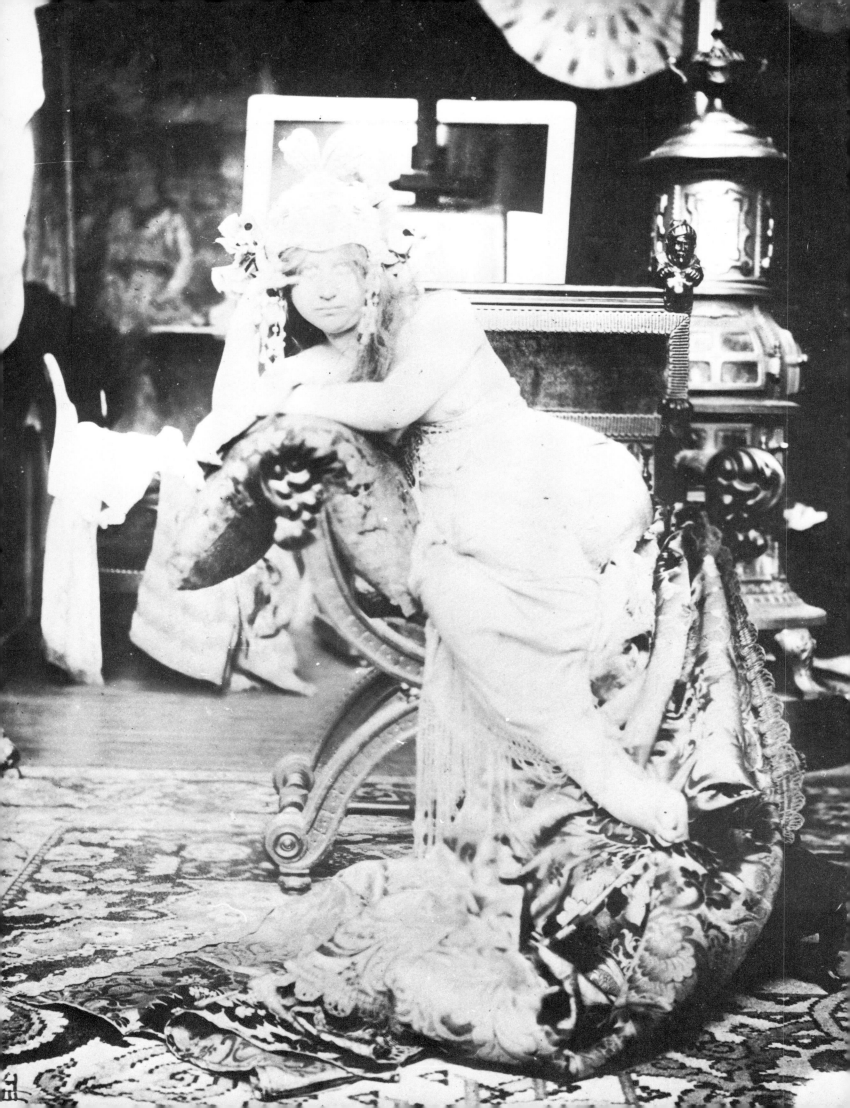

MENUS
PERIODICALS
MISCELLANEOUS

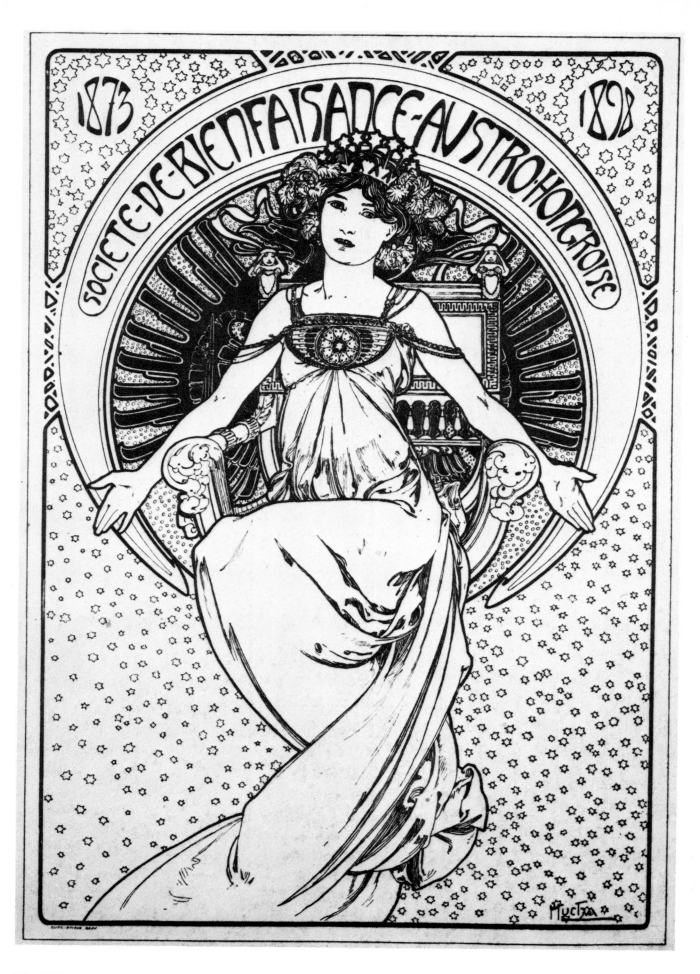

135. MENU FOR SOCIETE DE BIENFAISANCE

AUSTRO-HONGROISE 1898

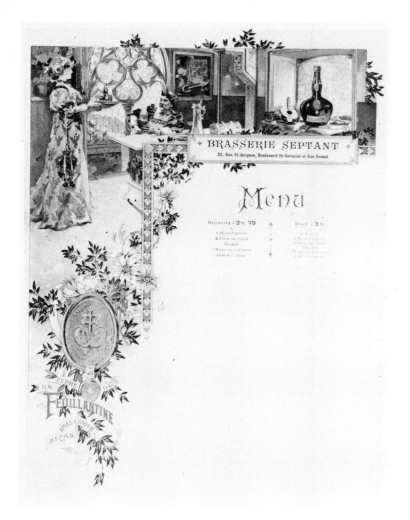

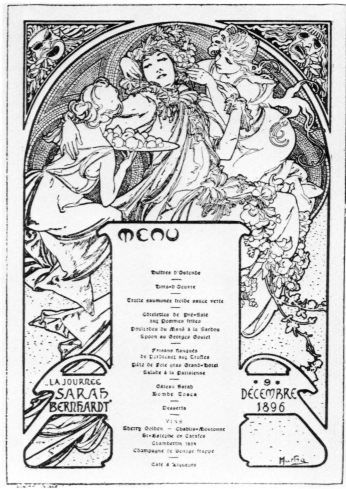

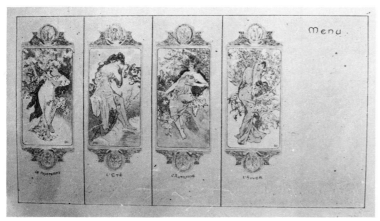

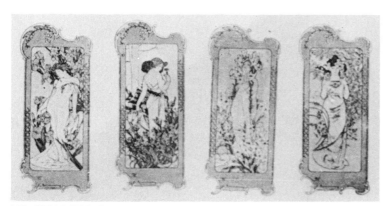

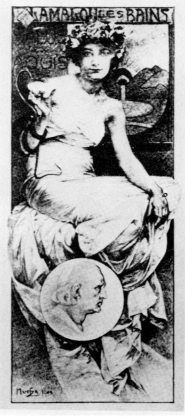

136. MENU FOR BRASSERIE SEPTANT 1894

137. MENU FOR SARAH BERNHARDT'S 50th BIRTHDAY 1896

138. SET OF FOUR MENUS OF THE SEASONS 1897

140. MENU FOR LAMALOU LES BAINS 1903

139. SET OF FOUR MENUS OF THE FLOWERS

141. ONE OF A SET OF FOUR MENUS c. 1900

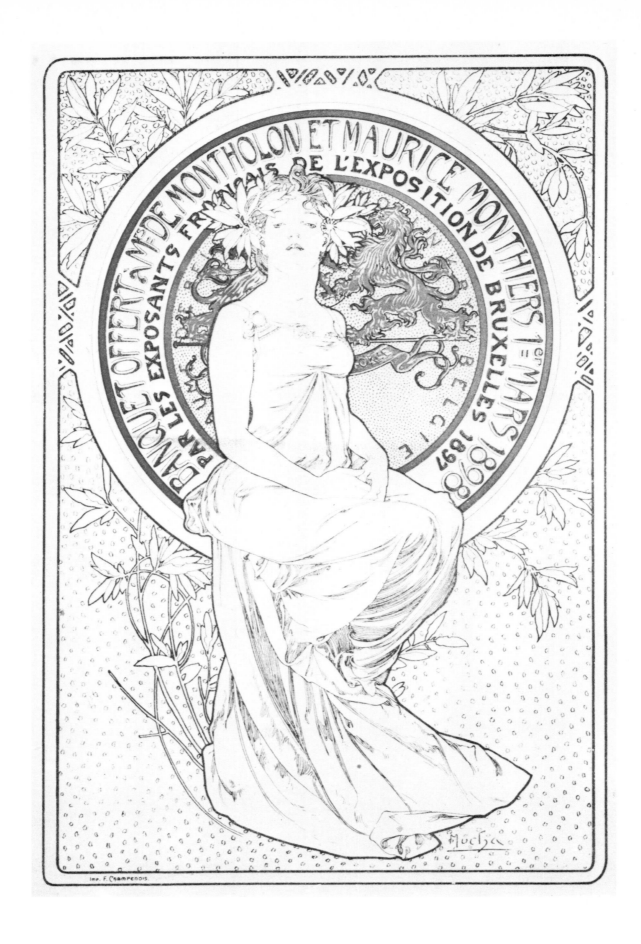

142. MENU FOR A BANQUET 1898

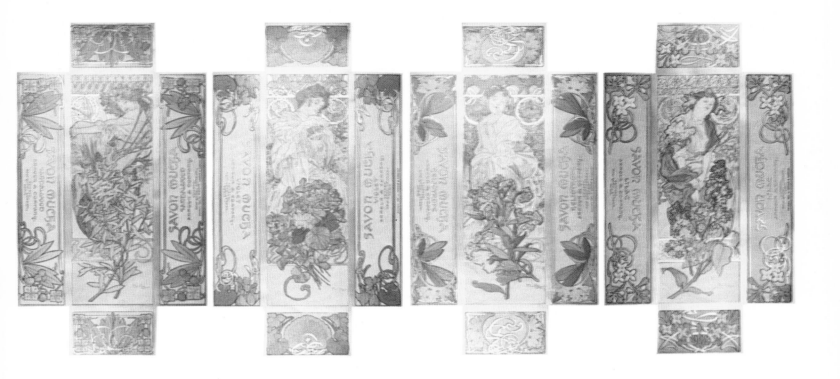

WRAPPERS FOR SAVON MUCHA 1906:

SANDAL WOOD

VIOLET

HELIOTROPE

LILAC

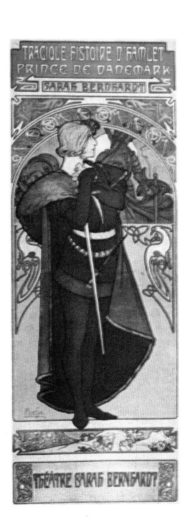

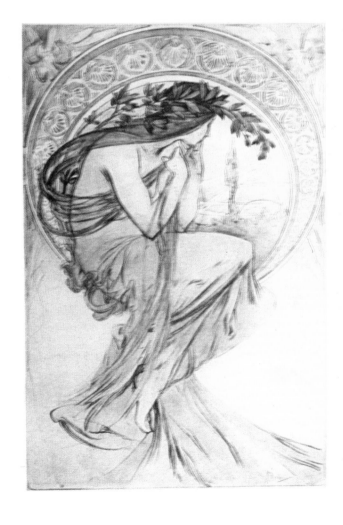

HAMLET 1899

LA POESIE 1898

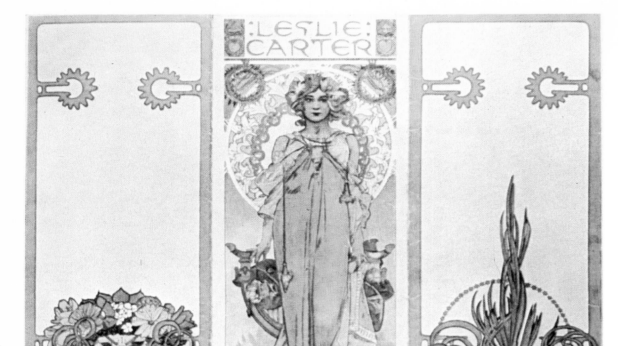

LESLIE CARTER
PROGRAMME COVER 1908

GIRL WITH PEN 1901

VARIANT OF REVERIE 1901

LYGIE 1901

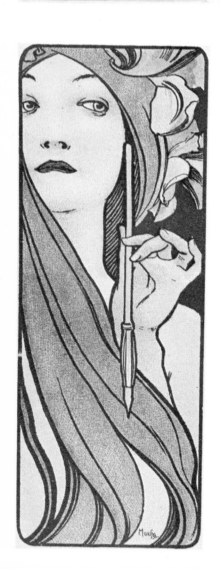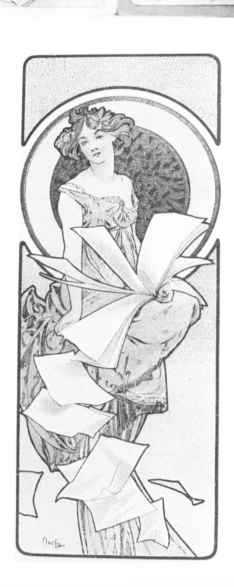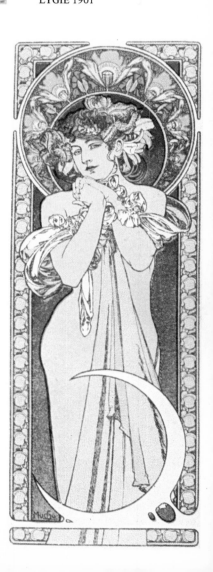

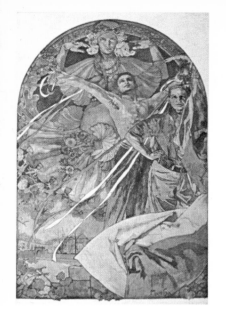

VIII SLET VSESKOLSKY 1926

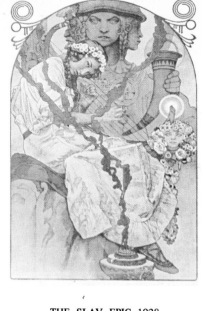

THE SLAV EPIC 1928

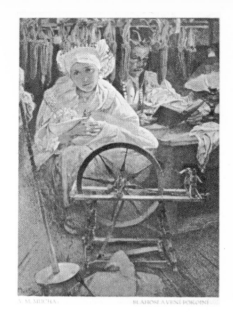

ONE BEATITUDE 1909

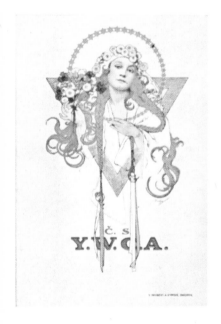

Y.W.C.A. c. 1922

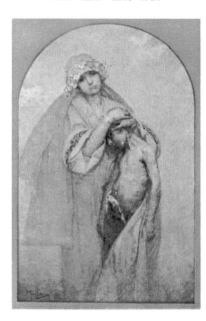

BOHEMIAN HEART CHARITY 1912

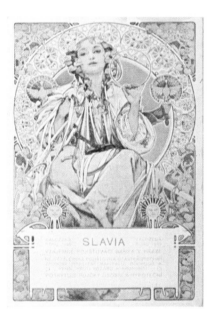

INSURANCE BANK SLAVIA 1907

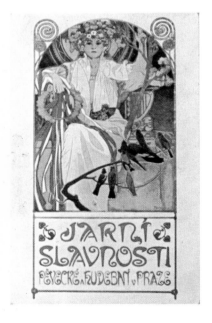

JARNI SLAVNOSTI c. 1914

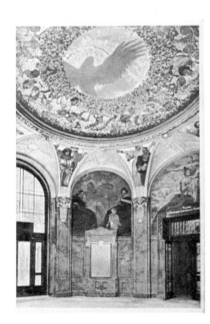

MURALS FROM THE LORD MAYOR'S
HALL 1913

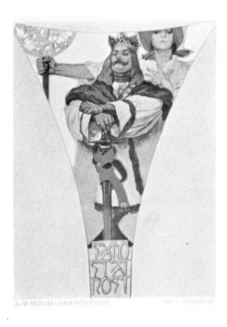

DETAIL FROM THE MURALS 1912

XXXV

ILSEE 1897

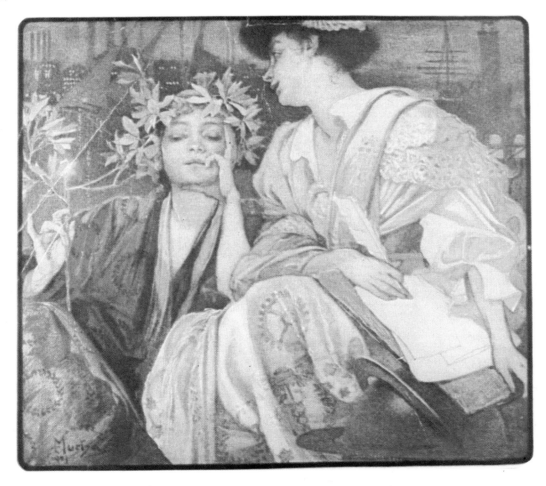

LITERARY DIGEST 1910

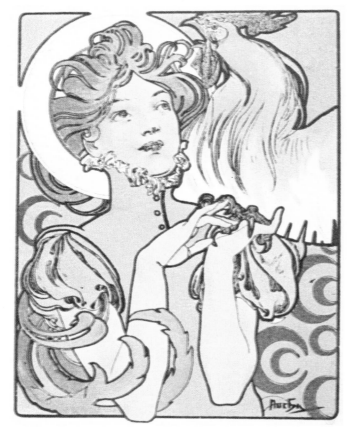

DESIGN FOR COCORICO 1900

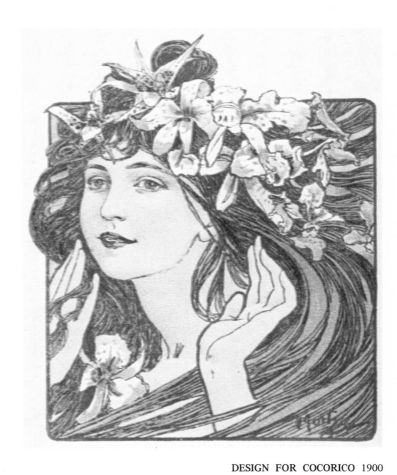

DESIGN FOR COCORICO 1900

SALOME 1900

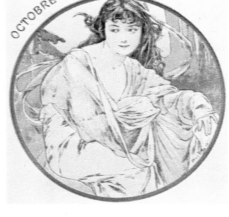

OCTOBER 1900

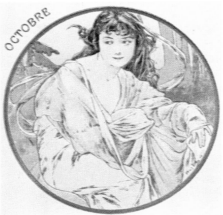

DESIGN FOR COCORICO 1900

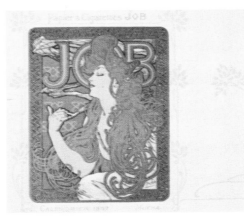

JOB CALENDAR ISSUED AS A POSTCARD 1900

XXXVII

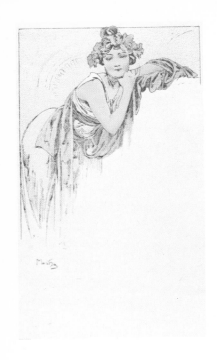
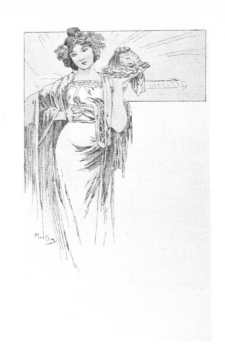
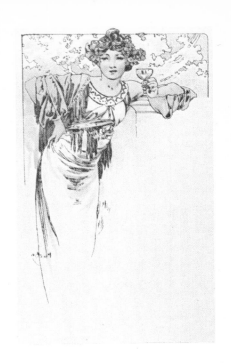

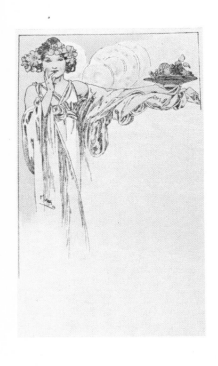
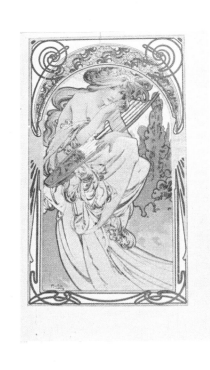
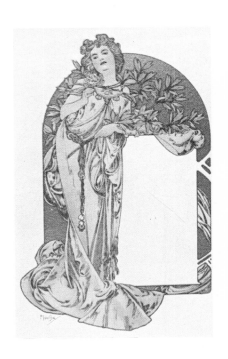

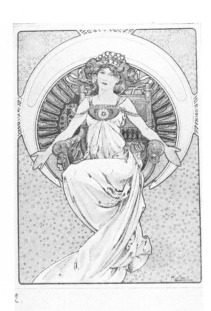
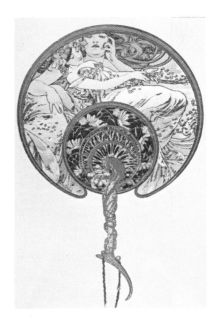
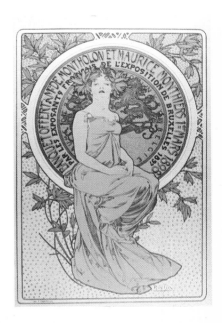

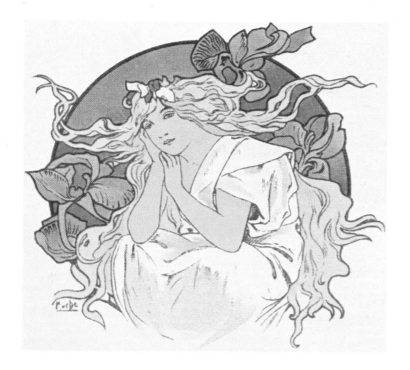

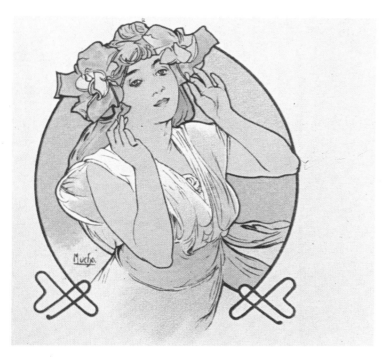

TWO VIGNETTES ISSUED AS POSTCARDS 1900

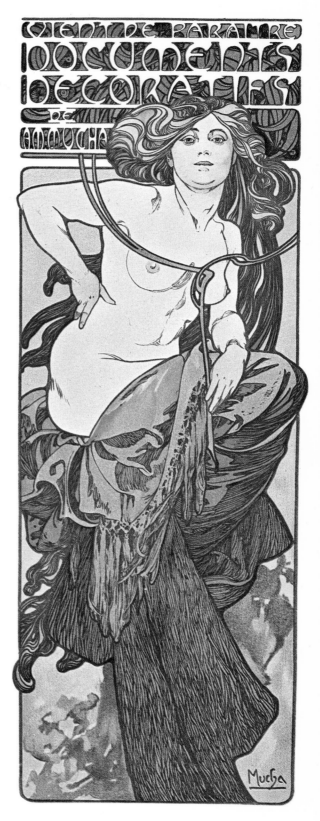

POSTER FOR DOCUMENTS DECORATIFS 1901

FACING PAGE:

SET OF FOUR DESIGNS FOR MENUS 1900

DESIGN FOR A SOIREE PROGRAMME 1901

DESIGN FOR A CALENDAR

DESIGN FOR A MENU 1900

DESIGN FOR A FAN 1900

INVITATION TO A BANQUET 1900

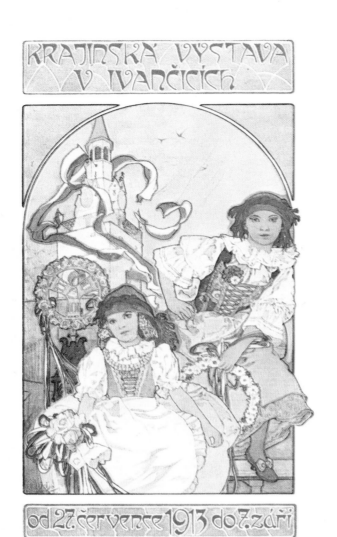

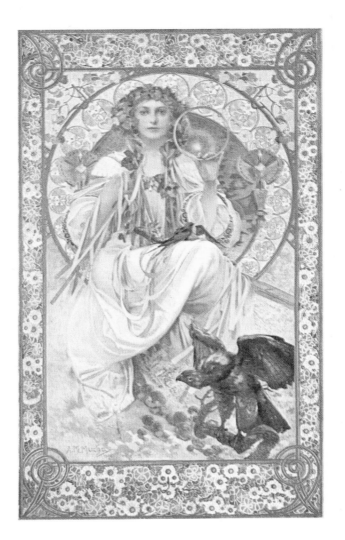

KRAJINSKA VYSTAVA V IVANICICH 1912

JOSEPHINE CRANE AS SLAVIA

DETAIL FROM CEILING OF THE LORD MAYOR'S HALL 1912

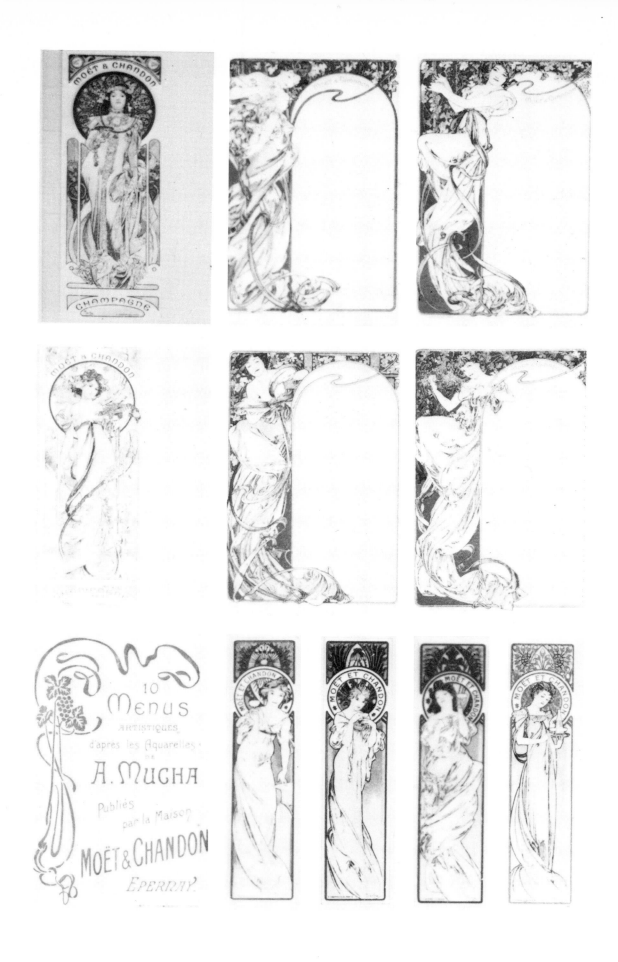

143. - 153 SET OF TEN MENUS IN AN

ENVELOPE FOR MOET & CHANDON 1897

KATALOG VÝSTAVY

MISTRA ALFONSE MUCHY

pořádané Moravským uměleckoprůmyslovým

museem Obchodní a živnostenské komory v Brně

od 4. října do 1. listopadu 1936.

Vydáno vlastním nákladem v Brně 1936.

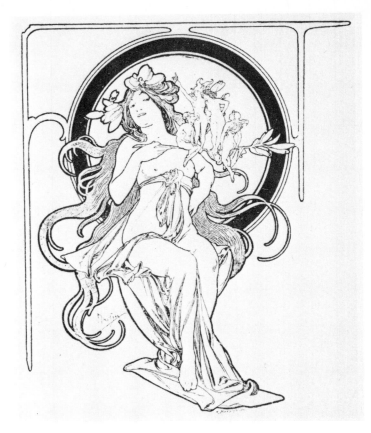

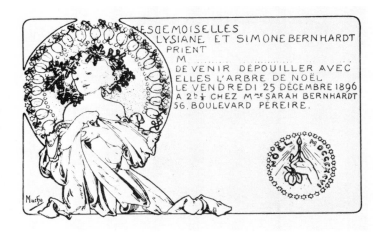

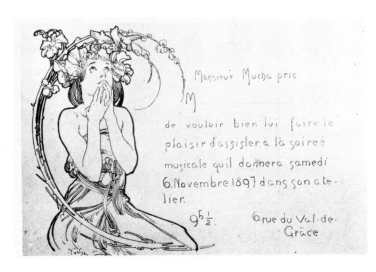

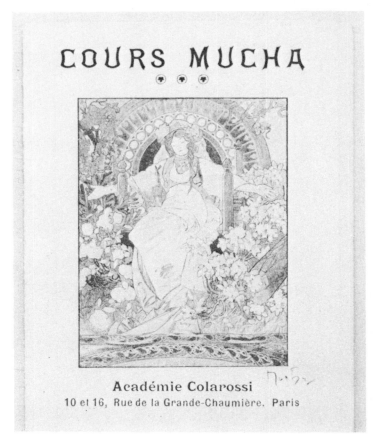

154. CATALOGUE FOR MUCHA EXHIBITION AT BRNO 1936

155. CHRISTMAS PARTY INVITATION 1896

156. INVITATION TO A SOIREE MUSICALE 1897

157. INVITATION TO LE BAL DES QUAT'Z' ARTS 1897

158. PROSPECTUS FOR COURS MUCHA, NEW YORK 1905

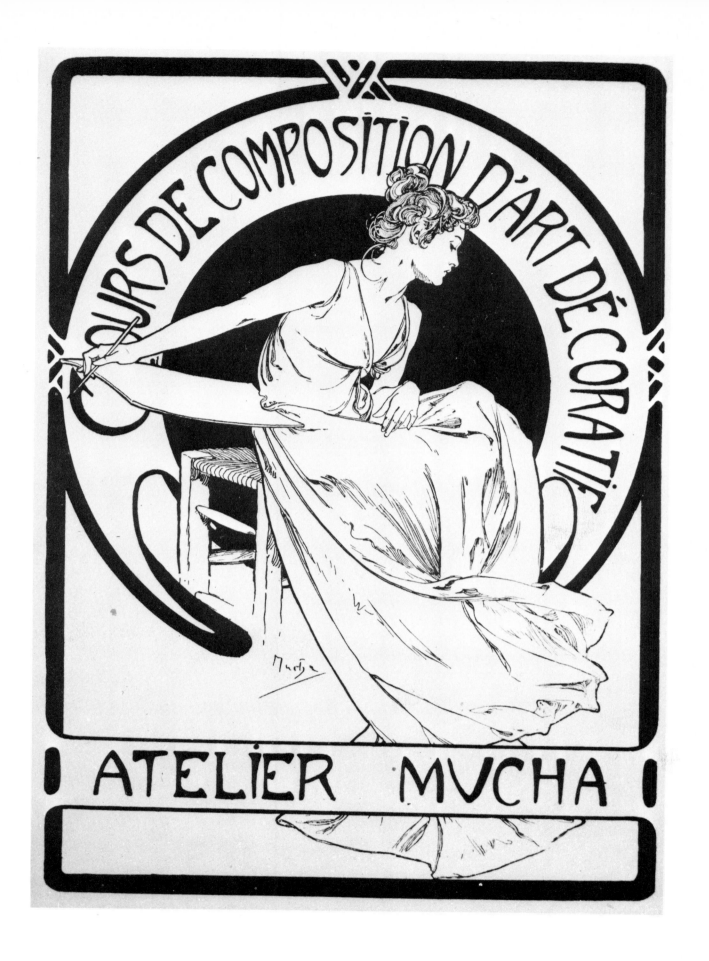

159. PROSPECTUS FOR ATELIER MUCHA 1896

99

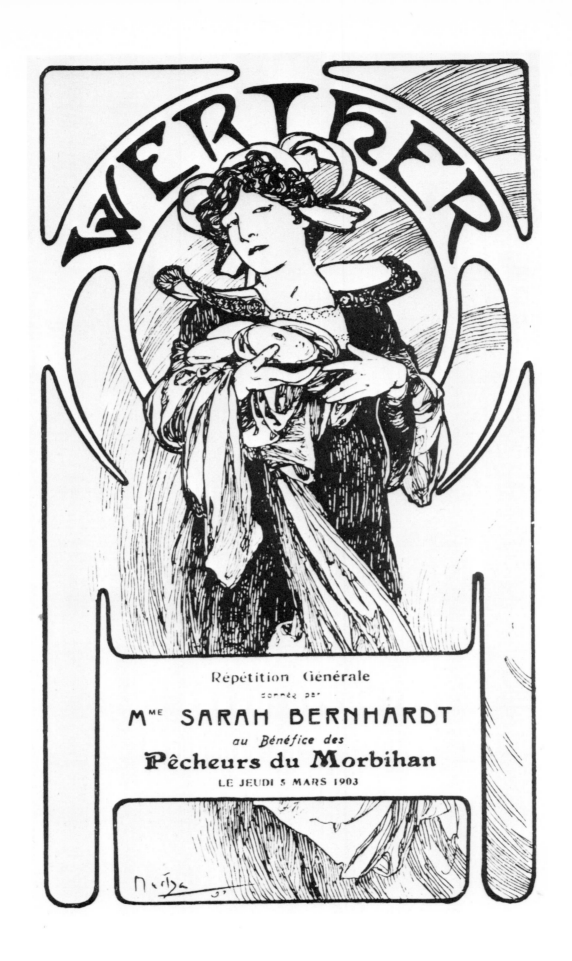

Répétition Générale

donnée par

M^{me} SARAH BERNHARDT

au Bénéfice des

Pêcheurs du Morbihan

LE JEUDI 5 MARS 1903

160. WERTHER 1903

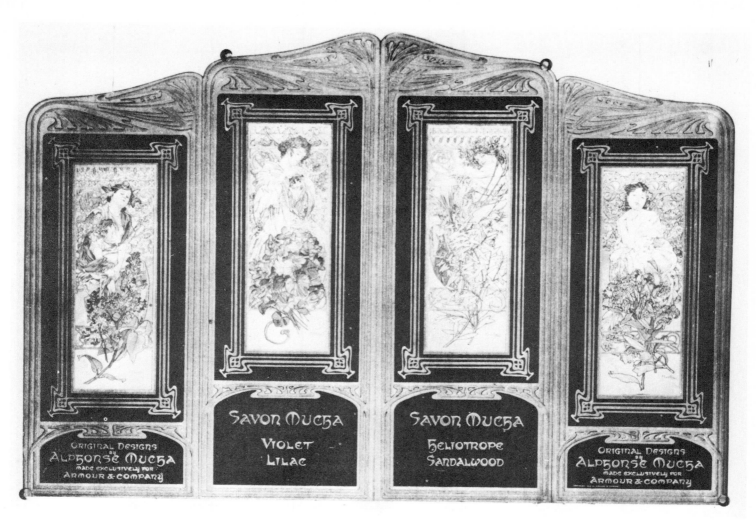

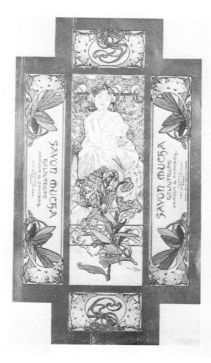

161 SAVON MUCHA WRAPPERS IN A FRAME

162. PROSPECTUS FOR COURS MUCHA 163. SAVON MUCHA WRAPPER 164. THE KISS OF SPRING c. 1919

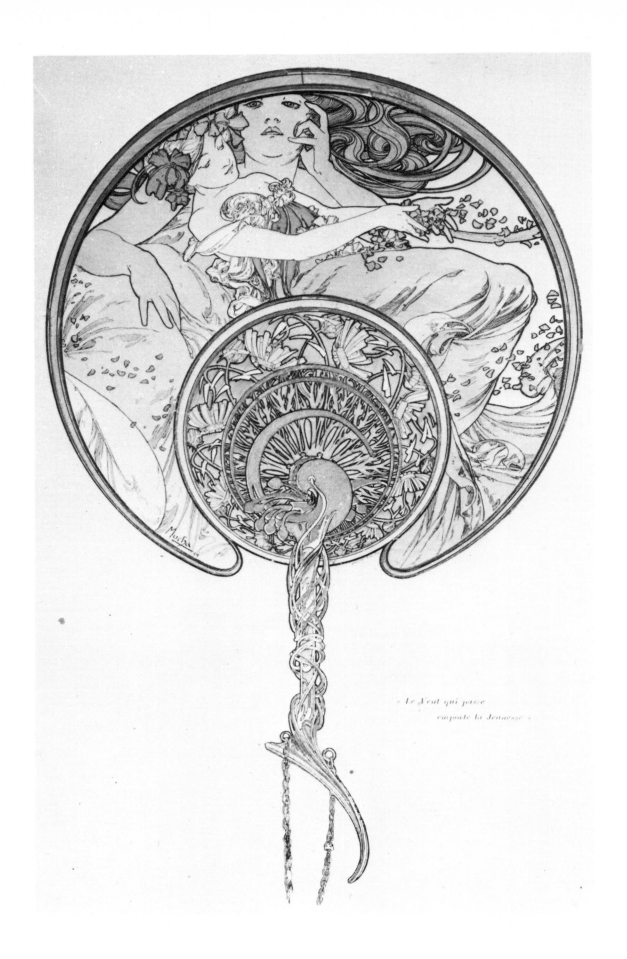

« Le Vent qui passe
emporte la Jeunesse »

165. DESIGN FOR A FAN

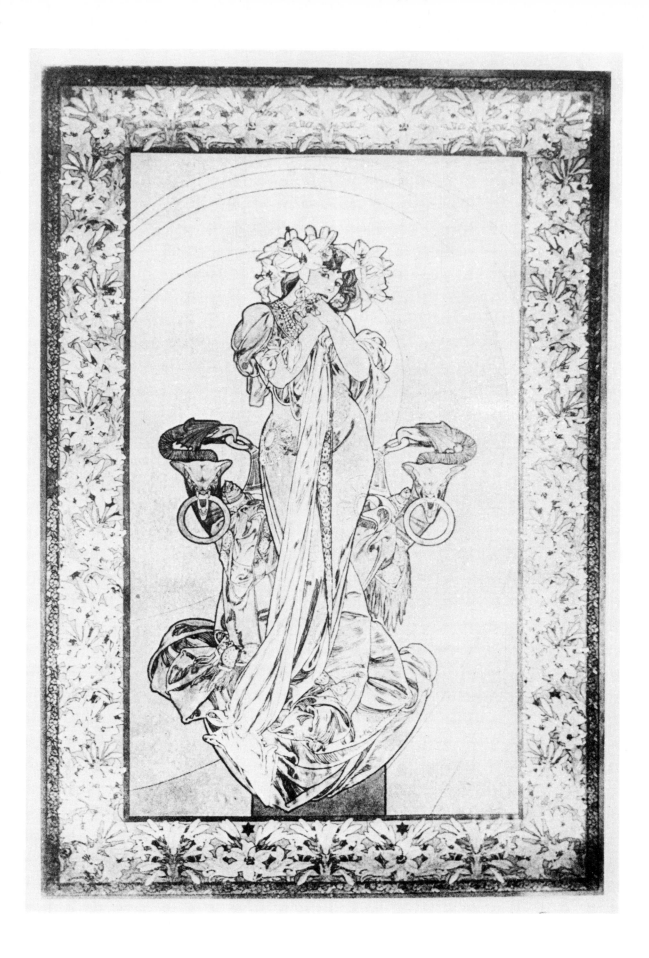

166. LA PRINCESSE LOINTAINE 1919

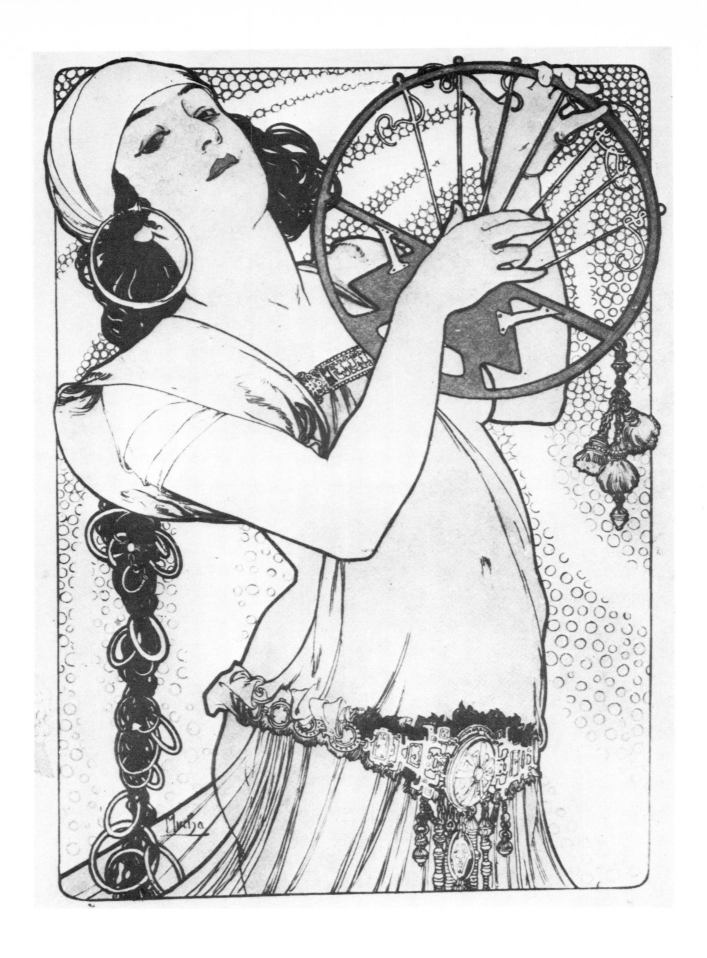

167. SALOME

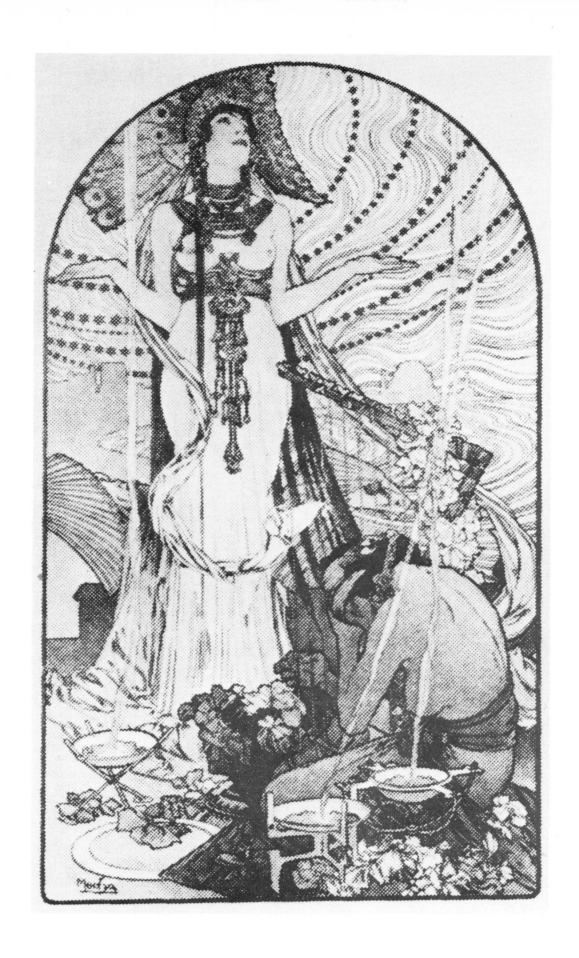

168. SALOMBO FROM L'ESTAMPE MODERNE 1896

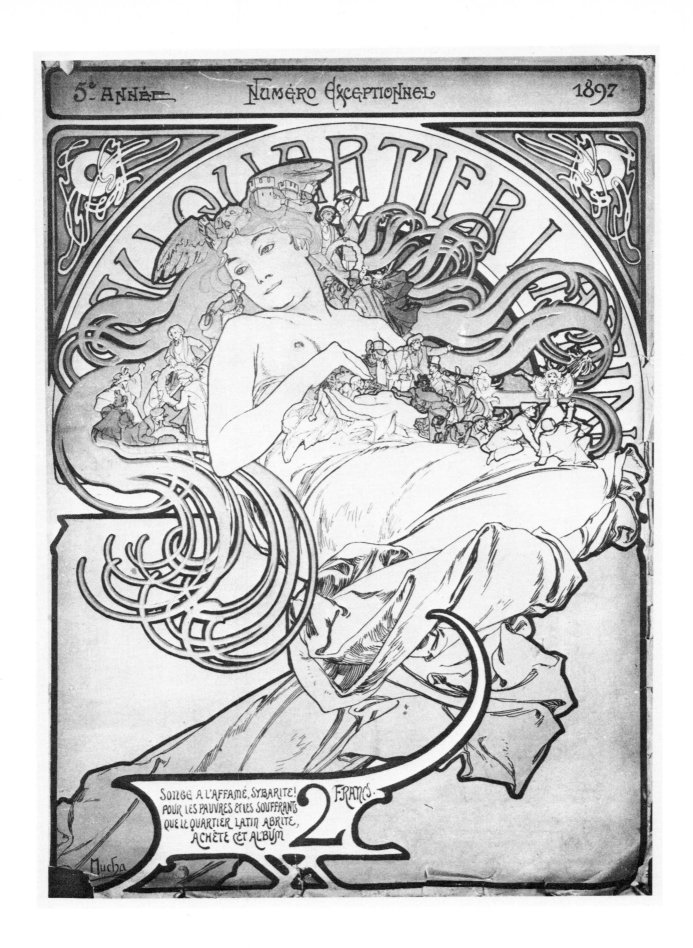

169. AU QUARTIER LATIN 1897

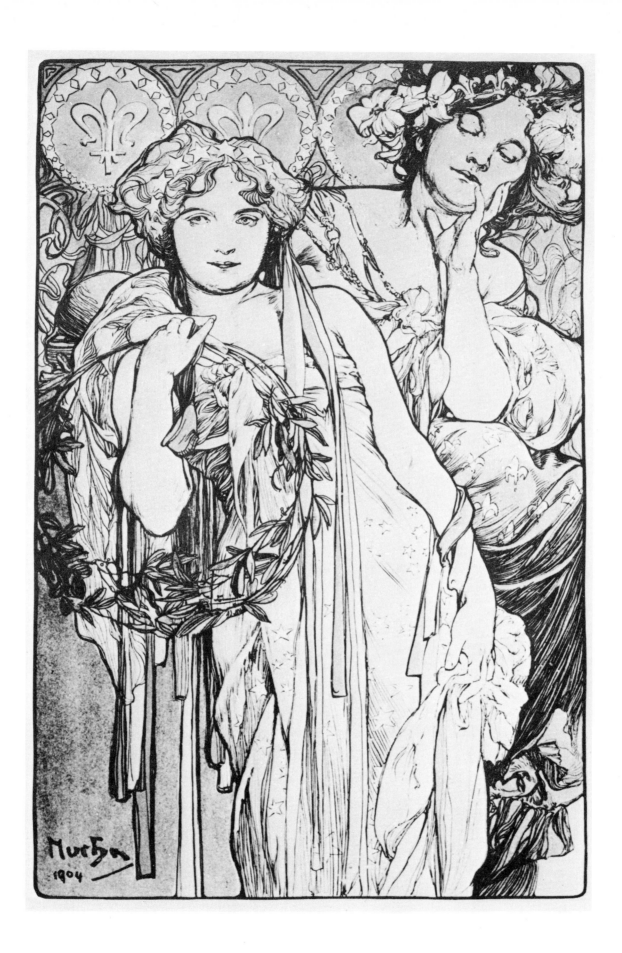

170. THE NEW YORK DAILY NEWS 1904

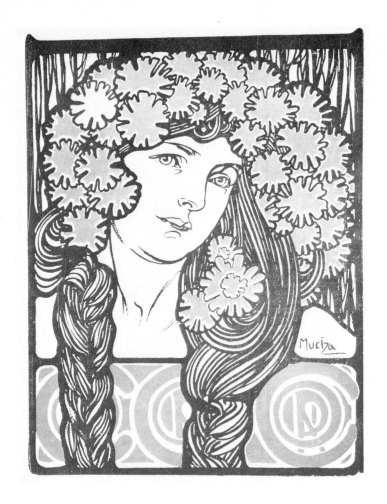

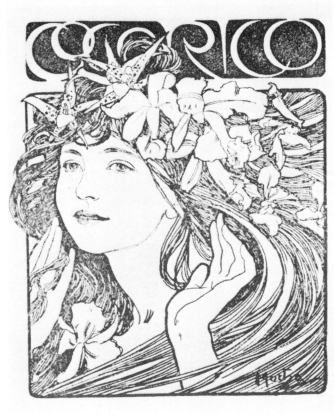

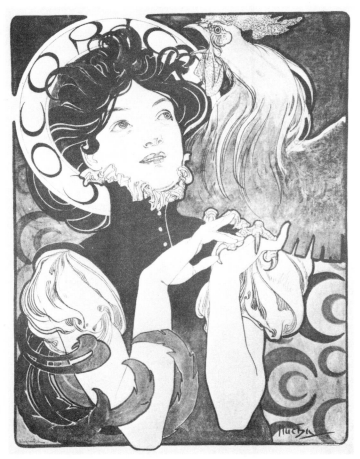

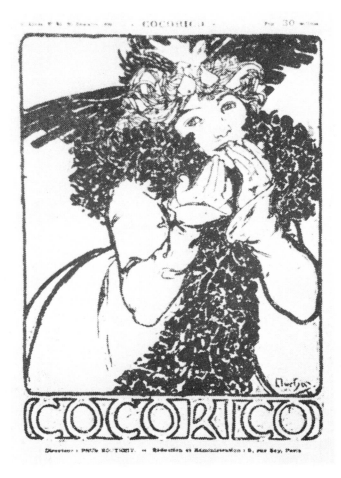

171-174. FOUR COVERS FROM COCORICO 1898-1902

THE CATALOGUE

NOTES

All dimensions, giving first the height and then the width of the printed area, are in centimetres. Most dimensions were measured from the originals but in a few cases marked by an asterisk, they were taken from secondary sources listed in the bibliography

Unless otherwise specified, all items were printed on paper. While most of the panneaux were reputed to be also printed on satin, this is indicated only when extant examples have been traced. A guide to the colours used in the posters and panneaux is given where accurately verified but omitted where originals were not available for inspection. The International Colour Code is used throughout.

The same basic design was often employed with variations for differing purposes. While it has proved impossible to trace all possible variants, those known have been listed and cross-referenced in the case of panneaux, posters and calendars. Where the same design is also used for postcards, books, periodicals etc. this is indicated, where known. for identification purposes Variants in differing sizes and with different lettering are also noted but it has proved impossible to trace proof state variants.

Lithographed or printed signatures and dates are given but subsequent signatures are omitted.

The majority of Mucha's graphics are now increasingly rare but the degree of rarity has been indicated by the letter 'R'. 'RRR' indicates that only one or two examples are known to exist. Entries followed by the abbreviation Ill. designate that the design is illustrated in black and white; the abbreviation Pl. indicates a colour reproduction.

PANNEAUX

REVERIE
1896
Colour lithograph
64 x 47.5 cm
Signed *Mucha* bottom right
Ill. 1, Pl. I
Variants:
Calendars Ill. 128. Also panneau
with ornamental design in top
centre panel

ZODIAC
1896
Colour lithograph
63 x 47 cm
Signed *Mucha* bottom right
Ill. 2
Variants:
Calendars Ills. 129, 131, Pl. XXVII

PRINTEMPS
1896
Lithograph in ten colours
98 x 50.5 cm
Signed *Mucha* bottom left and right
Ill. 3

ETE
1896
Lithograph in ten colours
98 x 50.5 cm
Signed *Mucha* bottom left and right
Ill. 4

AUTOMNE
1896
Lithograph in ten colours
98 x 50.5 cm
Signed *Mucha* bottom left and right
Ill. 5

HIVER
1896
Lithograph in ten colours
98 x 50.5 cm
Signed *Mucha* bottom left and right
Ill. 6, Pl. II

LES SAISONS
The above four panneaux in an
ornamental frame
1896
Colour lithograph
43 x 61 cm
Signed *Mucha* bottom right
Ill. 7

THREE SEASONS OF THE YEAR
c. 1896
Colour lithograph
64 x 47.5 cm
Signed *Mucha* bottom right
Ill. 9

LES FLEURS
The following four panneaux in an
ornamental frame
1897
Colour lithograph
42 x 61 cm
Ill. 8

IRIS
1897
Colour lithograph
100 x 41 cm
Signed *Mucha* bottom right
On satin RR
Ill. 10, Pl. IV

OEILLET
1897
Colour lithograph
100 x 41 cm
Signed *Mucha* bottom right
On satin RR
Ill. 11, Pl. IV

LYS
1897
Colour lithograph
100 x 41 cm
Signed *Mucha* bottom right
On satin RR
Ill. 12, Pl. IV

ROSE
1897
Colour lithograph
100 x 41 cm
Signed *Mucha* bottom left
On satin RR
Ill. 13, Pl. IV

L'ANNEE QUI VIENT
1897
Colour lithograph
82 x 33 cm
Signed *Mucha 97* bottom right
Variants:
Calendars Ill. 132
Also used as an advertisement
for a medicinal wine.

TETE BYZANTINE-BRUNETTE
c. 1897
Colour lithograph
34.5 x 28 cm
Signed *Mucha* bottom left
RR
Ill. 35
Also issued as a colour postcard. Pl. XI

TETE BYZANTINE-BLONDE
c. 1897
Colour lithograph
34.5 x 28 cm
Signed *Mucha* bottom right
RR
Ill. 36
Also issued as a colour postcard. Pl. XI

LA FLEUR
c. 1897
Colour lithograph
60 x 36.5 cm
Signed *Mucha* bottom right
R
Ill. 39, Pl. IX

LE FRUIT
c. 1897
Colour lithograph
60 x 36.5 cm
Signed *Mucha* bottom right
R
Ill. 40, Pl. VIII

LA POESIE
1898
Lithograph in twelve colours, gold
and silver
56 x 34 cm
Signed *Mucha* bottom right
On satin RR
Ill. 23, Pl. XXXIII

LA DANSE
1898
Lithograph in twelve colours, gold
and silver
56 x 34 cm
Signed *Mucha 98* bottom right
On satin RR
Ill. 24

LA PEINTURE
1898
Lithograph in twelve colours, gold
and silver
56 x 34 cm
Signed *Mucha 98* bottom left
On satin RR
Ill. 25

LA MUSIQUE
1898
Lithograph in twelve colours, gold
and silver
56 x 34 cm
Signed *Mucha 98* bottom right
On satin RR
Ill. 26

NENUPHAR
1898
Colour lithograph
21.5 x 29.5 cm
Signed *Mucha* bottom right
RR
On satin RRR
Ill. 14, Pl. VII

FLEUR DE CERISIER
1898
Colour lithograph
21.5 x 29.5 cm
Signed *Mucha 98* bottom left
RR
On satin RRR
Ill. 15, Pl. VII

GIRL WITH EASEL
1898
Colour lithograph
63.5 x 44.9 cm
Signed *Mucha* bottom left
RR
Ill. 27

LA PLUME
1899
Colour lithograph
71.5 x 27.5 cm
Signed *Mucha 99* bottom left
R
Ill. 16
Variant:
Without lettering Ill. 17, Pl. VI

PRIMEVERE
1899
Colour lithograph
71.5 x 27.5 cm
Signed *Mucha 99* bottom right
R
Ill. 18, Pl. VI

EVEIL DU MATIN
1899
Lithograph in twelve colours and gold
101.5 x 36.5 cm
Signed *Mucha 99* bottom right
Ill. 19, Pl. IV

ECLAT DU JOUR
1899
Lithograph in twelve colours and gold
101.5 x 36.5 cm
Signed *Mucha 99* bottom right
Ill. 20, Pl. IV

REVERIE DU SOIR
1899
Lithograph in twelve colours and gold
101.5 x 36.5 cm
Signed *Mucha 99* bottom right
Ill. 21, Pl. IV

REPOS DE LA NUIT
1899
Lithograph in twelve colours and gold
101.5 x 36.5 cm
Signed *Mucha 99* bottom right
Ill. 22, Pl. IV

AURORE
1899
Colour lithograph
68 x 103 cm
Signed *Mucha 99* bottom left
R
Ill. 31

CREPUSCULE
1899
Colour lithograph
68 x 103 cm
Signed *Mucha 99* bottom right
R
Ill. 34

TOPAZE
1900
Colour lithograph
99.5 x 36 cm
Signed *Mucha* bottom left
RR
Ills. 32,33
Small version:
60 x 24 cm
RRR

EMERAUDE
1900
Colour lithograph
99.5 x 36 cm
Signed *Mucha* bottom right
RR
Small version:
60 x 24 cm
RRR
Ill. 28, Pl. XI

AMETHYSTE
1900
Colour lithograph
99.5 x 36 cm
Signed *Mucha* bottom left
RR
Small version:
60 x 24 cm
RRR
Ill. 29, Pl. XI

RUBIS
1900
Colour lithograph
99.5 x 36 cm
Signed *Mucha* bottom right
RR
Small version:
60 x 24 cm
RRR
Ill. 30, Pl. XI

PRINTEMPS
1900
Colour lithograph
70 x 29.5 cm
Signed *Mucha 1900* bottom right
Ill. 45, Pl. III

LIERRE
1901
Colour lithograph
53 x 39.5 cm
Signed *Mucha 1901* bottom right
and *Mucha* centre right
R
Ill. 37, Pl. V

LAURIER
1901
Colour lithograph
Signed *Mucha 1901* bottom right
and *Mucha* centre right
R
Ill. 38

BRUYERE DE FALAISE
c. 1901
Colour lithograph
66.5 x 27.5 cm
Signed *Mucha* bottom right
On satin RR
Ill. 49, Pl. X

CHARDON DE GREVES
c. 1901
Colour lithograph
66.5 x 27.5 cm
Signed *Mucha* bottom right
On satin RR
Ill. 50, Pl. X

LA LUNE
1902
Colour lithograph
59 x 23.5 cm
Signed *Mucha* bottom left
RRR
Ill. 41

ETOILE DU SOIR
1902
Colour lithograph
59 x 23.5 cm
Signed *Mucha* bottom right
RRR
Ill. 42

ETOILE POLAIRE
1902
Colour lithograph
59 x 23.5 cm
Signed *Mucha* bottom left
RRR
Ill. 43

ETOILE DU MATIN
1902
Colour lithograph
59 x 23.5 cm
Signed *Mucha* bottom left
RRR
Ill. 44

ETE
1903
Colour lithograph
70 x 29.5 cm
Signed *Mucha 1903* bottom left
Ill. 46, Pl. III

AUTOMNE
c. 1903
Colour lithograph
70 x 29.5 cm
Signed *Mucha* bottom right
On satin RR
Ill. 47

HIVER
c. 1903
Colour lithograph
70 x 29.5 cm
Signed *Mucha* bottom left
Ill. 48

KOMENSKY SOCIETY
c. 1920
Lithograph
84 x 57 cm
Signed *Mucha* bottom right
Small version:
38 x 27 cm
Ill. 51

POSTERS

GISMONDA
1894
Colour lithograph: pink, yellow,
green, blue, gold
213 x 75 cm
Signed *Mucha* bottom left
Printed by Lemercier, Paris
Also published as plate 27 of *Les
Maîtres de l'Affiche,* 36 x 14 cm,
1896
R
Ill. 52, Pl. XII

PAPETERIE
c. 1894
Lithograph in red-brown
36 x 26 cm
Unsigned
Printed by Lemercier, Paris
Ill. 53

AMANTS
1895
Colour lithograph: blue, red, gold,
brown
99 x 130 cm
Unsigned
Printed by Affiches Camis, Paris
RRR
Ill. 54

LANCE PARFUM "RODO"
1896
Colour lithograph
42.5 x 41.5 cm
Signed *Mucha* bottom right
Printed by F. Champenois, Paris
RR
Ill. 55

SAVON DE NOTRE DAME
c. 1896
Colour lithograph: red, yellow,
blue
53 x 37 cm
Signed *Mucha* bottom right
Printed by F. Champenois, Paris
RRR
Ill. 56

JOB CIGARETTE PAPERS
1896
Colour lithograph: red, beige,
olive-green, violet, black, gold
51.5 x 39 cm
Printed by F. Champenois, Paris
Also published as plate 202 of
Les Maîtres de l'Affiche
Ill. 57, Pl. XV
Variant:
Calendar

SALON DES CENT
XXme Exposition
1896
Colour lithograph: red, yellow,
green, ochre, gold
61.5 x 40 cm
Signed *Mucha* bottom left
Printed by F. Champenois, Paris
Also published as plate 94 of *Les
Maîtres de l'Affiche,* 33 x 34 cm
1897
Ill. 58, Pl. XIV
Variant:
Cover of exhibition catalogue

BENEDICTINE
1896
Colour lithograph: red, yellow,
brown, blue
200 x 68 cm
Signed *Mucha* bottom right
Printed by F. Champenois, Paris
Ill. 59

REVUE POUR LES JENUES
FILLES
1896
Lithograph
123 x 49 cm
Signed *Mucha* centre left
Printed by F. Champenois, Paris
Ill. 60
Variant:
Without lettering

LORENZACCIO
1896
Colour lithograph: red, olive-green,
ochre, brown, gold
195.5 x 70 cm
Signed *Mucha* bottom right
Printed by F. Champenois, Paris
R
Also published as plate 114 of *Les
Maîtres de l'Affiche,* 35.5 x 14 cm
1898
Ill. 61, Pl. XIII

LA DAME AUX CAMELIAS
1896
Colour lithograph: olive-green,
ochre, sepia, red, silver
201.5 x 69.5 cm
Signed *Mucha* bottom left
Printed by F. Champenois, Paris
RR
Ill. 62, Pl. XII
Variant:
Farewell American Tour
Printed in U.S.A. in 1906 with
different colours.
Ill. 63. Pl. XVI
Also published as plate 144 of *Les
Maîtres de l'Affiche,* 35 x 14 cm
1898

LA SAMARITAINE
1897
Colour lithograph: red, olive-green,
turquoise, ochre, gold
167 x 54 cm
Signed *Mucha* bottom right
Printed by F. Champenois, Paris
R
Also published as plate 166 of *Les
Maîtres de l'Affiche,* 37 x 14 cm,
1899, and as plate 19 of *La Décor-
ation,* Vol. 1. No. 8.
Ill. 64, Pl. XIII

SARAH BERNHARDT
La Plume du 15 Decembre publiera
un article sur Sarah Bernhardt
1897
Colour lithograph: red, blue
violet, brown, black, gold
62.5x40.5 cm
Signed *Mucha* bottom left
Printed by F. Champenois, Paris
Ill. 65
Variants:
With alternative lettering:
*En l'honneur de Sarah Bernhardt ses
admirateurs et ses amis.* Also without
lettering (RR). Also issued as a colour
postcard. Pl. XXXII

LA TRAPPISTINE
1897
Colour lithograph: vermilion, red,
beige, olive-green, light blue, ochre
201 x 70 cm
Signed *Mucha* bottom right.
Printed by F. Champenois, Paris
Ill. 66

COURS MUCHA
1897
Colour lithograph: olive-green,
brown, gold, on green paper
64 x 27 cm
Signed *Mucha* centre right
Printed by F. Champenois, Paris
RR
Ill. 67

SALON DES CENT
Exposition de l'Oeuvre de A. Mucha
1897
Colour lithograph: pink, green,
violet, ochre
63.5 x 43 cm
Signed *Mucha* bottom right
Printed by F. Champenois, Paris
R
Ill. 72

**SOCIETE POPULAIRE DES
BEAUX-ARTS**
1897
Colour lithograph: vermilion, red,
yellow, grey, black, gold
58 x 42 cm
Signed *Mucha* bottom right
Printed by F. Champenois, Paris
R
Ill. 69

MONACO-MONTE CARLO
1897
Colour lithograph: red, olive-green,
turquoise, violet, ochre, brown, grey
110 x 76 cm
Signed *Mucha 1897* bottom left
Printed by F. Champenois, Paris
Ill. 70

BIERES DE LA MEUSE
c. 1897
Colour lithograph: red, yellow,
olive-green, green, blue, ochre
154 x 107 cm
Signed *Mucha* bottom left
Printed by F. Champenois, Paris
Ill. 68
Variants:
Without lettering, Ill. 71

Also in smaller size 123 x 88.5 cm
RR
Also published as plate 182 of *Les
Maîtres de l'Affiche,* 32 x 22 cm
1899

CHAMPAGNE RUINART
1897
Colour lithograph: red, green, brown,
grey
173 x 59 cm
Signed *Mucha* bottom right
Printed by F. Champenois, Paris
Ill. 73

**HOMMAGE RESPECTUEUX
DE NESTLE**
1897
Colour lithograph: red, yellow,
green, blue, ochre, black, gold
199.5 x 298 cm
Signed *Mucha* bottom right
Printed by F. Champenois, Paris
RRR
Ill. 75

IMPRIMERIE CASSAN FILS
1897
Colour lithograph: red, olive-green,
blue, ochre, sepia
166 x 59.5 cm
Signed *Mucha* bottom left
Printed by Cassan Fils, Toulouse
R
Ill. 74
Variant:
Small Version RRR

WAVERLEY CYCLES
1897
Colour lithograph
98 x 101 cm
Signed *Mucha* bottom right
Printed by F. Champenois, Paris
RR
Ill. 76

CYCLES PERFECTA
c. 1897
Colour lithograph
150 x 105 cm*
Signed *Mucha* bottom right
Printed by F. Champenois, Paris
RRR
Ill. 77

BLEU DESCHAMPS
EN VENTE ICI
c. 1897
Colour lithograph on satin: blue,
yellow, brown, red
35 x 25 cm
Signed *Mucha* bottom left
Printed by F. Champenois, Paris
RRR
Ill. 78

BLEU DESCHAMPS
c. 1897
Colour lithograph on satin: blue,
grey, gold, red, green, yellow
50.5 x 33.5 cm
Signed *Mucha* centre right
Printed by F. Champenois, Paris
RRR
Ill. 79

MEDEE
1898
Colour lithograph: vermilion,
yellow, olive-green, blue, ochre,
gold
199 x 69 cm
Signed *Mucha 98* bottom left
Printed by F. Champenois, Paris
R
Ill. 80
Also published as Plate 19 of
La Décoration, Vol. 1. No. 8.

NESTLE'S FOOD FOR INFANTS
1898
Colour lithograph
74 x 33 cm
Signed *Mucha* bottom left
Printed by F. Champenois, Paris
RR
Ill. 81

THE WEST END REVIEW
1898
Colour lithograph: vermilion, red
yellow, olive-green, blue, black
286 x 205.5 cm
Unsigned
Printed by Lemercier, Paris
RRR
Ill. 83

JOB CIGARETTE PAPERS
1898
Colour lithograph: red, yellow,
olive-green, turquoise, grey, black
138.5 x 92.5 cm
Signed *Mucha* bottom left
Printed by F. Champenois, Paris
Ill. 82, Pl. XVI

MOET & CHANDON
WHITE STAR
1899
Colour lithograph
58 x 19.5 cm
Signed *Mucha* bottom left
Printed by F. Champenois, Paris
RR
Ill. 84

MOET & CHANDON
IMPERIAL
1899
Colour lithograph: red, yellow,
blue, ochre, brown
58 x 19.5 cm
Signed *Mucha 99* bottom left
Printed by F. Champenois, Paris
R
Ill. 85, Pl. XVII

VIN DES INCAS
c. 1899
Colour lithograph: red, yellow,
olive-green, blue, ochre
74.5 x 191.5 cm
Signed *Mucha* bottom right
Printed by F. Champenois, Paris
Variant:
Small version, 36 x 14 cm
Ill. 86, Pl. XVI

NECTAR
1899
Colour lithograph: vermilion,
yellow, olive-green, blue, brown,
grey
64 x 26 cm*
Signed *Mucha* bottom right
Printed by Librairie Centrale des
Beaux Arts
Ill. 87, Pl. XVII

HAMLET
1899
Colour lithograph: red, olive-green,
blue, ochre, gold
196.5 x 67.5 cm
Signed *Mucha 99* bottom left
Printed by F. Champenois, Paris
R
Ill. 88, Pl. XXXIII

LA TOSCA
1899
Colour lithograph: pink, yellow,
olive-green, blue, gold
102 x 38 cm
Signed *Mucha 99* bottom left
Printed by F. Champenois, Paris
RR
Ill. 89

OESTERREICH AUF DER WELT-
AUSSTELLUNG PARIS 1900
1900
Colour lithograph: vermilion,
olive-green, ochre, black, gold
96 x 63 cm
Signed *Mucha/Paris* bottom left
Printed by S. Czetger, Vienna
The left half of the poster was also
published separately
Ill. 91

LYGIE
1901
Colour lithograph
174 x 58 cm
Signed *Mucha 1901* bottom left
Printed by F. Champenois, Paris
RRR
Ill. 90
Also issued as a colour postcard
Pl. XXXIV

VYSTAVA VE VYSKOVE
Exhibition of Agriculture, Industry
and Ethnology at Vyskov
1902
Colour lithograph: red, yellow,
blue, black, gold
115 x 50 cm
Signed *Mucha Paris 1902* bottom left
Printed by Unie, Prague
RR
Ill. 92

VYSTAVA V HORICICH
Exhibition of Agriculture, Industry
and Art at Horice
1903
Colour lithograph: pink, vermilion,
orange, beige, olive-green, grey, black
149 x 56 cm
Signed *Mucha 03* bottom right
Printed by Unie, Prague
RR
Ill. 93

EXPOSITION UNIVERSELLE &
INTERNATIONALE DE ST. LOUIS
1904
Colour lithograph
105 x 77 cm*
Signed *Mucha 1904* bottom right
Printed by F. Champenois, Paris
R
Ill. 94

LA PASSION
1904
Lithograph printed on two sheets
225 x 70 cm
Signed *Mucha* bottom left
Printer unknown
RR
Ill. 95

RUDOLF FRIML
c. 1905
Colour lithograph: red, green, black,
Dimensions unknown
Signed *Mucha* bottom right
Printer unknown
RRR
Ill. 96

FAREWELL AMERICAN TOUR
1906
Colour lithograph
Variant of *La Dame aux Camélias*
Ill. 63, Pl. XVI

INSURANCE BANK SLAVIA
1907
Colour lithograph: red, yellow,
blue, brown
55 x 36 cm
Signed *Mucha 1907* bottom centre
Printed by J. Stenc, Prague
Ill. 97
Variants:
Smaller size, 48 x 30 cm. Basic
design used in several other graphics.
Also issued as a colour postcard
Pl. XXXV

LESLIE CARTER
1908
Colour lithograph: blue, violet,
yellow, red
202.5 x 69 cm
Signed *Mucha* bottom right
Printed in U.S.A.
RR
Ill. 98

DOCUMENTS DECORATIFS
Vient de Paraître
1901
Colour lithograph: red-brown, black
70 x 40.5 cm
Signed *Mucha* centre
Printed by Librairie Centrale des
Beaux Arts
Ill. 99, Pl. XXXVII

PEVECKE SDRUZENI UCITELU
MORAVSKYCH
(Moravian Teachers Choir)
1911
Colour lithograph: red, beige,
yellow, olive-green, blue, brown, black
105.5 x 77 cm
Signed *Mucha 1911* bottom left
Printed by V. Neubert, Prague
RRR
Ill. 100

PRINCESS HYACINTH
1911
Colour lithograph: red, olive-green,
turquoise, ochre, black, silver
117.5 x 78.5 cm
Signed *Mucha 11* bottom left
Printed by V. Neubert, Prague
RR
Ill. 101, Pl. XVIII

LOTERIE NARODNI JEDNOTY
(Lottery of the Union of South-
Western Moravia)
1912
Colour lithograph: vermilion, red,
yellow, ochre, brown, grey, black
170 x 94 cm
Signed *Mucha 1912* bottom right
Printed by V. Neubert, Prague
R
Ill. 102

VI SLET VSESOKOLSKY 1912
(VI Sokol Festival 1912)
1912
Colour lithograph: red, yellow,
green, black, silver
166 x 82 cm
Signed *Mucha 1912* bottom right
Printed by V. Neubert, Prague
Ill. 105
Variant:
With Russian text at the bottom
Ill. 106
RRR

KRAJINSKA VYSTAVA V
IVANCICICH
(Regional Exposition at Ivancice)
1913
Colour lithograph: vermilion, red,
green, light blue, ochre, grey, black,
silver
89.5 x 48.5 cm
Signed *Mucha 12* bottom left
Printed by V. Neubert, Prague
Ill. 103
Also issued as a colour postcard
Pl. XL

ZDENKA CERNY
1913
Colour lithograph: beige, olive-
green, violet, ochre
102 x 104 cm
Signed *Mucha 1913* bottom left
Printed by V. Neubert, Prague
RR
Ill. 108

JARNI SLAVNOSTI
(Spring Festival of Song and Music
in Prague)
1914
Colour lithograph: vermilion, beige,
yellow, green, turquoise, purple,
brown, silver
143 x 71 cm
Signed *Mucha 1914* bottom right
Printed by V. Neubert, Prague
RRR
Also issued as a colour postcard
Ill 107, Pl. XXXV

SOKOL LOTTERY
1916
Black and white lithograph
87 x 34.5 cm
Signed *Mucha 1916* centre right
Printer unknown
RRR
Ill. 104

MUCHA EXHIBITION
Brooklyn Museum
1921
Colour lithograph: green, red, brown
45 x 30 cm
Signed *Mucha* centre left
Printed in U.S.A.
RR
Ill. 109

Y.W.C.A.
c. 1922
Colour lithograph: pink, yellow,
blue, gold
66.5 x 37.5 cm
Signed *Mucha* bottom right
Printed by V. Neubert, Prague
RRR
Ill. 110
Variant:
Small version, 25 x 14.5 cm
Also issued as a colour postcard
Pl. XXXV

RUSSIA RESTITUENDA
1922
Colour lithograph: red-brown,
green, blue, ochre, black
76 x 43.5 cm
Signed *Mucha* bottom right
Printed by Melantrich, Prague
Variant:
Small version, 50 x 28.5 cm
Ill. 111

VIII SLET VSESOKOLSKY 1926
(VIII Sokol Festival 1926)
1925
Colour lithograph: vermilion, yellow,
olive-green, blue, gold
176.5 x 78.5 cm
Signed *Mucha 25* bottom right
Printed by J. Ziegloser, Prague
Ill. 112
Also issued as a colour postcard
Pl. XXXV

DE FOREST PHONOFILM
1927
Colour lithograph: vermilion, red,
beige, yellow, green, turquoise, gold
146 x 66 cm
Signed *Mucha 27* bottom left
Printed by V. Neubert, Prague
Poster for the first sound film
in Prague
RRR
Ill. 113

SLAV EPIC
(text only)
1928
Colour lithograph: red, olive-green,
gold
66 x 89 cm
Unsigned
Printed by V. Neubert, Prague
Poster for the first Prague exhi-
bition of the Slav Epic
Ill. 114

SLAV EPIC
(with text)
1928
Colour lithograph: vermilion,
yellow, green, blue, turquoise,
brown, gold
140 x 89 cm; text: 76 x 55 cm
Signed *Mucha 28* bottom right
Printed by V. Neubert, Prague
Ills. 115, 116
Variant:
Small version, 118 x 76 cm
Poster for the first public exhi-
bition of the Slav Epic
Illustration and text were published
both separately and together
Also issued as a colour postcard
Pl. XXXV

KRINOGEN
c. 1928
Print taken from India ink
drawing
44.5 x 44.5 cm
Unsigned
Printed by V. Neubert, Prague
Ill. 117
RRR

DENTIFRICES DES
BENEDICTINS DE SOULAC
Listed as No. 52 in the *Salon des
Cent* exhibition catalogue
No other information available
Ill. 118

"1918-1928"
1928
Colour lithograph: red, yellow,
olive-green, dark green, blue,
ochre, gold
116.5 x 78.5 cm
Signed *Mucha* bottom right
Printed by K. Kriz, Prague
R
Ill. 119

MEZINARODNI VYSTAVA
SLEPECKEHO TISKU
(International exhibition of Braille
printing)
1935
Colour lithograph
49.5 x 34 cm
Signed *Mucha* bottom left

DIK SLEPCU
(Thanks of the Blind)
c. 1935
Colour lithograph
24 x 12 cm
Signed *Mucha* bottom left
Ill. 120

BISCUITS CHAMPAGNE
Listed as No. 32 in the *Salon des
Cent* exhibition catalogue
No other information available

CALENDARS

CHARLES LORILLEUX ET CIE
1892
Lithograph in blue, 12 leaves
24 x 19.5 cm
Signed *Mucha* bottom left (each)
Ills. 121, 122, 123
Variants:
Minor variations for successive years

PERPETUAL CALENDAR FOR L'IMPRIMERIE VIEILLEMARD ET FILS
c. 1894
Listed as No. 61 bis in the *Salon des Cent* exhibition catalogue
No other information available
Ill. 134

CHOCOLAT MASSON CHOCOLAT MEXICAIN
1895-1900
Colour lithograph
42.5 x 58 cm
Signed *Mucha* bottom right
Printed by F. Champenois, Paris
Ill. 125
Variants:
Les Calendriers des Saisons without advertising lettering in top panels or at foot of illustrations. Also without lettering and with calendar part cut off. Also as four separate panels, same size.
Pl. XIX

CHAMPENOIS (REVERIE)
1896
Colour lithograph
64 x 47.5 cm
Signed *Mucha* bottom right
Printed by F. Champenois, Paris
Ill. 128
Variants:
With lettering in centre panel above.
Also panneau Ill. 1

CHAMPENOIS (ZODIAC)
1896
Colour lithograph
63 x 47 cm
Signed *Mucha* bottom right
Printed by F. Champenois, Paris
Ill. 129, Pl. XXVII
Variants:
Pannueau Ill. 2
Calendar for *La Plume* Ill. 131
Central figure enlarged also issued as calendar for Savon de Bagnolet (RR) Ill. 130

CALENDRIER MAGGIE
c. 1897
For preliminary design see *Alphonse Mucha Posters and Photographs* p. 118
No other information available

JOB CALENDARS
1896-97
Colour lithographs
Signed *Mucha* bottom right
Printed by F. Champenois, Paris
Variants:
Posters Ill. 57
Also issued as a colour postcard
Pl. XXXVII

L'ANNEE QUI VIENT
1897
Colour lithograph
94.5 x 33 cm
Signed *Mucha 97* bottom right
Printed by F. Champenois, Paris
Ill. 132
Variants:
Panneau Ill. 133
Also without lettering

CHOCOLAT MASSON CHOCOLAT MEXICAIN
1897-98
Colour lithographs, four sheets
92 x 21 cm (each sheet)
Signed *Mucha* centre left
Printed by F. Champenois, Paris
Ill. 127
See postcards for all four illustrations of the centre panel: *Childhood, Adolescence, Manhood, Old Age*
Pl. XIX

BISCUITS LEFEVRE-UTILE
1897
Colour lithograph
60.5 x 43 cm
Signed *Mucha* bottom left
Printed by F. Champenois, Paris
Ill. 126

F. GUILLOT-PELLETIER ORLEANS
1898
Colour lithograph
34 x 52 cm
Signed *Mucha* bottom left
Printed by F. Champenois, Paris
Ill. 124, Pl. XXVII

MENUS

MENU FOR BRASSERIE SEPTANT
c. 1894
Colour lithograph
31 x 23 cm
Unsigned
Printed by Lemercier, Paris
RR
Ill. 136

SET OF FOUR MENUS
Printemps, Eté, Automne, Hiver
Colour lithographs
Printed by F. Champenois, Paris
Ill. 138
Variants:
Panneaux Ills. 3 - 6, Pl. II

MENU FOR SARAH BERNHARDT'S 50TH BIRTHDAY
1896
Lithograph
28.5 x 19.5 cm
Signed *Mucha* bottom right
Printed by F. Champenois, Paris
RR
Ill. 137

SET OF FOUR MENUS
Iris, Lys, Rose, Oeillet
Colour lithographs
Printed by F. Champenois, Paris
Ill. 139
Variants:
Panneaux Ills. 10 - 13, Pl. IV

MENUS FOR MOET & CHANDON
Set of ten cards with envelope
c.1897
Colour lithographs
Card size: 14 x 9 cm
Unsigned
Printed by F. Champenois, Paris
RR
Ills. 143-153, Pl. XXIX-XXXI

MENU FOR LA SOCIETE DE BIENFAISANCE AUSTRO-HONGROISE
1898
Engraving made from a pen and ink drawing
24.5 x 17 cm
Signed *Mucha* bottom right
Also used for a programme cover
RR
Ill. 135
Also issued as a colour postcard
Pl. XXXVIII

MENU FOR A BANQUET
In honour of Mrs. de Monthalen and Maurice Monthiers
1898
Engraving taken from pen and ink drawing
25.5 x 14 cm
Signed *Mucha* bottom right
Printed by F. Champenois, Paris
Ill. 142, Pl. XXXVIII

SET OF FOUR MENUS
c. 1900
Monochrome lithographs
Printed by F. Champenois, Paris
Ill. 141
Also issued as colour postcards
Pl. XXXVIII

MENU FOR LAMALOU LES BAINS
1903
Lithograph in blue
28.5 x 13.5 cm*
Signed *Mucha 1903* bottom left
Printer unknown
On Satin RR
Ill. 140

POSTCARDS

A. Printed in 1898 by Cinos, Paris
Colour lithographs
Size of card: 14 x 9 cm

SARAH BERNHARDT POSTERS
Set of four cards:
Gismonda, Lorenzaccio, La Dame aux Camélias, La Samaritaine
Variants of posters Ills.52, 61, 62, 64, Pl. XII, XIII

B. Printed by F. Champenois, Paris
Size of card: 14 x 9 cm

JOB CALENDAR 1897
Colour lithograph
Variant of poster
Also issued as a postcard in 1911 probably by another printer together with a variant of the *Job* poster of 1898
Pl. XXXVII

SET OF TEN CARDS FOR MOET & CHANDON
Colour lithographs
Printed 1900
See menus Ills. 143-153
Pl. XXX, XXXI

COCORICO
Two-colour lithograph
Printed 1900
Pl. XXXVII
Variant of periodical cover Ill. 173

C. Printed 1900-1901 by F. Champenois, Paris
These postcards were issued in numbered series (sets of 12 in a folder). At least seven series were issued.
Colour lithographs
Size of card: 14 x 9 cm

CARTES POSTALES ARTISTIQUES 1ERE SERIE 1900

Printemps, Eté, Automne, Hiver
Variants of panneaux Ills. 3-6, Pl. II

Iris, Oeillet, Lys, Rose
Variants of panneaux Ills. 10-13, Pl. IV

Childhood, Adolescence, Manhood, Old Age
Pl. XIX
Variants of calendars Ill. 127

CARTES POSTALES ARTISTIQUES 2ME SERIE 1900

Tête Byzantine-Blonde,
Tête Byzantine-Brunette
Pl. XI
Variants of panneaux Ills. 35, 36

Set of four Seasons
Variants of calendars Ill. 125, Pl. XIX

La Poésie, La Musique, La Danse,
La Peinture
Variants of panneaux Ills. 23-26,
Pl. XXXIII

Rêverie, Zodiac
Variants of panneaux Ills. 18, 2, Pl. I

CARTES POSTALES ARTISTIQUES
3ME SERIE 1900

Three Vignettes
Pl. XXXVII

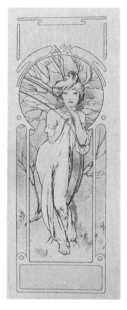 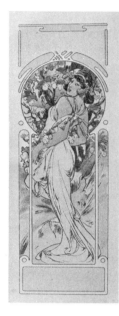

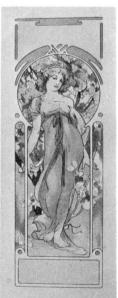 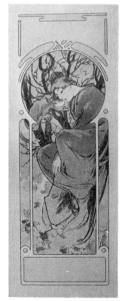

Printemps, Ete, Automne, Hiver
A series of seasons only published as
postcards

Salomé
Pl. XXXVII
Variant of the lithograph in
L'Estampe Moderne, Ill. 167

Crépuscule, Aurore
Variants of panneaux Ills. 31, 34

Primevère, La Plume
Variants of panneaux Ills. 18, 16, Pl. III

CARTES POSTALES ARTISTIQUES
4ME SERIE 1900
Janvier, Février, Mars, Avril, Mai, Juin,
Juillet, Août, Septembre, Octobre,
Novembre, Décembre
Pl. XXXVII
Variants
with several minor alterations
First published as monochrome
lithographs in *Le Mois.* See Periodicals.

CARTES POSTALES ARTISTIQUES
5ME SERIE 1900

Sarah Bernhardt, from "La Plume"
Pl. XXXII
Variant: without lettering
See also panneau Ill. 16

Bienfaisance Austro-Hongroise
Variant of menu Ill. 135 without
lettering
Pl. XXXVIII

Three covers for "Cocorico"
Pl. XXXVII
Colour variants of the periodical covers

Design for the Menu for a Banquet in
honour of Mrs. de Monthalen and
Maurice Monthiers
Pl. XXXVIII
Variant of menu Ill. 142

Set of four designs for Menus
Pl. XXXVIII
Colour variants of the menus Ill. 141

Design for a fan
Pl. XXXVIII
Variant of Ill. 165

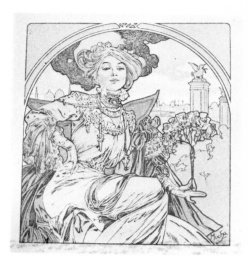

Paris 1900
Colour variant of catalogue cover
Pl. XXVIII

CARTES POSTALES ARTISTIQUES
6ME SERIE 1901

Design for a Calendar
Pl. XXXVIII

Eveil du Matin, Eclat du Jour,
Rêverie du Soir, Repos de la Nuit
Variants of panneaux Ills. 19-22, Pl. IV

Rêverie
Ill. 128
Variant of panneau Ill. 1, Pl. 1
Design for a soirée programme
Variant of cover Ill. 156

Papeterie
Colour variant of poster Ill. 53

Printemps
Variant of panneau Ill. 45, Pl. III

Girl with Pen
Pl. XXXIV
Colour variant of *L'Estampe Moderne*
cover

Nénuphar, Fleur de Cérisier
Variants of panneaux Ills. 14, 15, Pl. VII

CARTES POSTALES ARTISTIQUES
7ME SERIE (?) 1901

Automne
Variant of panneau Ill. 47

Bruyère de falaise, Chardon de Greves
Variants of panneaux Ills. 49, 50, Pl. IX

Lierre, Laurier
Variants of panneaux Ills. 37, 38, Pl. V

Lygie
Pl. XXXIV
Variant of poster Ill. 90

Topaze, Emeraude, Améthyste, Rubis
Variants of panneaux Ills. 28-30, 32, XI
33, Pl. XI.
La Fleur, Le Fruit
Variants of panneaux Ills. 39, 40, Pl. VIII, IX

D. Postcards printed in Czechoslovakia after 1902
The following list gives only a partial selection of postcards printed during this period.

VYSTAVA VE VYSKOVE
Exhibition of Agriculture, Industry
and Ethnology at Vyskov
Card in colour
1902
Printed by Jan Hona, Vyskov
Signed *Mucha Paris 1902* bottom left
Variant of poster Ill. 92

INSURANCE BANK SLAVIA
Card in colour
1909
Printed by Stenc, Prague
Signed *Mucha 1909* bottom centre
Pl. XXXV
Variant of poster Ill. 97

JOSEPHINE CRANE AS SLAVIA
Card in colour
1909
Printed in U.S.A.
Signed *A.M. Mucha 1909* bottom right
Pl. XL

THE BEATITUDES
Set of nine(?) cards in colour
First published in a New York periodical.
Printed by L. Novotny, Prague
Signed *Mucha* bottom left or right
Pl. XXXV

STUDENTS FAIR
Card printed in black and gold
1909
Printed by Politika, Prague
Variant:
Also used as a programme for a dance
Signed *Mucha* bottom right

MEMORY OF NATIVE IVANICE
Card in three colours
1909
Printed by Navratil, Ivanice
Signed *Mucha* bottom right

MURALS FOR THE LORD MAYOR'S HALL
Prague municipal building, murals painted by
Mucha
Set of fifteen cards in colour
1912
Printed by L. Novotny, Prague
Unsigned
Pl. XXXV, XL

BOHEMIAN HEART CHARITY
Card in colour
1912
Printed by Politika, Prague
Unsigned
Pl. XXXV

KRAJINSKA VYSTAVA V IVANCICICH
Regional exhibition at Ivanice
Card in colour
c. 1912
Printed by Neubert, Prague
Signed *Mucha 1912* bottom left
Pl. XL
Variant of poster Ill. 103

JARNI SLAVNOSTI
Card in colour
c. 1914
Printed by Neubert, Prague
Signed *Mucha* bottom right
Pl. XXXV
Variant of poster Ill. 107

DEFENCE OF NATIONAL MINORITIES
Card in colour
1915
Printed in Prague
Signed *Mucha* bottom left

KOMENSKY SOCIETY
Card in black and white
c. 1920
Printed in Prague
Signed *Mucha* bottom right
Variant of panneau Ill. 51

RUSSIA RESTITUENDA
Card in monochrome
c. 1922
Printed by Neubert, Prague
Unsigned
Variant of poster Ill. 111

Y.W.C.A.
Card in colour
c. 1922
Printed by Neubert, Prague
Signed *Mucha* bottom right
Pl. XXXV
Variant of poster Ill. 110

VIII SLET VSESOKOLSKY
VIII Sokol Festival
Card in colour
1926
Printed by Jan Ziegloser, Prague
Signed *Mucha* bottom right
Pl. XXXV
Variant of poster Ill. 122

THE SLAV EPIC
Set of ten cards in colour
1928
Printed by Neubert, Prague
Unsigned
Pl. XXXV
Variant of poster Ill. 116

SPOLEK PRO PECI O SIROTKY
(Orphans charity)
1928
Card in three colours
Printed in Prague
Variants:
Membership card for the organisation.
Also charity stamp.
Signed *Mucha* bottom right

EMMAHOF CASTLE
Card in black and white from an
original drawing by Mucha
1931
Signed *Mucha* bottom right

NATIVITY
Card in colour
1934
Printed by Pece o mladez, Prague
Signed *Mucha* bottom left

FIFTY YEARS OF IVANICE
SOKOL ORGANISATION
1937
Card in black and white
Printed by Navratil, Ivanice
Unsigned

DIK SLEPCU
(Thanks of the blind)
c.1939
Printed in Prague
Signed *1933 Mucha* bottom left
Variant of poster Ill. 120

DVACATY VEK
(The 20th Century)
Card in black and white
Printed in Prague
Originally used as a magazine cover
Signed *Mucha* bottom right
Variants:
La Revue du Bien, card in black and
white, printed in Paris. Also used as a
magazine cover.

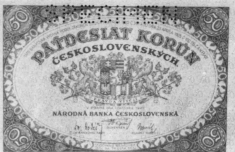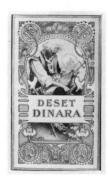

MISCELLANEOUS

CHRISTMAS PARTY INVITATION
from Sarah Bernhardt's grand-children
1896
Lithograph
13 x 18.5 cm
Signed *Mucha* bottom left
Printed by F. Champenois, Paris
RRR
Ill. 155

COURS MUCHA
Prospectus for Académie Colarossi,
Paris
c. 1896
9 x 6.5 cm
Unsigned
Printer unknown
RR
Ill. 158

LE BAL DES QUAT'Z' ARTS
Invitation
1897
Lithograph
Signed *Mucha* bottom left
Printer unknown
RRR
Ill. 157

SOIREE MUSICALE INVITATION
From Alphonse Mucha
1897
Print taken from a pen and ink
drawing
11.5 x 14.5 cm
Signed *Mucha* bottom left
Printed by F. Champenois, Paris
RRR
Ill. 156

ATELIER MUCHA
Prospectus
c. 1897
Print taken from India ink drawing
22.5 x 16 cm
Signed *Mucha* centre
R
Ill. 159

CHAMPENOIS CATALOGUE
Cover
c. 1899
Signed *Mucha* bottom centre
Printed by F. Champenois, Paris
Variant:
Reprinted as a frontispiece for the
catalogue for the Mucha exhibition
at Brno, 1936
Ill. 154

WERTHER
Programme cover
1903
Lithograph in brown
25.5 x 16.5 cm
Signed *Mucha* bottom left
R
Ill. 160

COURS MUCHA
Prospectus for the New York School
of Applied Design for Women
1905
Front cover: 8 x 8 cm
Signed *Mucha* bottom centre
Back cover: 6.5 x 6.5 cm
Signed *Mucha* bottom centre
Printed in U.S.A.
RR
Ill. 162

SAVON MUCHA
Box and set of four wrappers
1906
Colour lithograph
31 x 18 cm
Signed *Mucha* and once *Mucha 1906*
bottom right
Ill. 163
Variant:
The four wrappers in an ornamental
frame
1906
42 x 61.5 cm
RR
Ill. 161, Pl. XXXIII

LESLIE CARTER
Programme cover
1908
Colour lithograph
31 x 34.5 cm
Signed *Mucha* bottom centre
Printed in U.S.A.
Pl. XXXIV
Variant:
Central panel design used for
poster
Ill. 98

STUDENTS FAIR
Programme cover
1909
Printed by Politika, Prague
Signed *Mucha* bottom right

FETE FRANCO-TCHEQUE
Programme cover
1909
16 x 10 cm
Printer unknown

SPOLEK PRO PECI O SIROTKY
(Orphans charity)
1928
Membership card in three colours
Printed in Prague
Signed *Mucha* bottom right

LA PRINCESSE LOINTAINE
Sarah Bernhardt
c. 1895
No other information available

DESIGN FOR FAN
Le vent qui passe emporte la jeunesse
1899
Colour lithograph
26 x 16 cm
Signed *Mucha* centre left
Also issued as a colour postcard
Ill. 165, Pl. XXXVIII

THE KISS OF SPRING
(Spring awakening sleeping Nature)
1919
Lithograph
Signed *Mucha 1919* bottom left
Printer unknown
Ill. 164

BANK-NOTES

Between 1919 and 1929 Mucha
designed several bank-notes for
the new Czechoslovak state:
Some of the notes printed in
Prague, e.g. the first 100 crown
note, were too easy to forge, and
were withdrawn. Mucha's daughter
is the model for the girl on the
ten and fifty crown notes. The
hundred crown note incorporates
Josephine Crane as Slavia (see
Postcard Pl. XL)

One crown note
Designed 1919, Prague

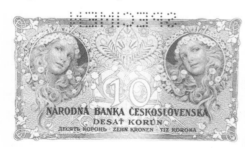

Ten crown note
First issued February 1920
Withdrawn May 1944
Two variants

Twenty crown note
Issued 1920

Fifty crown note
Issued 1931
Withdrawn early 1945

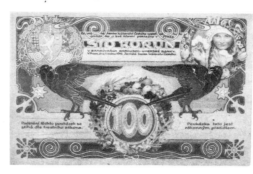

Hundred crown note
(grey-blue)
Issued July 1919
Withdrawn January 1921
RR
Variant: Hundred crown note
("green")
Issued in 1921

Five hundred crown note
First issued 1919
Two variants

Mucha also designed bank-notes
for Bulgaria and Yugoslavia:

Fifty leva note
(Bulgaria)

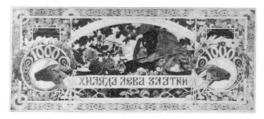

One thousand leva note
(Bulgaria)

Ten dina note
(Yugoslavia)

POSTAGE STAMPS

Mucha designed a series of the
first Czechoslovak stamp towards
the end of the first World War,
when Czechoslovakia was still part
of the Austro-Hungarian Empire.
Some of the stamps were issued

in vast quantities, there were, for
example, three and a half thous-
and million copies made of the
5h newspaper stamp. Several of
the stamps were also over-printed
for special delivery and postage
dues. For full information see
"Katalog Znamek-Ceskoslovensko"
(Postovni filatelisticka, Sluzba-Praha)
100 h=100 haleru=1 crown=1 kc

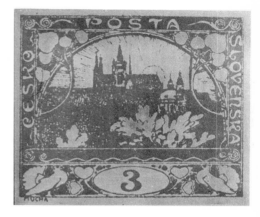

HRADCANY
Design: Hradcany castle (seat of
the Czech kings in Prague) in
silhouette, with the rising sun in
the background and the church
of St. Vitus in the foreground.
Several variations were made to
the original design.

5h, 10h issued 18.12.1918
3h, 20h, 25h issued 12.1918

The series of 28 stamps from
1h-1000h was completed in 1920

HUSITA
Design: A Hussite priest holding
a chalice in his hand. It was
badly printed and soon recalled
due to opposition from the
Catholic Church.

80h issued 1.6.1920
90h issued 10.6.1920

ZNAMKY SPESNE
(Express printed matter)
Design: Two doves

2h, 5h, 10h issued 1919/1920

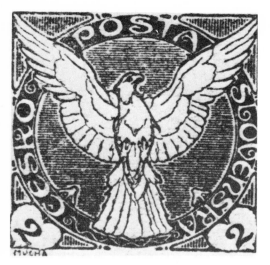

ZNAMKY NOVINOVE
(Newspaper stamp)
Design: Falcon in flight

2h, 5h, 6h, 20h, 30h, 50h,
100h issued between 1918 and
1920

ZNAMKY DOPLATNI
(Excess Postage)
Design: decoration based on
linden leaves.
14 denominations from 5h to
2000h issued 1919/20.

*30 LET CESKOSLOVENSKE
POSTOVNI ZNAMKY*
10 kcs 1948 to commemorate
the 50th anniversary of the
Hradcany stamp. Souvenir sheet
designed by J. Schmidt, incor-
porating a re-engraving of the
Hradcany stamp.

DEN CS. ZNAMKY
60h 1960 special stamp to
commemorate the centenary of
Mucha's birth. Design by
M. Svabinsky incorporates a
portrait of Mucha. Also a first
day cover reproducing one of
the Sarah Bernhardt posters.

STAMPS ISSUED AFTER 1968
These stamps incorporate designs from
Mucha's Panneaux:

Princesna Hyacinta
60 crown stamp issued 1969

La Danse
1 crown stamp issued 1969

La Peinture
30 heller stamp issued 1969

La Musique
40 heller stamp issued 1969

Améthyste
2.40 crown stamp issued 1969

Rubis
2.40 crown stamp issued 1969

PERIODICALS

LA VIE POPULAIRE
No. 41, 22 May 1890
24 x 19 cm
Signed *Mucha* bottom right
Cover

LE PETIT FRANCAIS ILLUSTRÉ
Journal des écoliers et des écolières
Vol. 3, No. 114 2.5.1891
One of Mucha's illustrations for *Les
Lunettes bleues* is used on the cover

LE PETIT FRANCAIS ILLUSTRÉ
Journal des écoliers et des écolières
Vol. 3, No. 115, 9.5.1891
One of Mucha's illustrations for *Le
Premier shampoing d'Absolon* is used
on the cover

LE PETIT FRANCAIS ILLUSTRÉ
Journal des écoliers et des écolières
Vol. 4, No. 149, 2.1.1892
Mucha's illustration *"Le Premier
jour de l'an chez la grand'mère,"* is
used on the cover

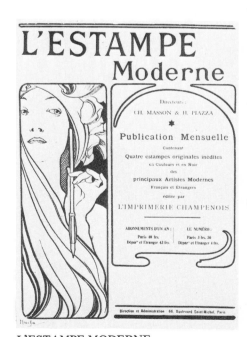

L'ESTAMPE MODERNE
1892
Black and white engravings
16 x 11.5 cm
Signed *Mucha* bottom left
Cover
Also issued as a colour postcard
Plate XXXIV

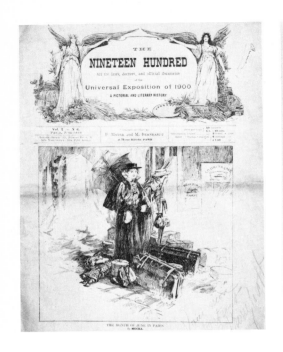

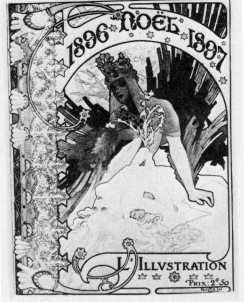

L'ESTAMPE MODERNE
1897
Salomé
Colour lithograph
33 x 23 cm
Signed *Mucha* bottom left
Ill. 167
Also issued as a colour postcard
Pl. XXXVII

AU QUARTIER LATIN
1898
Colour lithograph
44 x 31 cm
Signed *Mucha 98* bottom right
Cover
RR

COCORICO
Vol. 1, No. 1, 31.12.1898
Blue lithograph on blue paper
27 x 20 cm
Signed *Mucha* bottom right
Cover
Ill. 173
Also issued as a colour postcard
Pl. XXXVII

THE NINETEEN HUNDRED
Vol. 2, No. 6, June 1896
38 x 28 cm
Signed *Mucha* bottom centre
Cover

L'ESTAMPE MODERNE
1896
Salambô
Colour lithograph
38 x 21.7 cm
Signed *Mucha* bottom left
Cover
Ill. 168

FIGARO ILLUSTRÉ
Vol. 14, No. 75, June 1896

L'AFFICHE ILLUSTRÉE
1896
One illustration by Mucha

L'IMAGE
Revue artistique et littéraire
Vol. 1 No. 1, Dec. 1896
Cover

AU QUARTIER LATIN
Numéro Exceptionnel, 1897
Colour lithograph
44 x 31 cm
Signed *Mucha* bottom left
RR
Ill. 169, Pl. XXXII

L'ILLUSTRATION
1896-Noël-1897
Colour lithograph
38 x 26.5 cm
Signed *Mucha 896* bottom right
Cover

LA PLUME, NUMERO CONSACRE A ALPHONSE MUCHA
1897
Colour lithograph
22 x 15.6 cm
Signed *Mucha* bottom right
Special issue with articles about Mucha and his work illustrated with reproductions of his designs (see "Books")
Plate XXVI

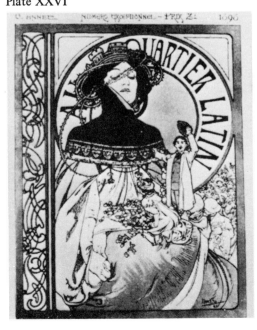

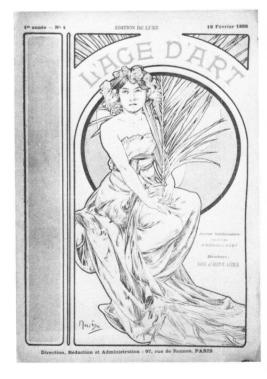

L'AGE D'ART
Vol. 1, No. 4, 19.2.1898
Lithograph, colour varying monthly
28.5 x 19.5 cm
Signed *Mucha* bottom left
Cover

L'ESTAMPE MODERNE
Vol. 2, No. 20, Dec. 1898
Cover

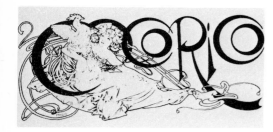

COCORICO
Vol. 1, No. 4, 15.12.1898
Black and white print
7.5 x 16 cm
Signed *Mucha* bottom left
Frontispiece

L'ART PHOTOGRAPHIQUE
1899
Colour lithograph
Signed *Mucha 99* bottom left
Cover used in successive issues
Plate XXXII

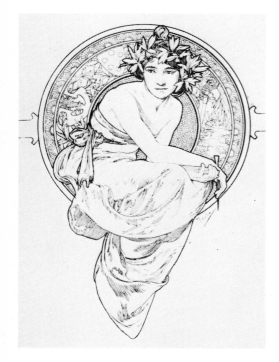

LE MOIS
1899
Black and white lithograph; also colour
11 x 7 cm
Signed *Mucha* centre right
Emblem for *Le Mois*
R
Variant: Title page for *Clio* by Anatole France (see Books)

COCORICO
1899
Twelve months of the year, one appearing each month
Black and white prints
19 x 13 cm
Signed *Mucha* bottom right

COCORICO
Vol. 1, No. 4, 15.12.1899
Monochrome lithograph
Also reproduced on metal sheet
27 x 21.5 cm
Signed *Mucha 99* bottom right
RRR
Ill. 172
Also issued as a colour postcard
Pl. XXXVII

COCORICO
1899
Lithograph
27 x 20 cm
Signed *Mucha 99* bottom right
Title page
R
Ill. 174

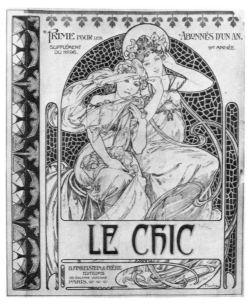

LE CHIC
Vol. 9, Suppl. No. 96, 1899
Blue monochrome print
39 x 31.5 cm
Signed *Mucha 99* bottom right
Cover

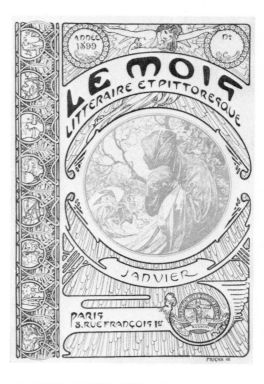

LE MOIS LITTERAIRE ET PITTORESQUE
1899-1900
Twelve months of the year, one appearing each month (2 series)
Monochrome lithographs
25 x 17 cm
Signed *Mucha 98* bottom right and *Mucha* bottom of picture
Also issued as colour postcards
Pl. XXXVII

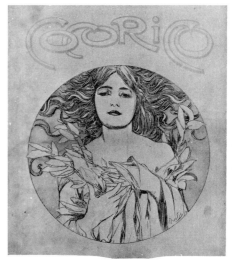

COCORICO
Vol. 2, No. 19, 5.10.1899
Lithograph in blue and black
25 x 19.5 cm
Signed *Mucha 99* bottom right
Cover
Also issued as a colour postcard
Pl. XXXVII

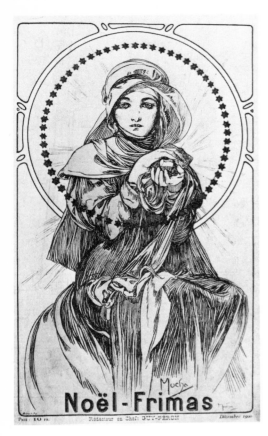

LE QUARTIER LATIN
Noel 1900
Colour lithograph
44 x 31 cm
Signed *Mucha* bottom right
Cover
RR

L'IDEE
Vol. 16, No. 58, 1900
Monochrome print, colour varying
monthly
29 x 20 cm
Signed *Mucha 99* bottom right
Cover

PARIS WORLD
Dec. 1901
Colour lithograph
25 x 17 cm
Signed *Mucha* centre left

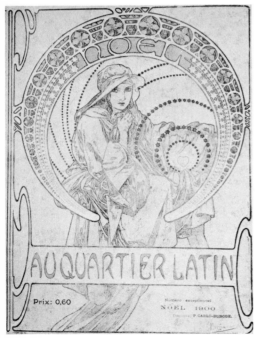

AU QUARTIER LATIN
Numéro exceptionel. Noel 1900
Signed *Mucha* bottom right
Cover

L'UNIVERSELLE
Vo. 2, No. 4, 1900
Print
28 x 22.5 cm
Signed *Mucha* centre right
Cover

REVUE DES DEBATS
EUROPEENS
March 1901
Print
25 x 16 cm
Signed *Mucha* bottom centre
Cover

COCORICO
Vol. 5, No. 62, 7.4.1902
Colour lithograph
27 x 20 cm
Signed *Mucha* centre right
Cover
R
Ill. 177

VZPOMINKY
Memories -Dedicated to F.J. Kubr
1903
Print
26 x 18 cm
Signed *Mucha 1903* bottom right
Cover

LA REVUE DU BIEN
c. 1903
Monochrome print
Signed *Mucha* bottom right
Cover
Variant: cover for *Dvakaty Vek*

MAJ
Vol. 1, No. 26, 1903
Red monochrome print
26 x 18 cm
Signed *Mucha 1902* bottom right
Cover

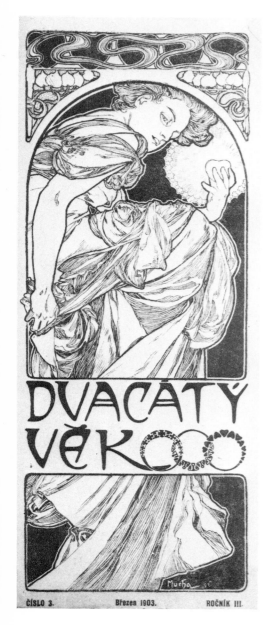

DVACATY VEK (20th century)
Vol. 3, No. 3, 1903
Black and white print
34 x 14 cm
Signed *Mucha* bottom right
Cover

LE CHRONIQUEUR DE PARIS
Vol. 4, No. 43, 19.11.1903
Print
36.5 x 26.5 cm
Signed *Mucha 1903* bottom left
Front page

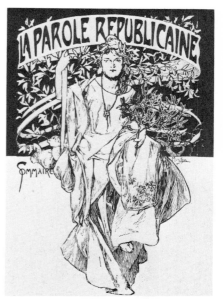

LA PAROLE REPUBLICAINE
1904
Print taken from indian ink drawing
Signed *Mucha 1904* centre right
RR

DVCATY VEK
Vol. 4, No. 8, 1904
Cover

THE NEW YORK DAILY NEWS
3.4.1904
Colour lithograph
48.5. x 33 cm
Signed *Mucha 1904* bottom left
Front page of the colour section also
published as a separate print
RR
Ill. 170
Plate XXXII

THE INDEX
Vol. 13, No. 2, 15.7.1905
Colour print
36 x 28 cm
Unsigned
Cover

TOWN TOPICS
Vol. 56, No. 23, 6.12.1906
Colour print
Signed *Mucha 906* bottom left
RRR

THE LITERARY DIGEST
Vol. 40, No. 6, 5.2.1910
Colour lithograph
Signed *Mucha 1907* bottom left
Cover
Pl. XXXVI

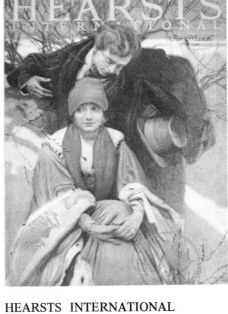

THE INDEX
Vol. 12, No. 26, 5.7.1905
Colour print
36 x 28 cm
Signed *Mucha* bottom left
Cover
Variant of a catalogue cover XXIX

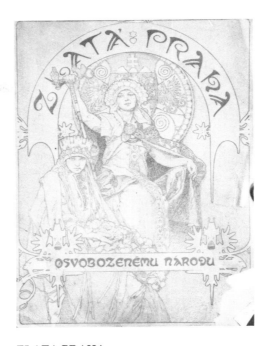

ZLATA PRAHA
Special number celebrating Armistice,
1918
Monochrome print
40 x 30 cm
Signed *Mucha* bottom right

LA DECORATION
Vo. 1 No. 8
Plate 19 reproduces *Médée* and *La
Samaritaine*

HEARSTS INTERNATIONAL
Twelve covers for 1922
Colour prints
Signed: *Mucha* bottom left or right
Pl. XXV

VESTNIK ZAHRANICNI
DOMOVINY

Vol. 3, No. 7, 1934
Monochrome print
21.5 x 15 cm
Signed *Mucha 30* bottom right
Cover

SALON
Prague
Signed *Mucha* bottom right
Cover
(no other information available)

THE BURR McINTOSH MONTHLY
35.5 x 23 cm
Signed *Mucha* bottom left
Cover

BOOKS

[. . . .]
Le Costume au Théâtre
Paris, 1890

PASCHAL GROUSSET
Histoire de deux Enfants de Londres.
Aventure Nautique. Les Bavardages
de Fanny.
Armand Colin, Paris, 1891

CHARLES NORMAND
Six Nouvelles
Le Paon couronné, Le Trois pachas,
Un Gendarme par téléphone. Le

premier shampoing d'Absalon, La
Saison des troupies,Les Tartes de
l'Oncle Brigaut. Nombreuses illustra-
tions d'après Henry Pille, Loulignie,
Mucha, Gerlier.
Armand Colin, Paris, 1891
The illustrations for "Le premier
shampoing d'Absalon" are by Mucha.

XAVIER MARMIER
Les Contes des grand-mères
Jouvert, Paris, 1892

MME MAGBERT
Les Lunettes Bleues. Récits
jurassiens. Illustrés de 33 gravures
d'après Mucha et Martin.
Armand Colin, Paris, 1892

JUDITH GAUTIER
Mémoires d'un Eléphant Blanc
Armand Colin, Paris, 1894

GERALD-MONTMAZIL(MABEL
GERALD)
Jamais contents
Armand Colin, Paris, 1895
2nd edition, 1908

MAITRES DE L'AFFICHE
5 volumes
Paris, 1896-1900
Contains 6 posters by Mucha:
Gismonda, Job of 1896, Salon des
Cent, La Samaritaine, Bières de la
Meuse, Lorenzaccio, La Dame aux
Camélias.

SIMON GODCHOT
Le I^{er} Régiment de Zouaves, 1852-1895, 2 volumes
Illustrations de M.E. Titeux, Krieger et Mucha. Librairie Centrale des Beaux-Arts, 1896-1898
The figure on the cover is used for both volumes and as a frontispiece in volume 1

ROBERT DE FLERS
Ilsée, Princesse de Tripoli
Lithographies de A. Mucha
H. Piazza, Paris, 1897
Limited edition of 252 copies, 180 of which are on vellum, 1 on parchment, 1 on silk, 15 on Japan paper and 35 on China paper.
Pl. XXII, XXIII.

ANDRE EMILE EMMANUEL PARMENTIER
Album Historique 4 volumes
Armand Colin, Paris, 1897-1907
Illustrations by Mucha only in volumes I and II

SVATOPLUK CECH
Adamite. Illustroval Alphons Mucha
F. Simacek, Prague, 1897

EDMOND ROSTAND
La Samaritaine. Evangile en trois tableaux en vers.
Eugène Fasquelle, Paris, 1897
The figure on the front cover is based on Mucha's poster for Sarah Bernhardt's production of the play.

LA PLUME
Alphonse Mucha et son oeuvre
Texte par Leon Deschamps, etc...
127 Illustrations par A. Mucha
Société anonyme La Plume, Paris, 1897
Originally issued in *La Plume* in six semi-monthly parts, 1st July - 15th September, 1897. Special edition prepared for Les XX. 20 copies on Japan paper, edition statement signed by Mucha; 20 copies on China paper. Original lithograph on both Japan and China (sketch reproduced on page 18). The cover of *La Plume* designed by Mucha is printed on Japan, on China, and, in colour, on vellum.
Pl. XXVI

CHARLES SEIGNOBOS
Scènes et Episodes de l'Histoire d'Allemagne. Illustrés de 40 compositions inédites par
G. Rochegrosse et A. Mucha
Armand Colin, Paris, 1898
A limited edition of 20 copies was printed in addition to the ordinary edition.

LUCIEN BIART
La Vallée des Colibris
Alfred Mame, Tours, 1898

EUGENE MANUEL
Poésies du Foyer et de l'Ecole
Extraites des oeuvres de l'auteur, avec des pièces inédites. Illustrations de A. Mucha. Portrait par L. Flament, Librairie Centrale des Beaux-Arts, Paris, 1898
Limited edition of 200 copies, 125 of which are on Holland paper

GEORGE PRICE
Les Chasseurs d'épaves
Alfred Mame, Tours, 1898

GEORGE PRICE
Les Chasseurs d'épaves. Illustrations de Ed. Zier, Alfred Mame, Tours (n.d.)
The six illustrations are by Mucha and were used, with others, in the 1898 edition noted above.

PAUL VEROLA
Rama. Poème dramatique en trois actes. Illustrations de Alphonse Mucha. Bibliotheque artistique et litteraire, 1898. Limited edition of 400 copies, 385 of which are on vellum

LEON MAILLARD
Les Menus & programmes illustrés
Invitations, billets de faire part, cartes d'adresse, petites estampes du XVII siècle jusqu'à nos jours. Ouvrage orné de quatre-cent-soixante reproductions d'après les documents originaux des meilleurs artistes.
G. Boudet, Paris, 1898
Limited edition of 1050 copies, some on vellum.
Covers by Mucha.

PAUL REDONNEL
Les Chansons éternelles. Nouvelle édition illustrée. Bibliothèque artistique et littéraire, Paris, 1898.
The cover design without the decorative border on the left and the shading in the preliminary pages.
Limited edition of 550 copies, 500 of which are on vellum.

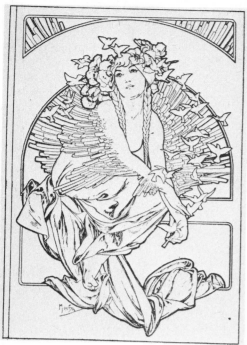

ALPHONSE MARIE MUCHA
Otcenas. Komposice A.M. Mucha.
B. Koci, Prague, 1899
Limited edition of 120 copies.

ALPHONSE MARIE MUCHA
Otcenas. Kresil, a napsal A. Mucha.
Unie, Prague (n.d.)
Reproductions, much reduced, of an
earlier Czech printing of Otcenas.
The commentary differs from the
text of the 1899 edition.

[. . . .]
Chansons d'aïeules. Dites par
Madame Amel de la Comédie française.
Préface de Jules Clérètie de
l'Académie française. Lithographies
de Mm. Fantin-Latour, E. Grasset,
Léandre, Lunois, Mucha, Steinlein,
Jean Verberm, Ad. Willette
Arrangements de E. Matrat
Henri Téllier, Paris c. 1898

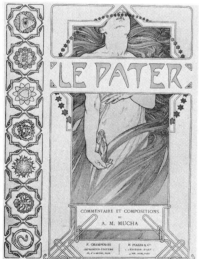

ALPHONSE MARIE MUCHA
Le Pater. Commentaire et com-
positions de A.M. Mucha
F. Champenois, H. Piazza, Paris, 1899
Limited edition of 510 copies, 400 of
which are on Marais paper.
The first 10 copies were printed on
Japan paper with an original water-
colour drawing.
Plate **XXIV**

ANATOLE FRANCE
Clio. Illustrations de Mucha.
Calman Levy, Paris, 1900
A limited edition of 150 copies was
printed with the covers on Japan
paper and the illustrations on China
paper.

EMILE GEBHART
Cloches de Noël et de Pâques
Illustrations et décoration de
A. Mucha.
F. Champenois, H. Piazza, Paris, 1900
Limited edition of 252 copies, 35 of
which are on Japan paper, and 215 of
which are on vellum. A few copies
were also printed on satin.

[B. KOCI]
Praha-Parizi. Prague à la ville de
Paris. Prague, 1900
Cover by Mucha

M. P. VERNEUIL, G. AURIOL,
A. MUCHA
Combinaisons Ornementales
Se multipliant à l'infini à l'aide du
miroir. Librairie Centrale des Beaux
Arts.
Paris, 1901
Cover by Mucha

M.P. VERNEUIL, G. AURIOL,
A. MUCHA
*Die Grotesklinie und ihre Spiegel
variation im modernen Ornament
und in der Dekorationsmalerei.*
Kanter & Mohr, Berlin, Cologne, 1901
A German reprint of *Combinaisons
Ornementales*, without Mucha's title
page.

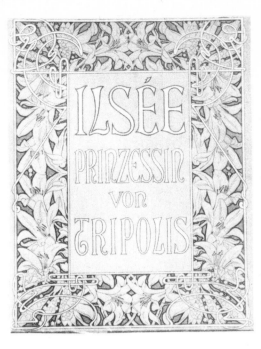

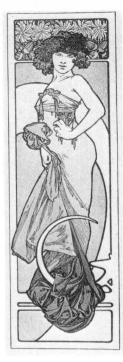

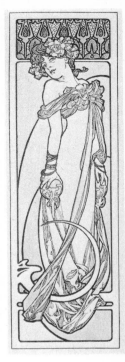

ALBERT DE ROCHAS D'AIGLUN
Les Sentiments, La Musique et la Gèste. H. Falque et Félix Perrin, Grenoble, 1900 (printed in 1899)
Limited edition of 1100 copies.

QUIDO MARIA VYSKOCIL
Placici madona
L. Mazac, Prague, (n.d.)

RIDVAL
Singoala
An epic poem

ROBERT DE FLERS
Ilsee, Prinzessin von Tripolis
Deutsch von Regine Adler.
Lithographien von A. Mucha.
B. Koci, Prague, 1901
Limited edition of 800 copies on vellum.

PAUL ROUAIX
Dictionnaire des Arts Décoratifs
2 volumes
Ouvrage illustré d'environ 600 gravures.
Montgredien, Paris, 1902

ALPHONSE MARIE MUCHA
Documents Décoratifs. Panneaux décoratifs, études et applications de fleurs, papiers peints, frises, vitraux, orfèvrerie, etc. 72 planches. Préface de Gabriel Mourey, Librairie Centrale des Beaux-Arts, Paris, 1902
Plates **XX, XXI**

POGGIO-BRACCIOLINI
Mistr Jan Hus na Koncilu Kost-nickem. Jeho vyslech, odsouzeni a upaleni dne 6. cervence 1415.
Illustruji a vlastnim nakladem vydavaji Alfons Mucha a Jan Dedina.
J. Otto, Prague, 1902

MAURICE PILLARD VERNEUIL
Encyclopédie Artistique et Docu-mentaire de la Plante. 4 volumes
Publiée sous la direction de M.P. Verneuil (Acquarelles de MM. Bailly, Colmet D'Age, de Schryver, Habert Dys, Vedy, etc. Dessins de MM. A. Mucha, Meheut, Berberis, etc. Photographies de M. Paluszewski)
Librairie Centrale des Beaux-Arts, Paris, 1904 - 1908
3 plates by Mucha

JAMES CLARENCE HARVEY
In Bohemia. Illustrations by A. Mucha and others.
H.M. Caldwell, New York, Boston, 1905

ALPHONSE MARIE MUCHA
Figures Décoratives. Quarante planches
reproduisant en fac-simile des dessins
de l'artiste. Librairie Centrale des
Beaux-Arts, Paris, 1905

[PLEIADES CLUB]
Yearbook
Pleiades Club, New York, 1909
Limited edition of 500 copies.
Two illustrations by Mucha.

QUIDO MARIA VYSKOCIL
Utok More (Romanova legenda.
Knizni vyzdoba od Alfonse Muchy)
E. Beaufort, Prague, 1928
A limited edition of 200 copies was
printed in addition to the ordinary
edition.

JOSEF HAIS-TYNECKY
Andelicek z baroka
Nakreslil Alfons Mucha
J. Otto, Prague, 1929
Limited edition of 300 copies, 200
of which were numbered and signed
by the author.

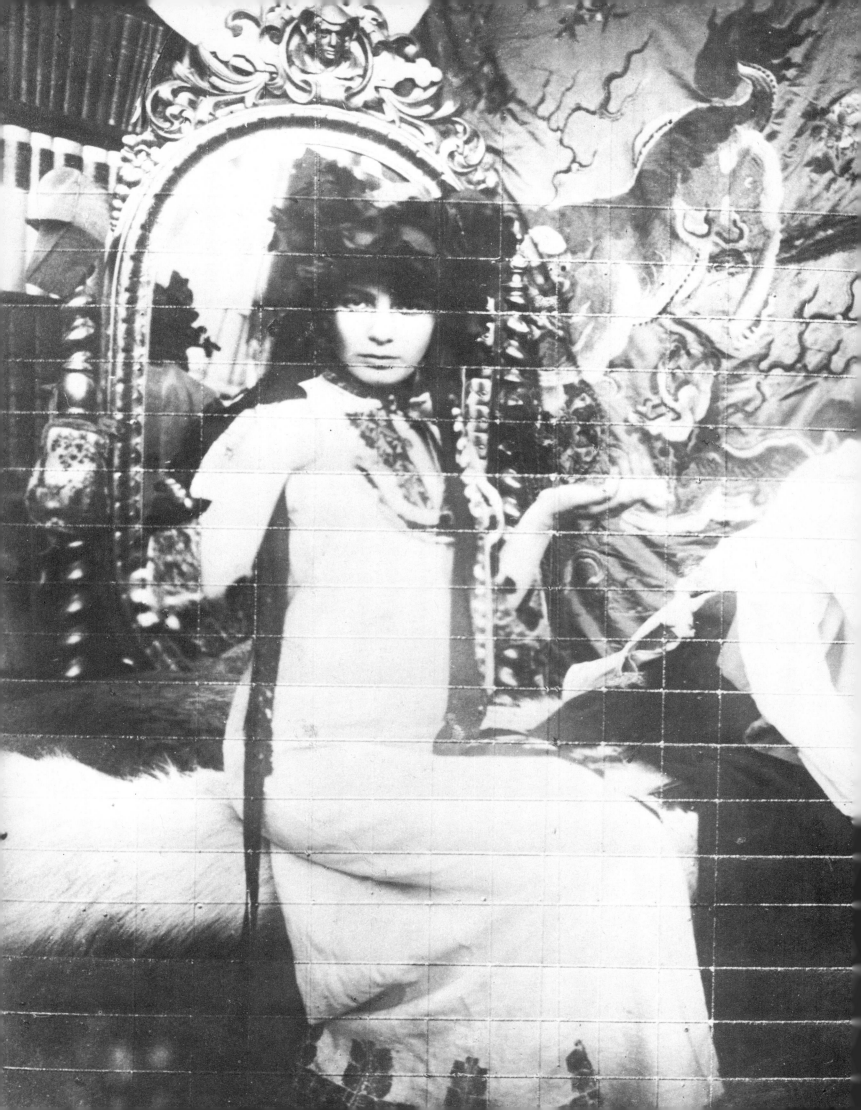

SIGNATURES

1880 - 1890

1890 - 1893

1894 - 1896

1896 - 1897

1897 - 1898

1898 - 1908

1908 - 1920

1920 - 1925

1925 - 1929

1929 - 1939

135

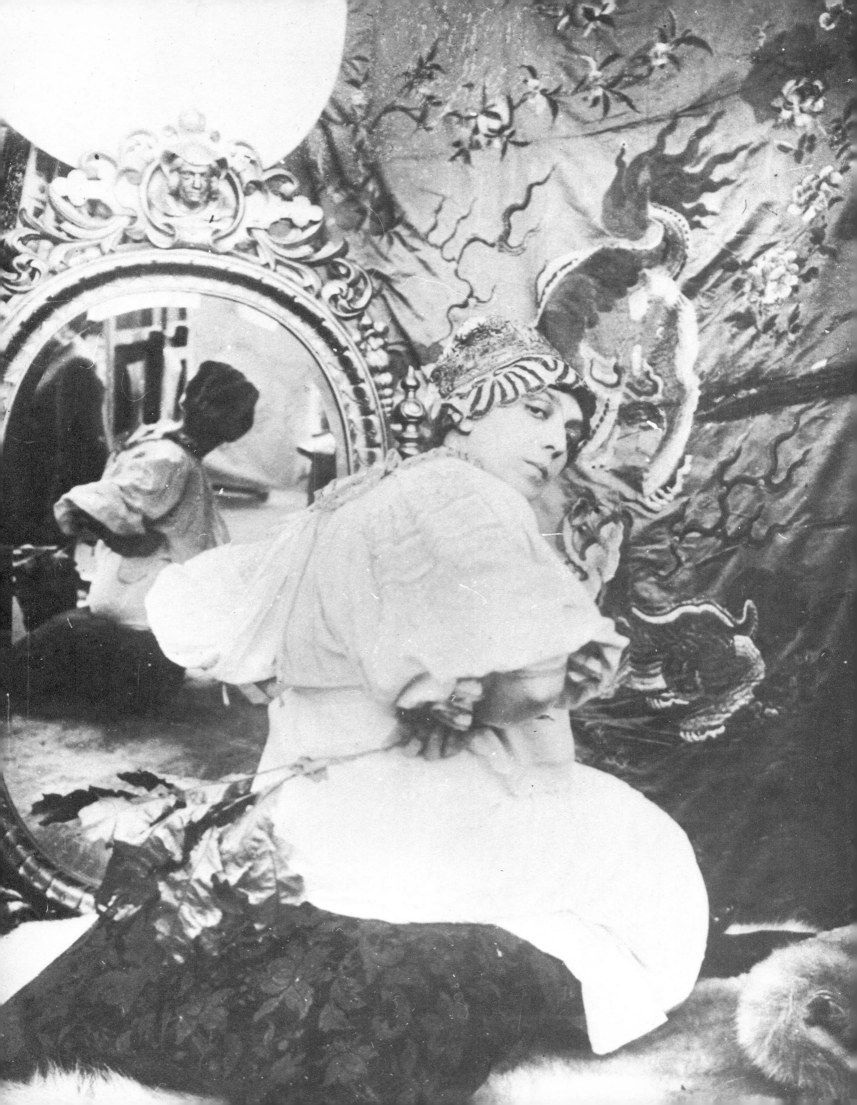

BIBLIOGRAPHY

BOOKS

Basika, Karel
Alphons Mucha, Filatelio, Prague 1958

Cadik, J.
A. Mucha, Manuscript

Mucha, Alphonse
Tri projevy o zivote a dile, Brno 1936

Mucha, Jiri
Alphonse Mucha the Master of Art Nouveau,
Prague 1966

Mucha, Jiri
Alphonse Mucha, London 1966

Mucha, Jiri, Henderson, M., Scharf, A.
Alphonse Mucha Posters and Photographs,
London - New York 1971

Abdy, J.
The French Poster, London 1969

Amaya, M.
Art Nouveau, London 1966

Aragon, Louis
Les Cloches de Bâle, Illustré par A.Mucha –
préface. Oeuvres croisées d'Aragon et Elsa
Troilet, Robert Lafont, Paris 1965

Battersby, M.
Art Nouveau, London 1969

Curinier, C.E.
Dictionnaire national des contemporains,
Vol. 3, Office général d'éditions, de libraire
et d'imprimerie, Paris 1906

Graul, R.
Die Krisis im Kunstgewerbe, R.G., Leipzig
1901

Guerrand
L'Art Nouveau en Europe, Plon, Paris 1965

Harlas, F.X.
Malirstvy, Prague 1908

Hillier, B.
Posters, London 1969

Hladik, Vaclav
O soucasne Francii, J. Otto, Prague 1907

Hofstatter, H.H.
Jugendstil / Druckunst, Baden Baden 1968

Hutchinson, H.F.
The Poster, an illustrated history from 1860,
London 1968

Jirik, F.X.
Vyvoj malirstvi ceskeho v XIX. stoleti,
Prague 1909

Jullian, P.
Esthetes et Magiciens, Paris 1969

Koch, Robert
Louis C. Tiffany, Crown, New York 1965

Koreska-Hartman, L.
Jugendstil - Stil der Jugend, Munich 1969

Larkin, W. Oliver
Art and Life in America, rev. edn., Holt,
Rinehart & Winston, New York 1960

Madsen, S.T.
Sources of Art Nouveau, Oslo 1956

Madsen, S.T.
*Jugendstil / Europaische Kunst der Jahr-
hundertwende,* Munich 1967

Maindron, E.
Les Affiches illustrées 1886-1895, Paris 1896

Marx, Roger
Les maîtres de l'affiche, 5 vols., Imprimerie
Chaix, Paris 1896-1900

Mascha, O.
Osterreichische Plakatkunst, Vienna 1915

Morand, P.
1900, Paris 1931

Mucha, Alphonse
Documents décoratifs, preface by Gabriel
Mourey, Paris 1902

Otto, J.
Ottuv naucny slovnik: XVII, Prague 1901

Polivka, Eduard
*K historii vzniku pruni ceskoslovenske
tisicikoruny,.* Csl. numismaticka spolecnost,
Prague 1964

Price, Ch.M.
Poster Design, New York 1922

Rheims, Maurice
L'Objet 1900, Arts et Métiers Graphiques,
Paris 1964

Rheims, Maurice
Age of Art Nouveau, Thames & Hudson,
London 1966

Schardt, H.
Paris 1900, Franzosische Plakatkunst,
Stuttgart 1968

Sponsel, J.L.
Das Moderne Plakat, Dresden 1897

Thieme, Ulrich & Becker
Allgemeines Lexikon der bildenden Kunstler XXV,
E.A. Seaman, Leipzig 1931

Wallis, M.
Secesja, Warsaw 1967

Wexter, Dixon
The Saga of American Society, Scribner's,
New York 1937

PERIODICALS

Alte und Moderne Kunst, 94, pp 29-35, 1967

Amaya, Mario
'Mucha's Fantasy' *Apollo,* 77, pp 475-477,
1963

Banham, Reyner
'The First Master of the Mass Media' *The
Artist,* 30, pp 113-119, 1931

Bauer, G.
'Two Magicians of the Hoardings' *L'Echo de
Paris,* June 4, 1898

Boychot, H.
'propos sur l'affiche' *Art et Décoration,* 111,
pp 115-122, June, 1898

Brinton, Christian
'Midsummer in Bohemia' *Appletons Magazine,*
August, 1906

The Brooklyn Museum Quarterly, pp 57-61,
1921

Burns, Arthur
'The Art of Alphonse Mucha' *Smith's Magazine,*
1907

Champier, Victor
'L'Exposition de A. Mucha à la Bodinleve'
Revue des Décoratifs, 17, pp 58-60, 1897

Classens, Henri
'Le Modern Style' *Jardin des Arts,* No. 114,
pp 34-47, 1964

'Deux Peintures Thecoslavaques' *Beaux Arts,*
178, 1936

Ethische Kultur, 10, p 50, 1902.

Haydon, J., Clarendon, C.
'J. Mucha' *New York Daily News,* April 3, 1904

Helbings Monatsberater uber Kunstwissen-schaft 2, pp 97-100, 1902

Heppenstall, R.
'Mucha's Stamp Designs' *Apollo,* 208, p 73, 1968

Hiall, Ch.,
'Sarah Bernhardt', Mucha and some Posters' *The Poster,* 11, pp 236-242, 1899

Hilbert, J.
Zlata Praha, 15, p48, 1898

Hladik, V.
Zlata Praha, 17, p 557, 1900

Holme
'Modern Designs in Jewellery and Fans' *The Studio,* Special Winter Number, 1902

Horica, I.
Zlata Praha, 17, p 586, 1900

Kossatz, H.H.
'Style Mucha' *Alte und Moderne Kunst,* 124/125, pp 34-39, 1972

Kunst und Kunsthandwerk, 3, p 304, 1900

Lancelot
'Figures décoratives de A. Mucha' *Art et Décoration,* XVII, pp 33-36, 1905

Masson, C.
'Mucha' *Art et Décoration,* pp 129-138, May, 1900

Masson, C.
Zlata Praha, 17, p 539, 1900

Melville, Robert
'Le Style Mucha is Fashion' *Ambassador,* pp 89-93, 1963

Mitteilungen der Gesellschaft fur Verviel fattigung der Kunst, 1897-1898

'Alphons Mucha' *Svetozor,* 19, pp 226-227, 1897

'Alphons Mucha, *Umeni,* 12, p 298, 1939-40

'The Alphonse Mucha Exhibition' *Volne Smery,* Column 128, January, 1898

Mucha, Jiri
'The World of Mucha' *The London Magazine,* pp 43-52, August, 1963

La Plume, Numéro Consacré à Alphonse Mucha, Special Number, Paris, 1897

'Un Second Bronze de Mucha est Retrouvé' *Connaisance des Arts,* No. 155, p 11, January, 1965

Seneike, K. Wagner
'Mucha's Chicago Poster' *Chicago History,* 11, pp 26-30, 1972

Shellon-Williams, P.M.T.
'L'Art Nouveau and Alphonse Mucha' *Contemporary Review,* 203, pp 265-270 and 316-320, 1963

The Studio, 90, pp 38-40, 1925

Sylvester, David
'Sarah's Signwriter' *The Sunday Times Colour Magazine,* May 19, 1963

'Symbolism in Posters - Alphonse Mucha's Art Nouveau' *The Sphere,* CCLV, 5, pp 46-47, 1963

EXHIBITION CATALOGUES

1897 *Catalogue de l'Exposition des Oeuvres de Mucha,* Galeries de la Plume, Paris

1897 *Exposition des Oeuvres du peintres A. Mucha,* Galerie de la Bordiniere, Paris

1897 *Ausstellung Alfons Mucha,* Kunstsalon Artaria, Vienna

1897 *Alfons Mucha. Souborna vystava obrazu, kreseb a plakatu,* Topicuv Salon, Prague

1919 *Slovanska Epopej,* Klementinum, Prague

1921 *The Slav Epopee,* Introduction by Christian Brinton, Brooklyn Museum, New York

1928 *Alfons Mucha, Slovanska Epopej,* Veletrzni palac, Prague

1933 *Souborna vystava Alfonse Muchy,* Hradec Kralove

1933 *Souborna vystava Alfonse Muchy* Brno

1936 F. Kupka, A. Mucha
 Oeuvres Exposées, Musées des Ecoles Etrangères Contemporaines, Jeu de Paume des Tuileries, Paris

1959 Municipal Museum, Arnhem, Boyman's Museum, Rotterdam, Stedelijk Museum, Amsterdam. Citroen Collection cat.no. 12

1960-
1961 *Les sources du XXe siècle,* cat.no. 1131, Musée National d'Art Moderne, Paris

1961 *International Exhibition of Jewellery 1890-1961,* cat.no. 585, Goldsmith's Hall, London

1962 *Dix siècles de joaillerie française,* cat.no. 149, Musée du Louvre, Paris

1962-
1963 Hessisches Landesmuseum, Darmstadt, Citroen Collection, cat.no. 100

1963 *Art Nouveau & Alphonse Mucha,* B. Reade, Victoria & Albert Museum, London

1963 *Alphonse Mucha,* Grosvenor Gallery, London

1963 *Affiches 1900,* preface by R.H. Guerrand, Bibliothèque Forney, Paris

1963 *Alfons Mucha,* Slany Kulturni dum, uvod Yaroslav Mervart

1965 *Katalog k vystave v Usti nad Orlici,* Jaromir Pecirka

1965 *Bijoux 1900,* Hotel Solvay, Brussels

1966 Guerrand, R.H., David, A. preface by A. Mucha

1966 Guerrand, R.H., David, A. preface by Aragon, *Exposition Mucha,* Bibliothèque Forney, Paris

1966 *Alphonse Mucha,* Galleria del Levante, Milan

1966 *Art Nouveau,* Grosvenor Gallery, London

1966 *Mucha / Vystavni sin Domu kultury,* Usti nad Labem

1967 *Alphonse Mucha 1860-1939, Plakate und Druckgraphik,* Kunstgewerbe Museum, Zurich

1970 *Alfons Mucha,* Galerie Daniel Keel, Zurich

1972 *Alphonse Mucha, Zeichnumgen und Aquarelle,* Gallerie Christian M. Nebehay, Vienna

INDEX

ADDENDA

Although the editor and publishers have made every effort to verify all information included in this catalogue, a number of errors and ommissions may have occurred. Unpublished designs for posters and other graphic works are outside the scope of this book and have not been included.

Corrections and additions will be gratefully received by the publishers for inclusion in later editions.

POSTERS

BISCUITS LEFEVRE-UTILE
Colour lithograph
Poster with lettering
Signed *Mucha* bottom right

POSTCARDS

BISCUITS LU RECOMMANDES
Postcard from the Lefevre-Utile collection
1904
Seated woman holding drapery
Unsigned dated 1904 centre right

LE CERVEAU DU POETE DU CRAYON
Photograph showing a girl standing beside an easel with the *panneau Tete Byzantine Blonde* in the background
Signed *Mucha* top right

MISCELLANEOUS

L'ILLUSTRATION
Comedie Francaise Programme Cover
1897 - 1902
Embossed card, white on a blue background
Unsigned

BOOKS

BRISAY, HENRI DE
L'Aventure de Roland
Paris Charavay, Manteaux Martin
1896

CORRECTIONS

P. 131
ANATOLE FRANCE
Clio. Illustrations de Mucha
Calmann Levy, Paris 1900
Two limited editions were printed 100 copies on Japanese paper, and 50 copies on China paper with *suite*

P. 103
La Princesse Lointaine
c. 1895